GREAT
ADAPTATIONS

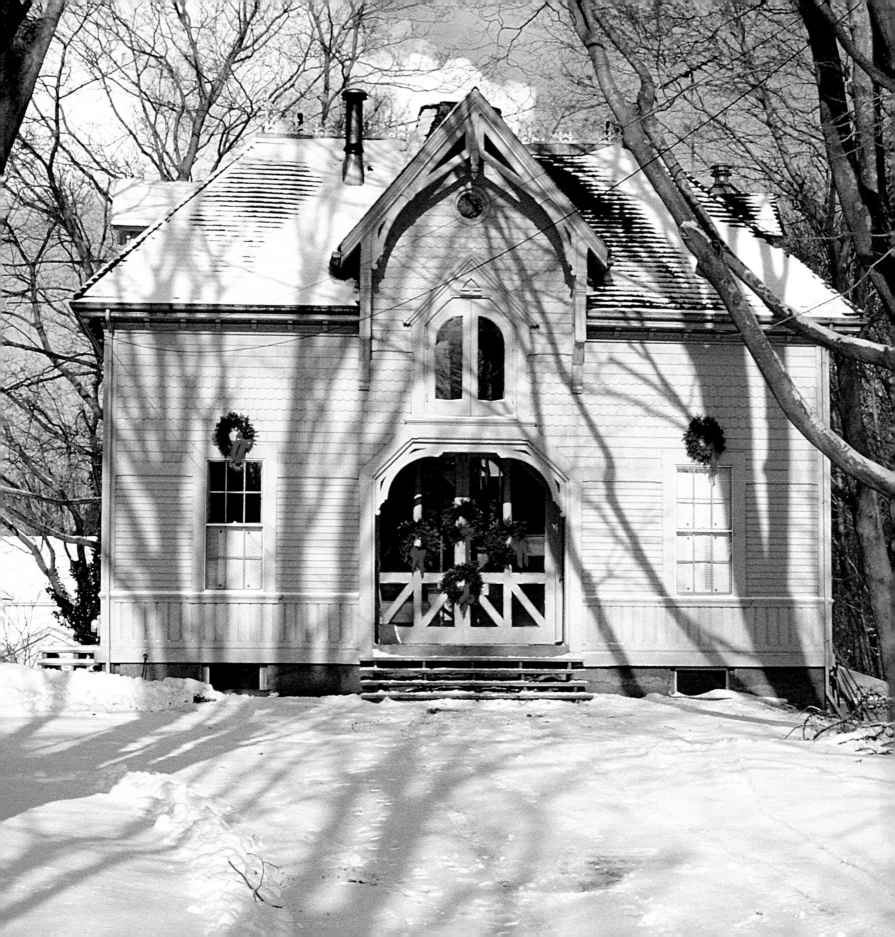

GREAT
ADAPTATIONS

New Residential Uses for Older Buildings

By Jill Herbers

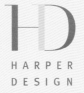

HARPER
DESIGN

An Imprint of HarperCollinsPublishers

GREAT ADAPTATIONS: MAKING OLDER BUILDINGS INTO DYNAMIC HOMES FOR TODAY

Copyright © 2005 by Jill Herbers. The book was published in a previous edition in 1990.

First published in 2005 by:
Harper Design,
An Imprint of HarperCollins*Publishers*
10 East 53rd Street
New York, NY 10022
Tel: (212) 207-7000
Fax: (212) 207-7654
HarperDesign@harpercollins.com
www.harpercollins.com

Distributed throughout the world by:
HarperCollins International
10 East 53rd Street
New York, NY 10022
Fax: (212) 207-7654

HarperCollins books may be purchased for educational, business, or sales promotional use.
For information, please write: Special Markets Department, HarperCollins Publishers Inc.,
10 East 53rd Street, New York, NY 10022.

Associate Publisher: Harriet Pierce
Editorial Consultant: Alison Hagge
Designer: Pooja Bakri
Production Manager: Kimberly Carville
Production Associate: Ilana Anger
Production Editorial Assistant: John Easterbrook
Indexer: Bob Zolnerzak

Library of Congress Cataloging-in-Publication Data

Herbers, Jill.
 Great adaptations : making older buildings into dynamic homes for today / by Jill
Herbers -- 2nd ed.
 p. cm.
 ISBN 0-06-072779-9 (hardcover)
 1. Dwellings -- United States -- Themes, motives.
2. Buildings -- Remodeling for other use -- United States. I. Title.
NA7205.H46 2005
728'.028'6--dc22
 2004020219

First Edition published 1990. Second Edition 2005

Printed and bound in China

1 2 3 4 5 6 7 / 11 10 09 08 07 06 05

DEDICATION

For Kevin, forever

ACKNOWLEDGEMENTS

For photographic material, the following are gratefully acknowledged: J. Brough Schamp, Enoch Pratt Free Library, Grattan Gill, Robert Perron, Peter Woerner, Dominic and Elizabeth Whiting, Richard Anderson, Mark McInturff, and Peter Doo.

◁ A former water mill in Arles, France, complete with sheep and a distinctive gambrel roof, still projects a feeling of home and shows the inherent charm of converted buildings.

◄ After the interior was gutted, the vertical space of a nineteenth-century Baltimore firehouse was made livable by having a "building within a building" made to go into the original structure, with balconies to connect different areas of the home.

INTRODUCTION

Architecture is life; or at least it is life itself taking form and therefore it is the truest record of life as it was lived today or ever will be lived.

—Frank Lloyd Wright

When Frank Lloyd Wright made that statement, he may not have had in mind the conversion of nonresidential structures into homes, but the message still applies. Buildings such as barns, firehouses, and churches that were never intended to house more than cows, fire trucks, and souls are being made into striking homes for people, and the lives of the buildings are being continued. Many of these structures are architectural treasures; all have stories to tell. As "records of life," whether of agricultural, industrial, or spiritual life, each not only tells something about history, but about the way people lived and worked and interacted.

Beyond their desire to preserve these stone, brick, and wood remembrances of the past, architects and homeowners are turning to them because they fulfill contemporary needs. Some of these needs are purely practical. The rising cost of new housing means that buying and converting an old building is often less expensive than buying or building a new one. Although this is not always true, since renovation and conversion costs can, of course, run quite high, most people have found that the cost per square foot in a large old barn or sprawling warehouse works out to be far smaller than that in a new house.

These old buildings fulfill psychic needs, as well, for a generation alienated by the strict and impersonal forms of modernism. After an era in which architects often "started from zero," forming visions of the future without reference to the past, more and more people are searching for a sense of history, and are seeking out the graceful detailing, craftsmanship, and care of other eras. Adaptations satisfy this contemporary longing for character and interest in architecture.

The pure originality of these buildings is also psychologically fulfilling in an age when so much is mass-produced, and it has a special fascination for those who have grown weary of the familiar forms of urban and suburban housing. Why, after all, settle in a tract house or nondescript high-rise when making a home in a firehouse is far more exciting, or in a tower by the sea more tranquil? Residents of former churches say that no other home could feel so intensely personal. It is perhaps for this sense of intimacy and singularity that these buildings are most appreciated.

Changing demographics are making more of these adaptable buildings available to homeowners. The sweeping societal changes in the latter part of this century have left many schools and churches quiet and empty, and the continued move away from an agrarian economy has driven cows from their barns. It is not uncommon for banks that weathered the Depression to now sit empty on main streets, abandoned for larger, more contemporary quarters. Sometimes, simple shifts in population have caused these once-cherished buildings to be left behind. But adaptive reuse is saving them. After the congregation in a small Virginia town outgrew its hundred-year-old church, the members moved down the street to an old house large enough to meet their needs. A family later bought the church and made it their home, putting life back into the distinguished structure and possibly saving it from demolition. The words of Dale Ahlum, a Pennsylvania contractor who specializes in converting outbuildings, may express the sentiment of the Virginia community: "I don't believe a building should lose its usefulness just because it has lost its original use." A house into a church and a church into a house: These are valuable lessons of adaptability that show how practical holding on to history can be.

GETTING TO KNOW SPECIAL SPACES

At first, people may choose to convert an old structure for reasons that seem immediately clear to them: It has architectural interest, or they were looking for something "different" and found it, or they were just drawn to the building the moment they saw it. The charm of these buildings is often instantly apparent. But what unfolds as time is spent converting and living in them is as compelling as what attracted the owners in the first place. Little pieces of the past present themselves in myriad ways, and what becomes evident is a specialness that is uncovered the way stripping away the paint from the staircase of a former carriage house reveals beautiful carved wood below. Often just the physical elements of these structures—how and even *where* they were built—make them worthwhile. Owners may discover after buying a mill house

> A former Oasthouse, which was used for storing hops to make beer, dates to 1837. This one is in Kent, a traditional beer-making area in southern England.

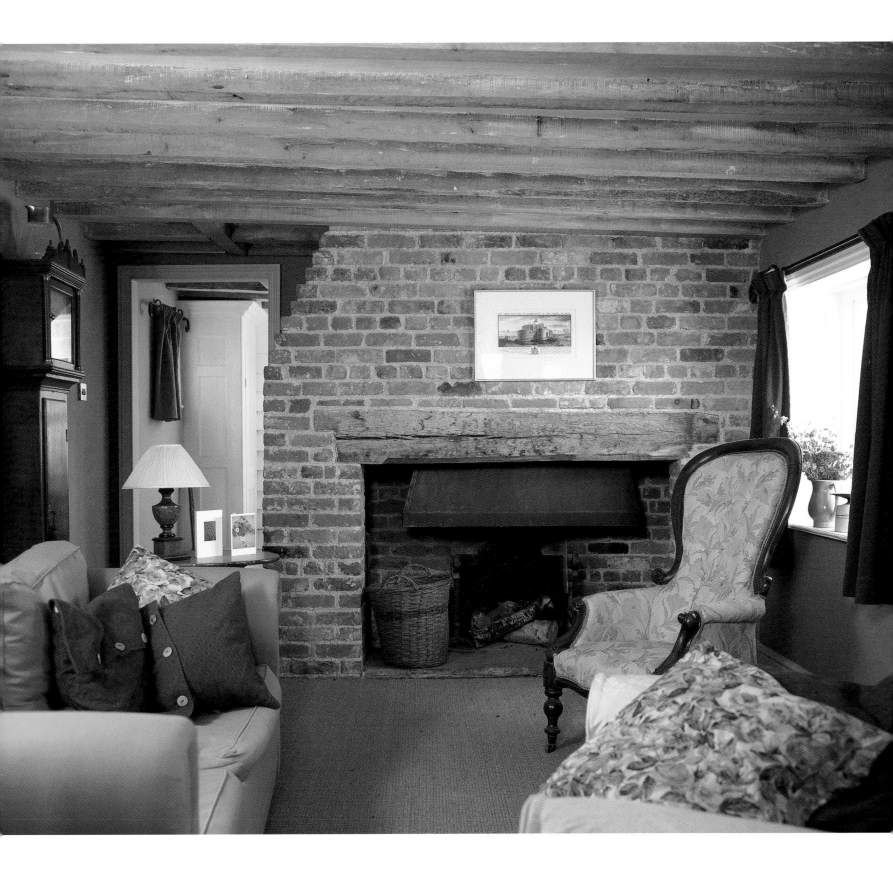

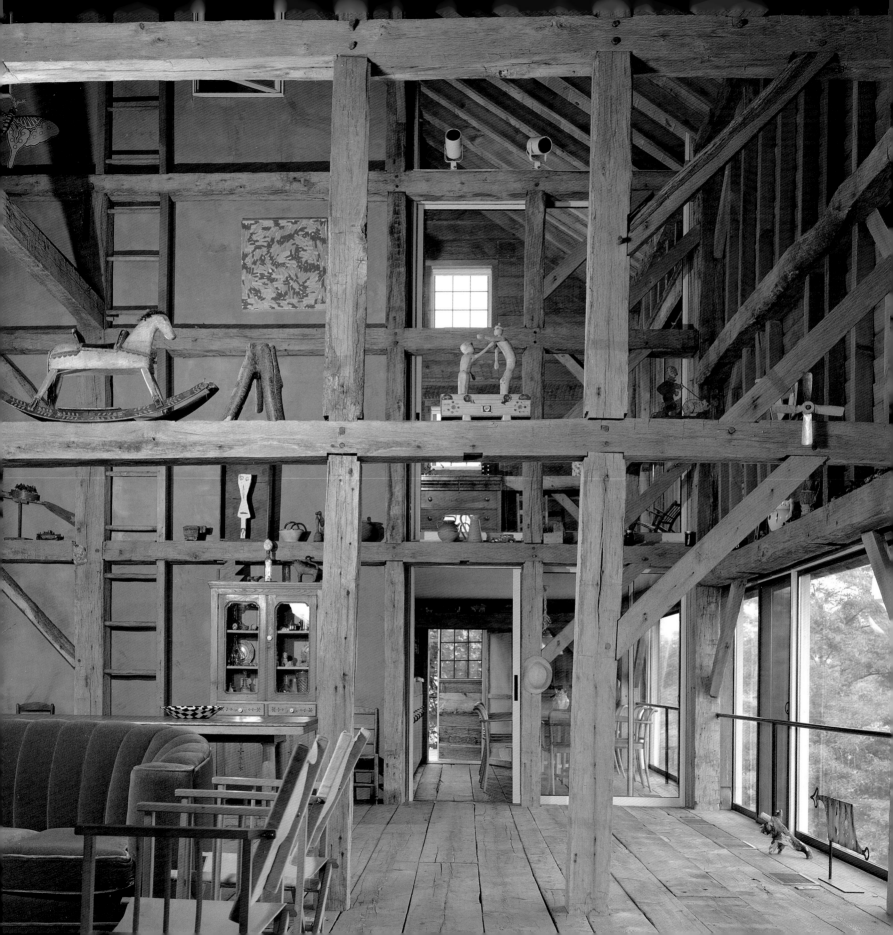

that they can hear the water gently running under what has become their bedroom, or that the fabulous detailing that drew them to a nineteenth-century library is continued in windows that were bricked up and not visible at the time of purchase.

But the deeper satisfaction offered by these buildings derives from the fact that they are already imbued with meaning when the owners come to inhabit them. In a sense, the owners are "borrowing" the spirit of the old buildings for their new homes. And much of that spirit remains. Converted churches are frequently pure and peaceful, and the owners of stables say the buildings have a gentle sense about them because animals lived there. These feelings are partly conveyed by the language of the architecture—the tranquil quality of church windows that carefully let in light, for example. But they often have little to do with the structure itself and more to do with what went on inside it. Even if the pole no longer remains in a converted firehouse, some of the spirit of clanging bells and rushing firemen does, evidenced, perhaps, by boot marks on the floor of the entryway. And the worn spots on the brick walls of stables, where horses rubbed their noses for years, make it hard to forget who used to live there.

These buildings are the ultimate found objects; they take on new meaning as the owners live within their walls and individualize them further. What follows is a look at what the owners discovered—and uncovered—that makes these buildings special and makes them loved.

TIES TO HISTORY

Commenting on the uses of architecture for relaying history, the critic Lewis Mumford wrote: "In a city, time becomes visible." In these buildings, history becomes not only visible but tangible as well. The years can be felt in an exposed-brick wall or a worn stone floor.

It is these ties to history that inspire a generation with a desire to be reminded of the past. In inhabiting old structures—dwelling underneath hundred-year-old posts and beams and between walls of intricate detailing from the Victorian era—these residents are not just living with history, but living *within* it. There is a pervasive feeling that something has come before.

The designer John Saladino talks about the Roman philosophy of building one element on top of another, creating "layers of history." It is a quite unconscious process in Rome, where several old steps weathered by time may lead to a new building, for example. This preservation of history—not in a museum but in the midst of our daily lives—is the result of converting old buildings, as well. Underneath the veneer of the new is a glimmer of the old, like the icons of angels that are just visible beneath layers of paint on a church ceiling. Every time the owners look upward from their couch, they look at history.

To describe the effect of the old layered with the new, architect Susana Torre uses the word *palimpsest*, an ancient term for parchment that was used and erased when the original text was unwanted, then reused. Intriguing traces of the old text were always still visible—and often legible—under the new. Being able to "read" parts of old structures underneath the new architectural "text"—seeing a smooth plaster wall reach up to meet roughhewn beams—relates past and present in a visceral way.

Respecting the history in these buildings is the key to a successful conversion, and when the conversion works—when

◄ Jane Clark Chermayeff and her husband, Ivan, disagreed about whether to get a new house or an old one, so with this 1863 barn in North Salem, New York, they made a new home within an old building. New window walls that bring light into the forty-foot family room coexist with historic elements like the original ladder that was used to reach the hayloft.

a balance is struck between saving the character of the old and adding the practicality of the new—the result can be far more exciting than anything newly built.

A SENSE OF COMMUNITY

Whether they intend to or not, those who turn old buildings into new homes are not just preserving history, they are also furthering the local community. The most immediate result of these adaptations is that, given new uses, the buildings are not torn down, since they are often the kinds of structure that would otherwise be slated for demolition. More than that, their very restoration boosts the area and encourages other improvements in what are often interesting, and sometimes classic, neighborhoods. One church in Cambridge, Massachusetts, for example, was converted as part of a rejuvenation of the failing waterfront district; today, old buildings and new sit side by side in the now-thriving historical area.

But most of all, saving and then upgrading buildings helps keep the community intact on a symbolic level. The barn on the edge of a landscape that lends contour and presence to the horizon continues to do so, only with a renewed sense of life. A firehouse on the corner of a city block can keep giving it interest and a place in history, only now without graffiti and broken windows.

The owners are also creating a community for themselves, something increasingly craved at a time when rushes of technology and shifts in lifestyle have resulted in a sense of disconnection. People are looking longingly back to a time when buildings were part of a neighborhood, not just a row of structures—a time when the symbolic importance of a building like the village church was enormous, and the meetinghouse on the main street was central to the town's identity.

Living in one of these buildings, and making it live again, ties the owners to the neighborhood because they are giving the building back to it.

Because a converted building is a shared building, a more intimate sense of community exists on the inside, where evidence of past lives is found. There is a certain presence felt from the carved initials of children on the wainscoting of an 1865 schoolhouse, the ink marks from the printing presses of a former printing factory, or the spots on church floors rubbed smooth from people kneeling to pray. These echoes remind owners they are the second dwellers of a building that once had a place in the lives of others, as well.

AN ARCHITECTURE APART

Beyond the historic importance of converting old buildings and past the sense of community they can offer is an aspect of the process that is of pure architectural interest. Of course, the buildings are chosen—and loved—for their special architecture, but the implications of *living* in them are what prove philosophically interesting. Architecturally, it is nothing less than a radical idea to inhabit buildings that were created for another purpose entirely. It is the farthest thing from the original intention of the builders—or of the building. Public structures such as churches and meeting halls are imbued with architectural symbolism; the vaulted ceilings of churches are intended to lift the spirit skyward, and the massive columns of meeting halls emphasize stability. To live in these buildings is to play with the symbolism and create a twist on their architectural meaning.

The entire idea is pleasantly disconcerting and the result is a quirky charm. Living in a place as reverent as a church, as playful as a schoolhouse, or as utilitarian as a barn produces an effect that no architect or designer could newly create.

> Architect Dan Shipley took a deteriorating 1918 firehouse in an inner-city neighborhood in Dallas and made it shine again. New structural elements inside the old building create a place for exhibiting art in part of the structure.

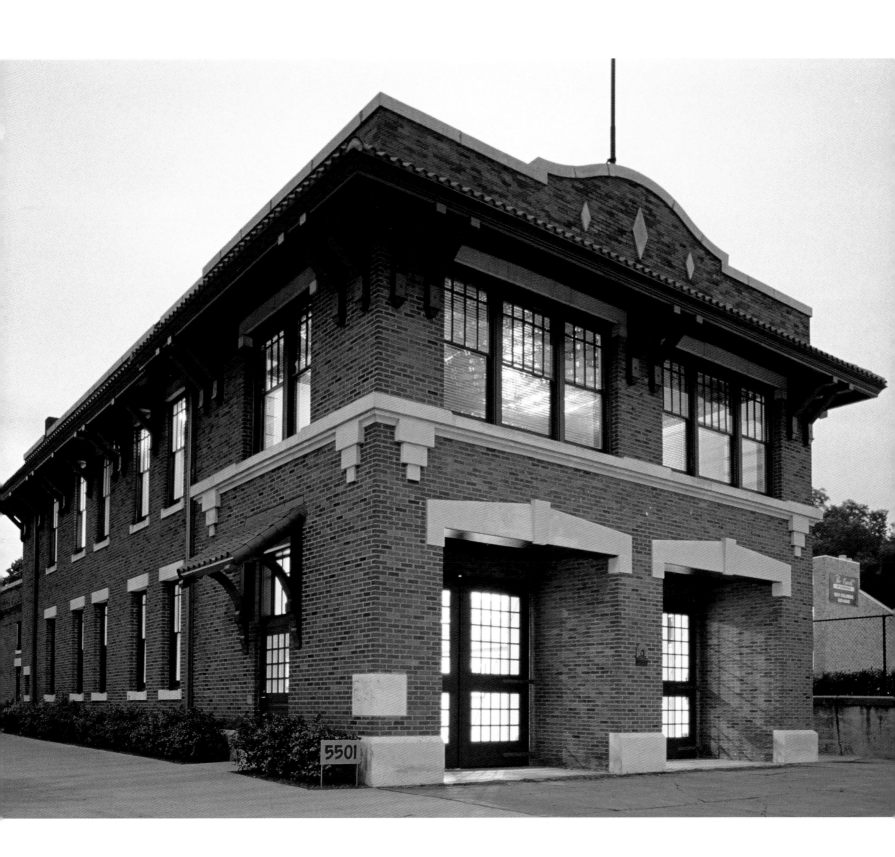

CREATING A GREAT ADAPTATION

Part of the excitement of the recent tendency toward conversion derives from the extraordinary range of adapted structures. Not only architects and builders, but individual homeowners as well are transforming structures in the middle of cities, in corners of the country, along coasts and rivers, in backwoods. Out of the thousands of fine examples that exist throughout the United States, England, and other countries, this book can offer only a representative sampling. It stops first to consider what makes these homes special and what they can mean to an owner and a community. The book also offers an examination of the conversion process: finding, deciding on, and buying a building; uncovering its history; and converting it to a place that will be comfortable and aesthetically appealing while retaining the original spirit of the structure.

Rather than giving instruction, this book shows by example what has worked in a number of vastly different and intriguing cases, pointing out elements that unify all conversions, and highlighting the most important, challenging, and fascinating aspects of great adaptations.

The last half of the book is a portfolio of case studies that explores in detail an astonishing array of buildings—from power stations to ballrooms to pigsties. These adaptations are as individual as their former uses suggest, and they illustrate both the practicality and pure joy of making a carriage house, a firehouse, or a schoolhouse into a home.

> A former forge near Fountainbleau, France is so large that architect Gilles Bouchez constructed the year-round home within it, leaving the outer part to be used only in warm weather.

>> The new glass walls and doors of the forge create only the slightest separation between the inner and outer parts of the building, dividing the two spaces physically but allowing them to remain visually connected.

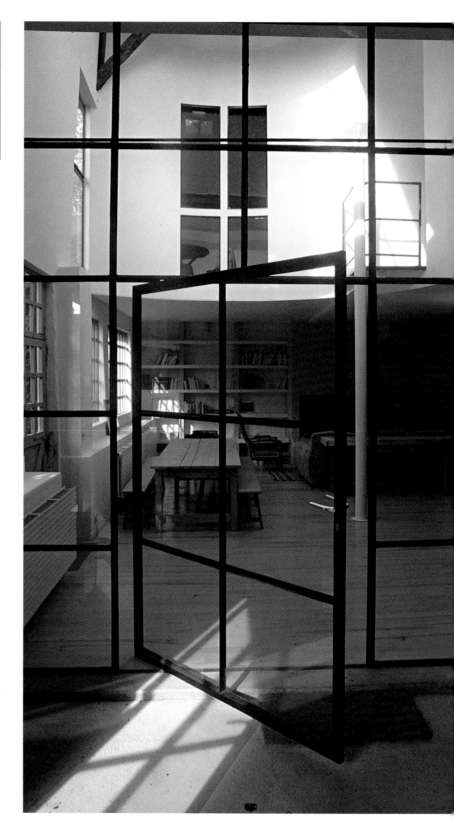

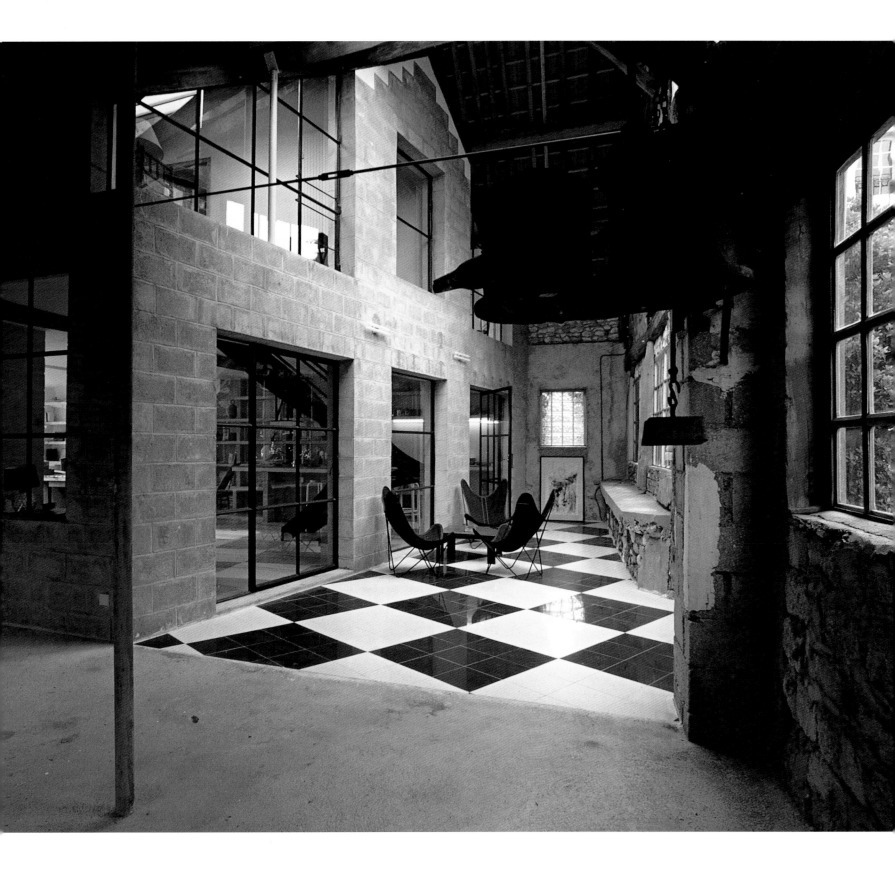

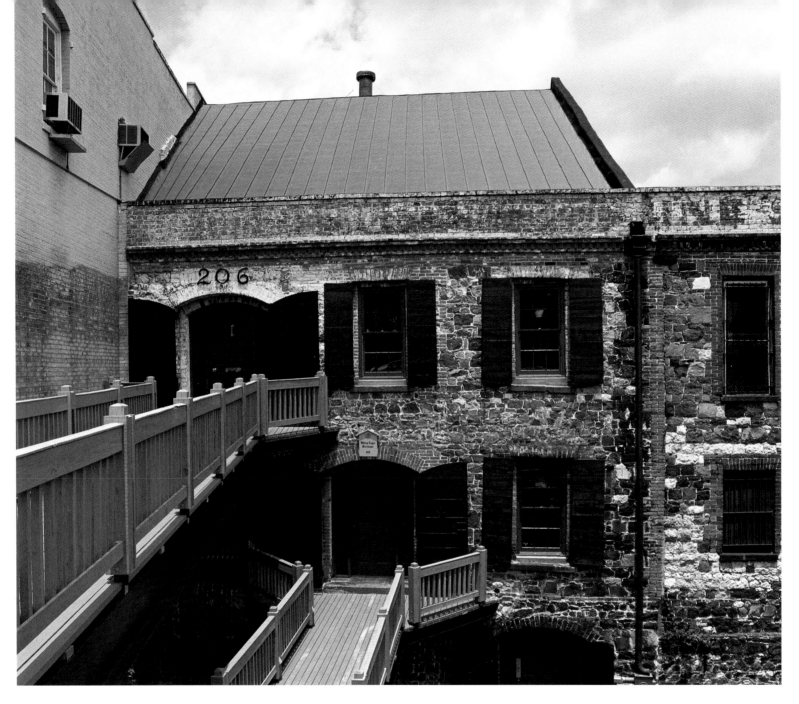

▲ Coming home to a converted cotton warehouse in Savannah, Georgia that once held thousands of bales of cotton is strikingly different from arriving at most residences.

➤ The weathered wood floors, beams, and workings of the cotton warehouse create a naturally warm setting for its living area, though the lift on the right was created to bring bales of cotton upstairs.

CHAPTER 1

RESEARCHING THE BUILDING

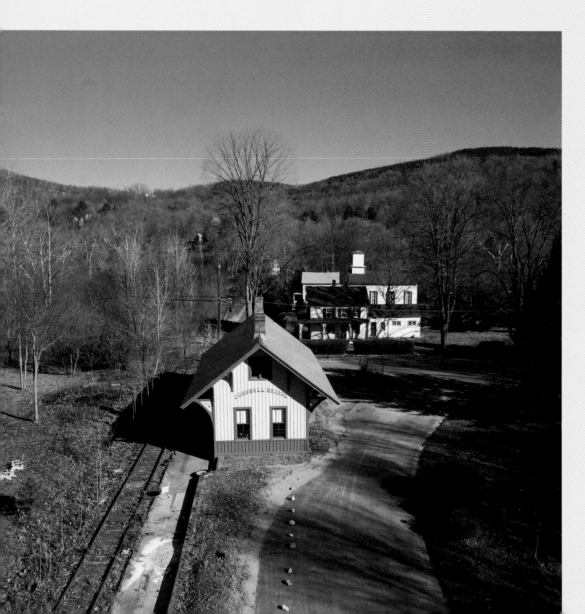

‹ A converted railroad station in Cornwall Bridge, Connecticut is on an intriguing site that would not be easily available in a conventional home; it sits all alone so that tracks would be able to run around it.

› The original weathered wood doors of the converted forge in Fountainbleau, France reveal the spirit of the building from the moment one enters it.

The buildings that are converted into homes are as diverse as the people who eventually inhabit them. The entire process of obtaining and converting these structures is very personal, which is, of course, one of its attractions. Another is that finding and researching a building can be an adventure, and often a lesson in history. Knowing as much as possible going in is not only the best practical approach, it enriches the entire experience.

CONDUCTING THE SEARCH

Although a few people start out knowing just what kind of building they want, most meetings between buildings and owners are serendipitous. Often, people happen upon a certain structure—a bank, a barn, a seaside tower—and simply fall in love with it, or with its potential. An architect in Chicago found his church while taking a shortcut home; a couple from Brooklyn happened upon an abandoned firehouse in a quiet cul-de-sac and took the initiative to find out about it. Whatever eventually brought these and other owners to their buildings, it was keeping their eyes open that enabled them to find the structures in the first place.

It makes sense, of course, to look for these special buildings where they are most likely to be situated; in cities, for instance, stables tend to be tucked away in small alleys lined with other old buildings. But just as often, it is a casual Sunday drive in the country that leads to the discovery of a captivating barn behind some hills, or an after-dinner walk in an undiscovered part of the city that turns up some fascinating historic structure.

These spaces are usually either too special on the one hand or too dilapidated on the other to show up in the real estate pages, although agents sometimes know of their existence. But outbuildings of large estates, such as carriage houses and

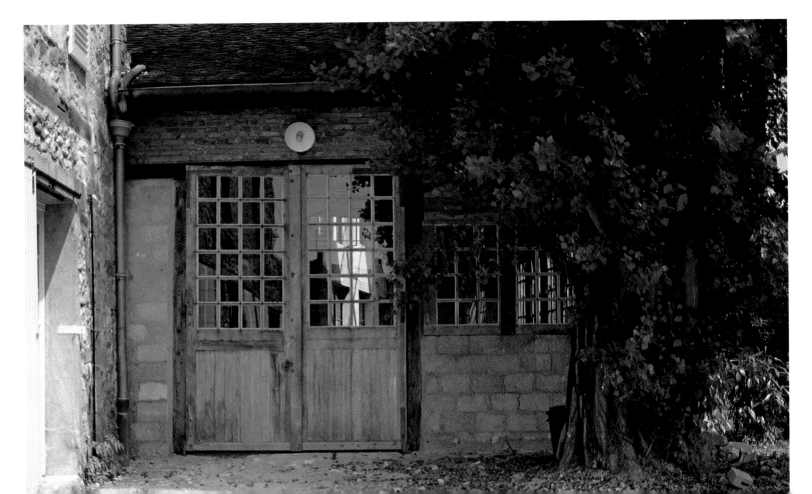

chauffeurs' cottages, will often be advertised when the estate has gone up for sale. And an old, city-owned building, such as the nineteenth-century library that one architect made his home, will sometimes appear in the paper with an RFP (request for proposal) asking for plans for the building's use and a bid. There are public auctions of buildings, too, which are usually advertised in local papers.

In a small town, asking residents about adaptable buildings can unearth them. Small-town gossip being what it is, this may be the surest way to find out everything else about the building as well. Those who do ask may be told, as one architect was, that the church on the hill had closed its doors after a Christmas Eve service years ago and had been empty, except for vandals, ever since. Or, like one family, they may be led to a friendly landmark such as the old dairy barn in Utah that was abandoned despite the town's fondness for it.

Living in a converted building often means being a pioneer: City buildings tend to be found in "undiscovered" towns or neighborhoods, and barns or mills may be left standing in fairly isolated swaths of country after prosperity and the population have moved on. But there are converted buildings throughout Boston, Chicago, New York, and London, as well as many scattered about in thousands of smaller but still-thriving places.

FINDING OUT ABOUT IT

The history of a building typically unfolds over time. Its secrets may be slowly uncovered only after someone inhabits it—details may relay pieces of its story, or facts and fables about it may come to light long after it has been made into a home. As architect Carlos Brillembourg says, "It's archeology." It wasn't until the floors were being restored in an old Massachusetts carriage house and newspapers from the 1880s were found underneath them, for example, that the structure could be dated. This kind of unexpected discovery is typical of the often surprising nature of adaptations.

It is wise, however, to find out as much as possible about a building before entering into the intimate relationship with it that conversion usually requires. Knowing about the building's history, site, and soundness—which can mean everything from checking its beams to asking the neighbors about it—will better a negotiating position, and make surprises fewer and decisions easier.

◄ A marker that is a piece of art unto itself proclaims the date of the original construction of a converted stable in New York City.

► The American Thermos Bottle Factory, which provided a way to transport milk for lunch for generations of schoolchildren, is located at One Thermos Avenue in Norwich, Connecticut. The factory was converted into condos by Frederick Bibesheimer of InterDesign.

Great Adaptations

Start with the site. Often, one of the attractions of these buildings is their location, such as the old Boston ballroom that sits in the center of the city but is tucked away in a back alley, or the barn situated among rolling hills that reminds its owner of an Andrew Wyeth painting. Because they are not subject to the zoning codes of residential areas, farm buildings and other rural structures are often in places with extraordinary views that are quite a departure from the vistas of suburbia. But because they are, in many ways, odd buildings, they are sometimes in odd places—mills, for example, were purposely isolated, and churches were deliberately set in the center of everything.

If the site is inappropriate, as a last resort many buildings can be moved. But moving historic city buildings may be a violation—if not of actual regulations, then of a building's place in history and on a certain block. Concerned residents have been known to lodge official objections—and have sometimes successfully blocked an owner's moving plans by court order. This can be avoided by obtaining a valid building permit from local authorities and by determining beforehand that local regulations don't require municipal approval to dismantle or remodel a historic structure.

Barns, on the other hand, are frequently transported to sites that are less isolated than their original settings, and they are relatively easy to break down and move. Indeed, architects have found that the original beams of many older barns are marked with Roman numerals designating their appropriate placement.

Buildings can be moved intact, too, and companies that specialize in this kind of work are easy to find in any part of the country through the yellow pages in the phone book.

When thinking about moving a building to another location, though, it should be remembered that the site is often part of the building's character: A historic graveyard may lie behind a church; outbuildings that illuminate the workings of nineteenth-century farm systems may sit just beyond a barn. So aside from affecting the livability of the building, the site is important because it is often part of a whole.

The next step is to find out about the past life of the building. Some methods to determine the structure's age—examining the nails used in construction, for example—require a professional. Local historical societies, libraries, and state historic preservation offices may have documents, such as old photographs, drawings, and records of the building, that can be both helpful and fascinating. And again, asking local residents almost always turns up something interesting, if only an anecdote about past occupants or rumors of the building being haunted.

The building's environs are often the best source of dating information. If surrounding structures are similar in style, they can yield clues not just about a building's age but about its construction, too. In rural settings, fences, stone walls, and wells can serve as historical markers. Stone foundations generally indicate buildings constructed before the twentieth century; only after 1900 was concrete used extensively as a foundation material.

The most important practical consideration is the state of the structure. Some buildings are remarkably sound, like the mill house in Woodbury, Connecticut, that was about as strong when its current residents found it as when the town's citizens gathered to celebrate its raising in 1707. Others may have their roofs caving in and their doors missing, with only the four walls apparently salvageable. But the structural soundness of a building cannot necessarily be judged by sight. Sometimes there are strong skeletons in a building whose

◄ Architect Grattan Gill converted a Cape Cod carriage house into his family home. The space started as a parking area for carriages, a tack closet, and a hayloft, and ended up a light and spacious three-bedroom house when the center was opened up to a three-story atrium and the heavy doors were replaced with glass.

exterior is failing, and sometimes a relatively new paint job or siding material hides serious problems underneath. Barns tend to weather the elements more successfully than other rural structures: Because of their importance to farmers, they were often better constructed than the farmhouses.

It is wise to get expert advice about how much work a building will require just for comfortable living. An architect or engineer can address considerations of loading capacity, plumbing, heating, and electricity. (A list of important factors to consider before buying a building for conversion can be found in the Appendix on pages 168–171.)

It takes vision to recognize what could be a home underneath a falling roof or behind a crumbling façade. But loving the structure goes a long way toward converting it. Good natural light and ventilation are good starts, and any building with adequate space and a comfortable layout for living contains important elements for a residence that may offset minor structural problems.

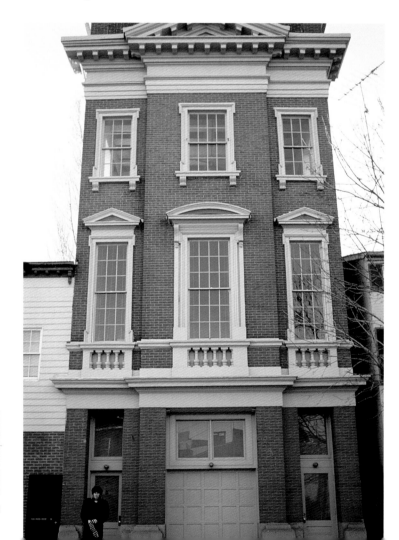

CONSIDERING IT

After getting an idea of what the building is all about it is time to weigh its advantages and limitations. First, it is important to determine whether the building can realistically meet the buyer's needs. Those who abandon their search for a carriage house when they fall in love with a barn may have more space than they know what to do with. A family captivated by a church may be wise to ask themselves if the choir loft will provide adequate sleeping space for the children.

The financial considerations are a little more complicated, and depend largely on the individual building. Sometimes the cost of buying and converting an old building is less than that of building or buying a new house. Even when the cost of conversion is higher, the low cost per square foot of larger structures like barns and municipal buildings can make adaptation an appealing alternative. Add to this the possibility of tax breaks, and the advantages are clear. (For information on tax incentives, see the Appendix on page 171.)

The financial disadvantages usually involve maintenance more than actual conversion costs. Old buildings almost always require extra care throughout their lives, even after an initial fix-up, and the costs can add up over the years. Another financial problem is the high cost of heating oversized spaces. Although additional insulation and the creation of smaller rooms within the structure can help offset these costs, the barn-dweller, for example, can still expect higher fuel bills—or colder winters. It should be noted, however, that most people feel that the aesthetic advantages outweigh the sacrifices.

‹ The firehouse in the historic Federal Hill neighborhood in Baltimore, Maryland is blessed with the light from unusually tall main windows that are almost ten panes high.

› Bernhard & Priestly Architecture converted an 1850s carriage house in Penobscot Bay, Maine with a sensitivity to its location in a coastal village; the hayloft doors on the second story are filled with glass, and a skylight structure was added at the top for more elevated views.

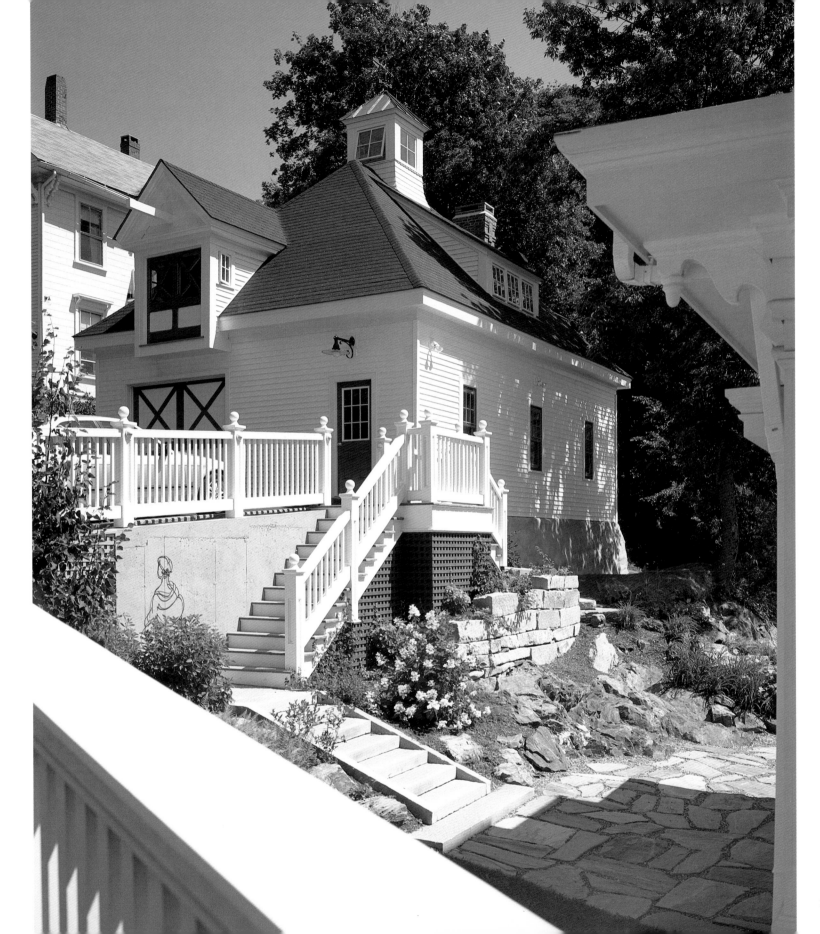

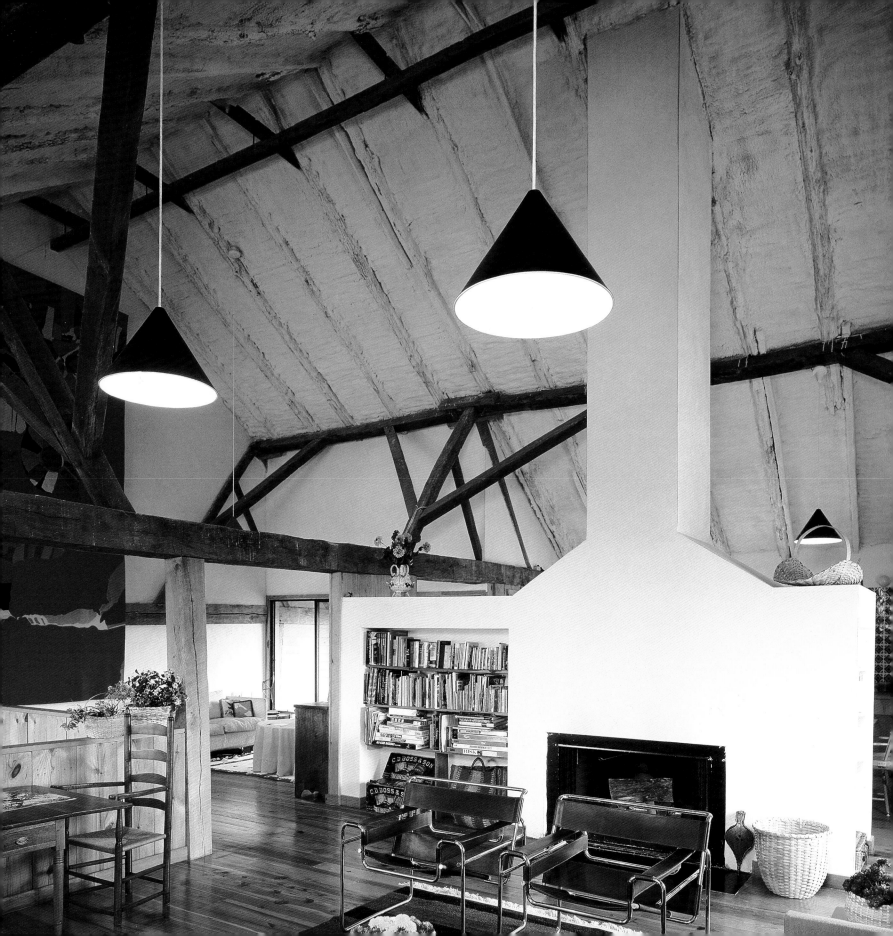

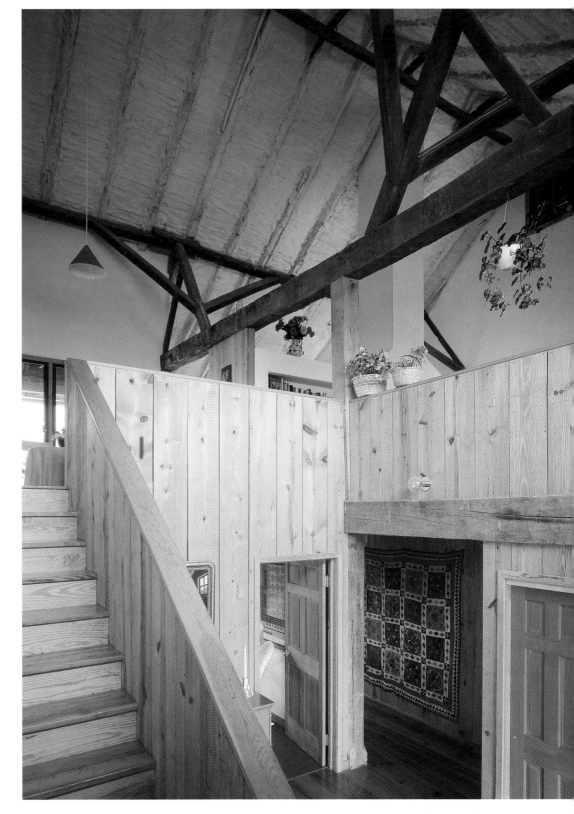

◄ It took Hessian soldiers three years to build this Virginia barn in the 1760s, but it only took ten minutes for Winthrop and Jeanne Faulkner to buy it. They found it after mentioning to a friend that they were looking for a barn and ten acres for about $20,000.

► Measuring eighty feet by fifty feet, the barn has a history as formidable as its size, serving as a hospital during the Civil War. Today, the original barn doors have glass doors behind them, but when the original doors are closed, one would never know the barn is a home.

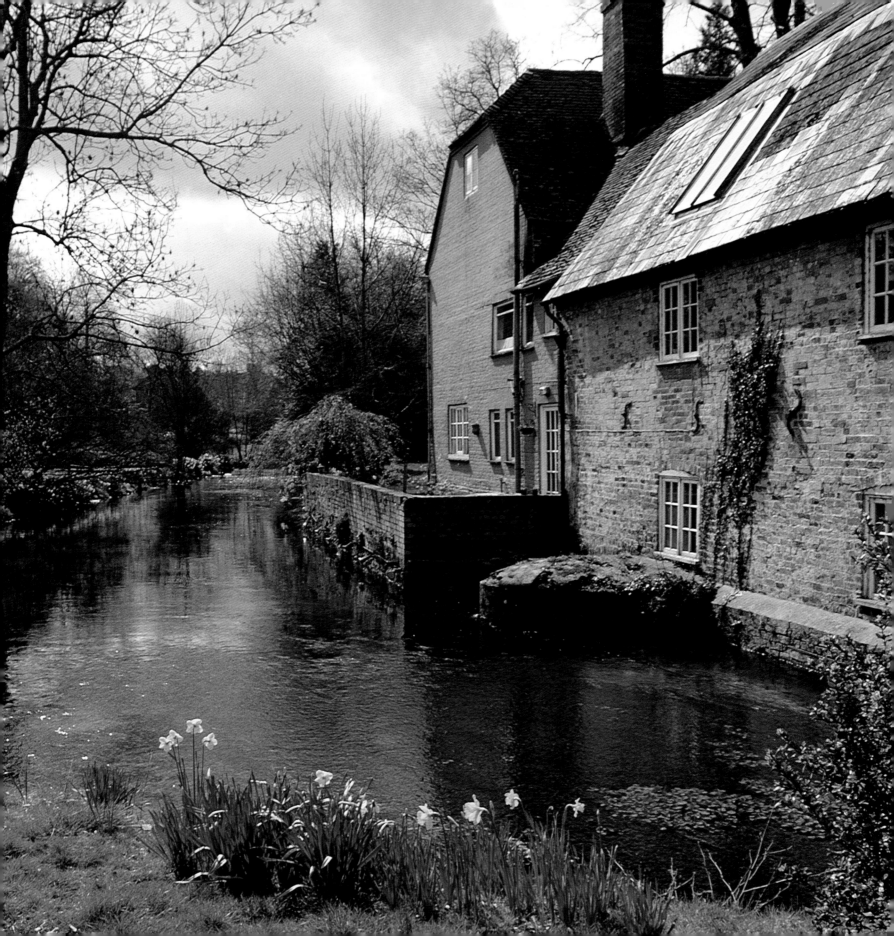

The physical layout is also important. The fact that these buildings were not made to be lived in is a source of enormous charm. It is also a frequent source of headaches. Some buildings are more difficult than others to convert; barns, for example, do not bend easily to transformation. They often do not come with plumbing, wells, heating, or insulation; they have few windows but far too much ventilation; their walls are not plumb and their floors are not level. But seeing the charm behind the problems helps. In a stable, for instance, a horse stall may stand in the most logical site for a kitchen, but it is a quaint inconvenience.

A major consideration is the amount of work involved. The truth is that most conversions involve plain hard labor: in a barn, moving a tractor out of what will be the living room; cleaning out the droppings that the average chicken coop collects from 2,000 birds; encouraging wild dogs to leave what has become their home; even handling the clearing of a graveyard from the back of an old church, as is sometimes necessary in England. The buildings are often abandoned and gutted—rotted by time, termites, and neglect if they are in the country, and marked by graffiti and other forms of vandalism if they are in the city.

There are legal considerations as well. Zoning variances may need to be granted to convert the structure for residential use. And buildings of historic interest, particularly those in historic districts, may have a commission watching over them that can restrict changes to their exteriors. The mayor's office can determine whether the building is subject to such ordinances. Though often strict, the commissions will usually work with the owners to devise solutions that fit both their requirements and the owners' needs.

Time is the final factor. Although every building is different, the average time for a conversion is about two years.

< The old water mill in France overlooks the mill pond, from which water was channelled over the mill wheel. A contemporary skylight was added in the classic, steeply pitched roof.

> Unusually shaped corners and bead board wood paneling are some of the many elements that make the converted railroad station a uniquely cozy home.

Some people start to feel that they will end up spending more time away from the building than in it—which may explain why once in their converted homes, people never seem to want to leave them.

BUYING IT

Buying a building, like everything else concerning the process of adaptation, is an experience unique to the structure. The purchase price may be quite low; the cost of buying a building is almost always less than that of converting it. A particular structure may go very cheaply, for example, if the town or neighborhood cares about it and wants to see it saved and sensitively revived, and this is something to remember in negotiations.

▲ The thermos factory in Connecticut was
reborn into condos, with skylights bringing in
light that the old factory was missing.

➤ The ambiance of the railroad station makes
one almost feel as if a train could still be
caught there.

Many of these buildings have been sitting derelict for years, and their owners may be happy to have them off their hands. The marks of vandalism are unsightly enough on many of the buildings to keep the price down, but often they do not represent any real damage. Again, it is the structure that matters most, and some sound structures have been known to sell very inexpensively. In the country, unusual deals can be struck that might not occur to someone used to dealing with the formal rules of city real estate: Sometimes the land itself is purchased, for example, and the barn on that land comes for free.

In addressing these considerations, it should be noted that not one person interviewed for this book said that he or she regretted going ahead with the conversion, even with the problems it caused. The process started to become as interesting as the building itself; in a sense, the buildings *became* the process—the product of the hard work and dreams that went into them. And with a few inevitable compromises, the dreams were realized.

CHAPTER 2
TRANSFORMING THE BUILDING

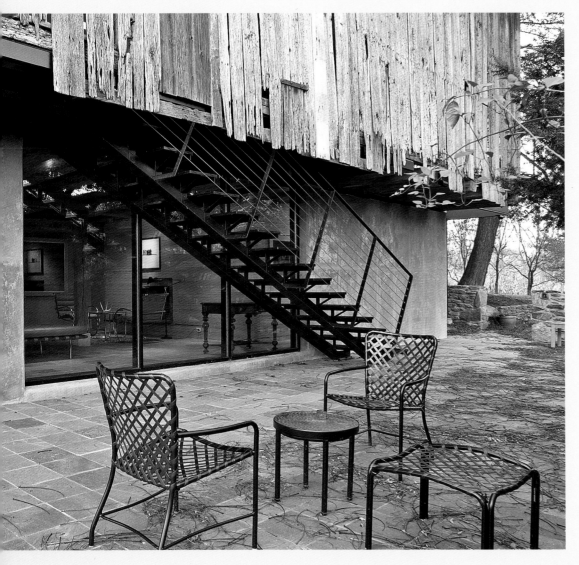

< A "falling down" bank barn's exterior in Hampstead, Maryland was kept falling down to retain the nature of it when it was found by the owners, with siding held together by a growth of poison ivy and hay stored inside that was at least sixty years old.

> What fell all the way down had to be replaced, so W Architects and Henry H. Lewis Contractors put a glass box within the old barn structure; at night it becomes a light box.

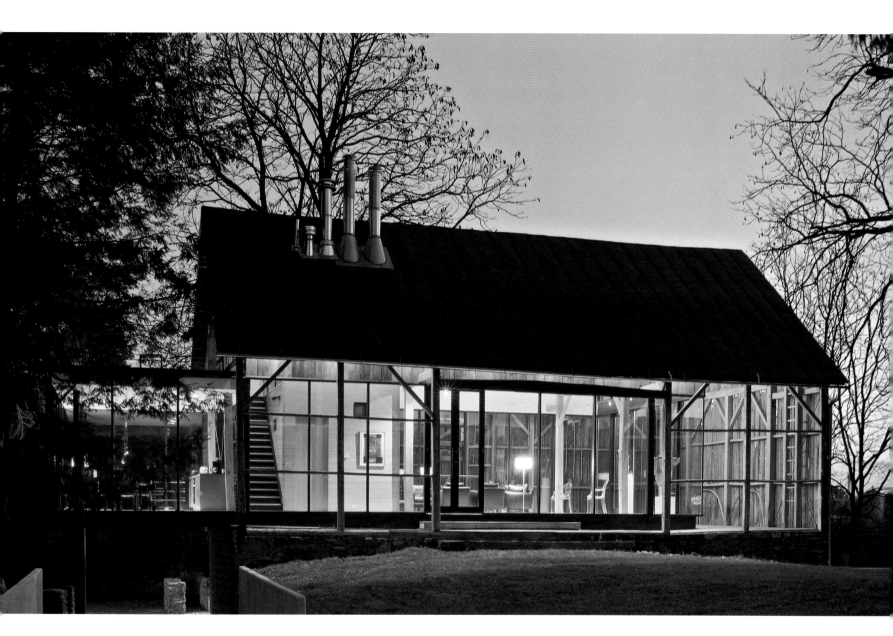

After the excitement of finding and buying the building is over, one is left, often stunned, with the building itself and the job of transforming it. After a woman in Massachusetts bought a Quaker meetinghouse, for example, she found herself the owner of a big empty room containing three pews—and a lot of potential. This can be enthralling, particularly to architects and designers who see the buildings as oversized blank canvases on which to work. But it can be daunting as well: There is a lot of room in a barn, for instance, to realize dreams. But making a home for cows comfortable for people takes a lot of sensitive planning.

Conversions present two basic challenges: making livable a space *not* designed for living, and retaining the spirit of the original structure while introducing the contemporary elements necessary for comfortable living. These design questions can inspire some wonderfully creative answers.

Whether those answers come from an architect, designer, builder, or the owners themselves is a decision that rests with the individual owner. At the very least, professionals will probably be necessary to provide general architectural guidelines and advice about structural matters. A straightforward conversion—

in which old elements are saved and restored, but few major changes are made—can be successfully carried out by the owners, particularly if the structure is fairly sound. But a real transformation, in which the building is brought into a more contemporary realm, is complicated in terms of themes and ideas and will probably be enhanced by an architect. In either case, certain basic problems inevitably present themselves.

MAKING THE SPACE WORK

There may be too much or too little of it, it may be in the wrong places or laid out in inconvenient ways—space is a unifying problem in conversions. In structures such as carriage houses, schoolhouses, and stables, space may be tight, while in buildings such as barns, mills, and granaries, it can be overwhelming.

The challenge is to keep some of the feeling of the original space while making it comfortable and usable. This means maintaining the monumentality and sense of freedom that the soaring ceilings and open volume of barns and churches convey, while bringing proportions into human scale; or retaining the charm and intimacy of a carriage house without its feeling crowded or claustrophobic. It is always better to work with the building rather than against it, to let the structure lead the way when possible. There is plenty of volume in a firehouse, for example; but it is more vertical than horizontal. In such

cases, lofts and balconies can make excellent use of the available interior space.

CLOSING OFF SPACE

The wide-open space offered by some of these buildings, although attractive, is not very livable in its raw form. To be comfortable, the space must be broken up, physically and visually, while the functions of living—cooking, dining, sleeping, bathing—require privacy and the creation of areas of "separateness." And all of this needs to be done without losing the feeling of openness or, in a barn, for instance, the memory of haylofts.

Architects often approach these spaces as they would a loft, or, when the building is very large, several separate lofts, with the idea, above all, of keeping the space open. Another common approach is to build a structure within the structure, a solution that brings space down to a manageable level and cuts down heating costs. Many architects have mixed old and new this way. A sleek, modern box was installed within the frame of a nineteenth-century barn, for example, with large, open spaces in it for views of the original beams and dimpled glass. A more abstract version of the interior box was used in a former ballroom: Latticed walls and partitions were installed to create a "house within a house" for a more intimate atmosphere in the home's main area.

An interesting solution is to move some of the space outside. One builder did this in a barn by carving an outdoor deck out of a large portion of the second floor. It worked for the home in several ways: The interior gained visual interest from the new lines and angles created by the deck. Energy costs were lowered both because there was less space to heat and because the large window opening out to the deck let in

▲ A classic New York City loft was a space that had only floors marked by machine oil and lots of potential until architect David Bergman made it industrial elegant. The artistic brick wall with an edge of white was achieved by tapping the old plaster and letting the loose parts fall off.

an abundance of solar heat. And the owners were left with a huge deck with a marvelous view of the surrounding hills.

The addition of a second floor is another solution, as long as the floor is hanging or suspended but not complete. The idea is to create a separate space without blocking off the whole interior view of the building. Lofts accomplish this particularly well, especially in churches and barns, where they recall choir lofts or haylofts. One converted barn features a whole progression of lofts that descend toward the wide-open living space at the bottom. The higher the loft, the more private its use, so the bedrooms are near the top of the barn, and kitchen and dining areas are closer to the bottom. These "levels of living" are not only practical, they provide the reassuring division of space and the feeling of privacy that most people look for in a home.

OPENING UP SPACE

Opening up the space in stables that have beams low enough to hit one's head on, or in stone outbuildings with entrances so small one has to duck to get inside, can be a real challenge. The most common and successful means of making these small buildings work is to use an open plan, which not only enlarges the space visually but actually allows it to function more efficiently. Installing lofts in the corners and on the sides of the interior conserves space and gives the main living area an expansive and luxurious feeling.

Many ingenious design solutions for buildings like firehouses and stables turn this idea upside down: The smaller, more private rooms are placed on the first floors, while stairways dramatically open up to soaring vertical living and dining spaces on top. These upside-down plans take advantage of views and light that are not available on darker, lower floors.

Windows always add a sense of expansiveness, not only letting in light but also by creating views, which bring the outside in. In a New York City carriage house a window wall was installed on the second floor, opening the space up to a canopy of trees just outside the glass.

Some plans capitalize on the intimate nature of a building to make the small space one of its charms. A kind of "tree house" effect may be the result, with the secluded lofts and alcoves resembling the nooks and secret rooms of childhood playhouses.

ADDING ON SPACE

Adding on to the original structure is another way to increase space, of course, but it also allows one to maintain the integrity of the original structure by leaving it virtually untouched. Putting a separate structure next to the original one is always preferable to tampering with the building by adding rooms directly on top or to the side of it. And a second structure can be connected to the first so that the original building still seems to stand alone. When the owners of a former squash court found they did not have enough room, for example, they had a compatible building constructed beside it that is connected by a breezeway. And when the resident of a Quaker meetinghouse wanted to keep the openness of the space, she had another structure built beside it for living and kept the original to work in; the two are connected by a foyer.

Although it is important for the new building to be sympathetic to the old, an attempt to create a copy of the original structure severely diminishes its integrity. Instead, sensitive and successful additions approximate or are compatible with the proportion, materials, color, and texture of the old building, but have their own contemporary character and

> ➤ Contemporary materials were used to contrast old and new in the Maryland barn house and art exhibition space; new aluminum supports are set against historic chestnut beams.

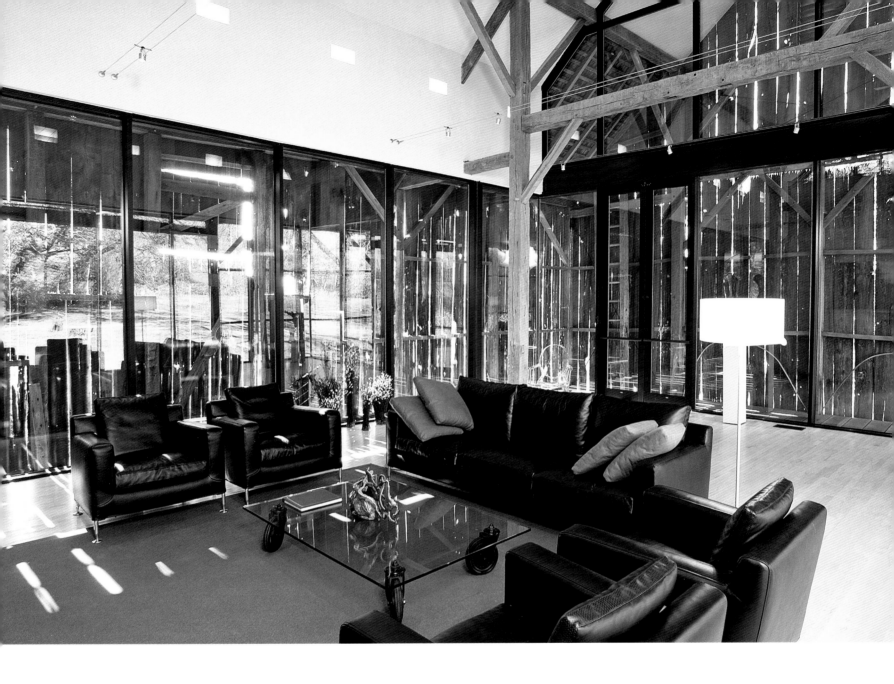

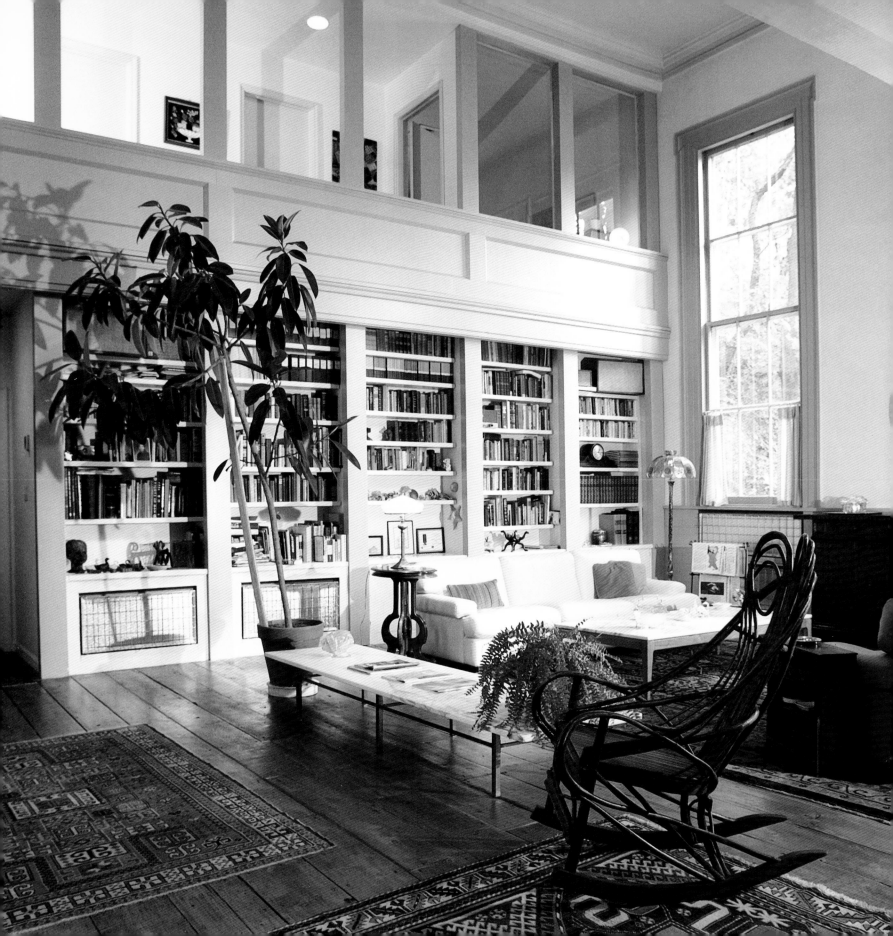

design. They are comfortable with the old buildings, but do not compete with them. In many cases, the new buildings are kept fairly simple, so as not to distract from the old. But even if they are a little more adventurous, the lines and forms and spirit of the old building should be followed in planning the new. The most important quality in achieving this delicate balance is respect for the old structure.

Elements of the old buildings can fit nicely into the structure of the new, blending the two harmoniously. So, for instance, the addition to the Quaker meetinghouse features new front doors and molding to match the old, and although occasional contemporary elements clearly place it in its own time, as one writer put it, "it is hard to believe it was not always there."

LETTING IN THE LIGHT

Light is, of course, a big factor in livability. Some of these buildings are bought for their light—a church with windows as high as its vaulted ceilings, designed to flood light into every corner; a squash court that featured a huge skylight to provide natural light for playing. And some of the light sources, if not generous, are too interesting to ignore: windows in libraries placed high to protect the stacks of books from direct sunlight; the slats in old Eastern stone barns made for Civil War soldiers to poke their guns through; the wonderful zigzag patterns of windows indigenous to shingled barns.

More often than not, though, light—or the lack of it—is a problem in these old buildings because many were not built with light in mind. Barns can be dark and gloomy; carriage houses are often closed and shadowy.

To find a solution, owners look everywhere for opportunities to bring in natural light. The most obvious answer is the addition of windows—lots of windows, if possible, and large ones, like the big arched window that became the dominant contemporary element in a nineteenth-century carriage house. As all new openings in conversions should, this window continues the play of old and new. Although it is unmistakably contemporary, its simple style does not conflict with the small stable windows on one side of the structure or the big carriage doors on the other. In fact, it successfully relates past and present. In a barn in New York, the original windows—placed near the ceiling so that animals and grain would stay dry—are juxtaposed with big sliding-glass doors below that make most of the east wall a contemporary window. It works because the original lines and forms were respected, and because the new windows are basic and do not distract from the old.

Windows don't always have to be created; sometimes they can be "found" in the old structure. Original windows may be hidden, having been covered up long ago when they proved more problematic than advantageous. The owners of a stable, for example, discovered bricked-up windows that were revealed to be glorious both in their detailing and their admittance of light. Looking for elements that might *become* windows is another solution—a particularly valuable approach in a historic structure, since the basic details of the building can be retained and just filled with glass. The tops of big stable and garage doors are often made into windows, for example, or the whole door can have glass inserted into its frame. The stained-glass windows of churches are sometimes replaced with clear glass for more light, but only as a last resort since the original glass is usually so beautiful it is worth trying to save.

‹ A former church now features a double-height living room, which is accentuated by the huge original window that extends to the second-floor balcony. The balcony, which runs all around the room, leads to the more private areas of the house.

When new windows are installed, it is still possible to follow the historical leads of the building. One architect painstakingly reproduced the period leaded-glass windows of his barn—letting in light and a sense of history at the same time. A nineteenth-century firehouse came with a beautiful skylight, so the owners installed others that almost exactly replicate the original.

Skylights, in fact, are a common way of letting light into conversions. Although there are almost entire ceilings made into skylights, the light that pours in through any size skylight can make an extraordinary difference in the interior space below. In barns and other large structures, the living room is often constructed as an atrium underneath a skylight so that both the wide-open space and the light are emphasized.

Sometimes the public windows of these buildings create problems of privacy and light control. Some possible solutions include sandblasting, translucent paper screens, and simple custom-made ceiling-to-floor blinds that let in light—and the outdoors—only when desired.

Usually, it is a combination of solutions that lights up a building. For one firehouse, which was typically long, narrow, and dark, the architects created a central "light well" by hollowing out the center of the building. Then they created an upside-down plan for the house, placing the more private rooms below and the more public rooms above, to take advantage of the light coming in through a large skylight above. They also punched out new windows and installed artful etched-glass panels in the floors of the upper rooms to let light filter through to the lower floors. In this case, it took all of these efforts together to make the building a light place.

CAPTURING THE VIEWS

Many adaptable buildings come with remarkable views, interior and exterior, that need to be emphasized. Interior vistas should show off the most interesting parts of the structure; views to the outside should take full advantage of the often-spectacular sites. Since so many of these buildings are one with the site—whether a historic city district full of other old buildings or a river by a country mill house—exposing the view is part of bringing out the building's character. The scene from the living area of a converted barn, for example, is central to the feeling that the house is part of the countryside, rather than merely sitting within it.

Catching these views often means lots of windows—in some cases positioned all around the circumference of the

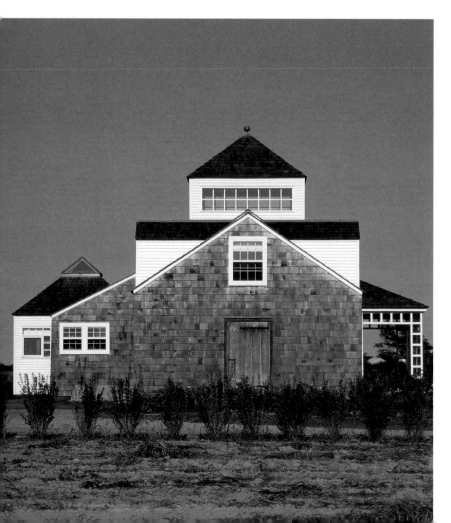

◄ Architect Carlos Brillembourg joined two native barns in Sagaponack, Long Island; all the new parts of the home are painted white to emphasize the difference between old and new, while enhancing both.

► The trellis design, which copies the order and pacing of the windows, is echoed on the indoors, giving the outdoorsy feeling of a barn.

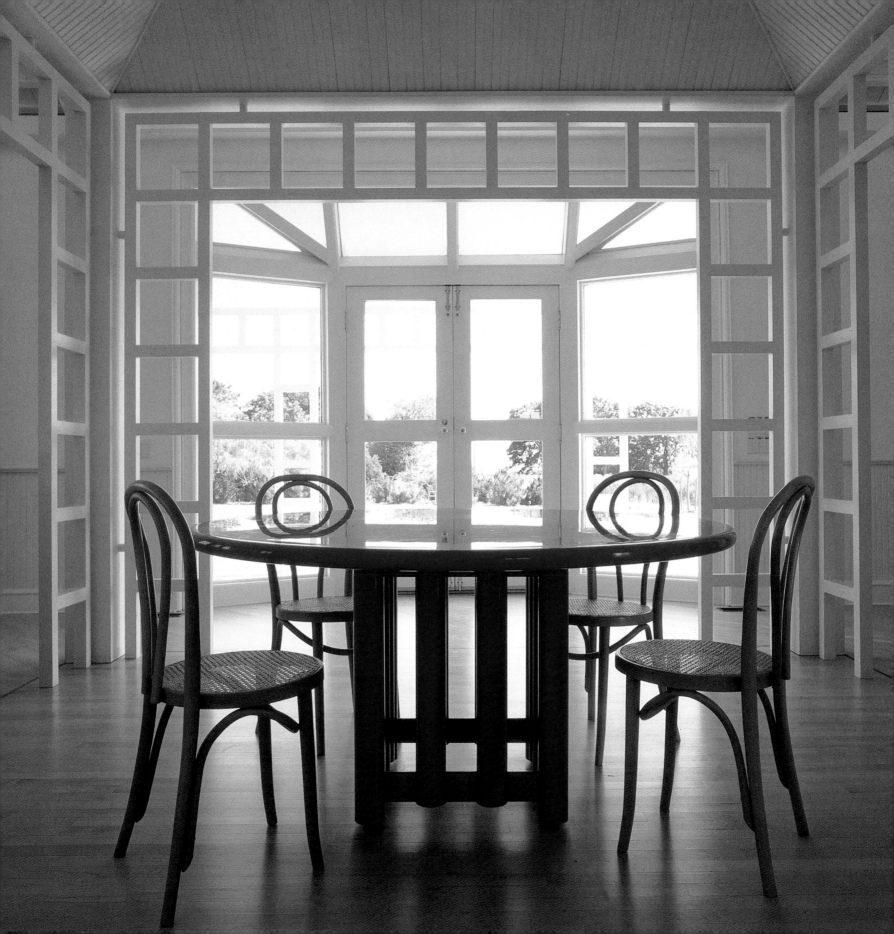

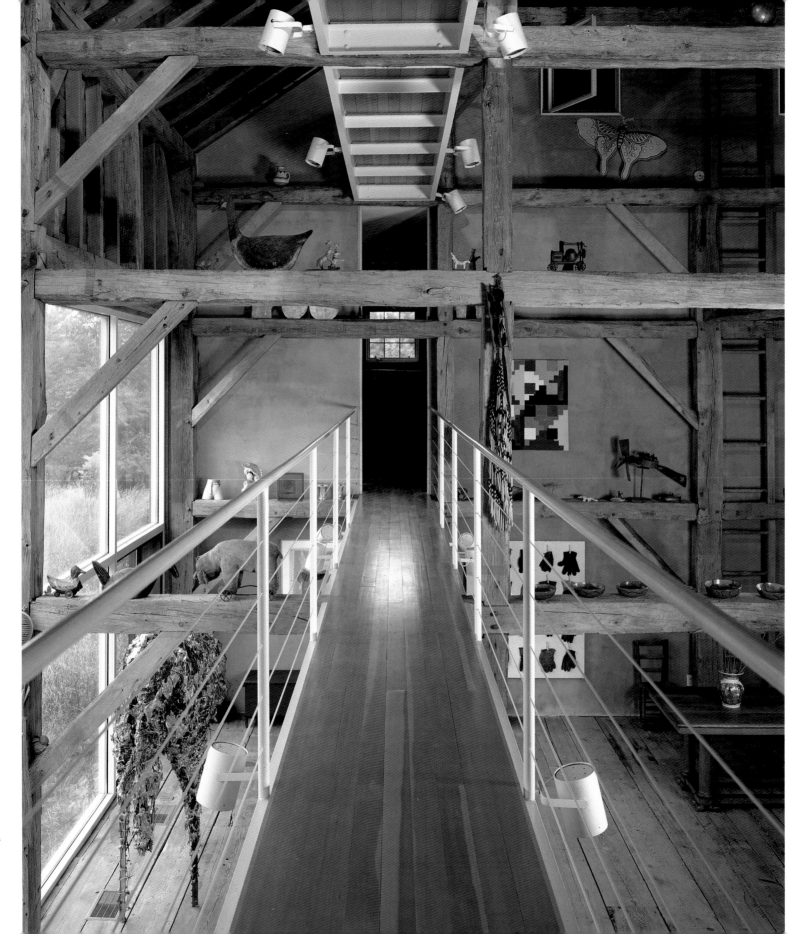

structure. Sometimes, it just means sensitive placement of a few windows to frame the best views of the landscape, or of elements such as sun porches, positioned on the west side, for example, to take advantage of sunset scenes.

Within the building, lofts, partial second stories, and second-story corridors that pass through the center of the structure allow views of the interior. Standing on a loft in a converted barn and looking out and down, one can recall the feeling of being a child ready to jump from a hayloft; taking in the expanse of space from the hanging second story of an old ballroom, one can imagine the orchestra and dancers below. In a converted commercial building, the staircase leads to a second-story balcony with openings in it made like windows that invite one to stop and take advantage of the open vista.

BALANCING THE OLD AND THE NEW

Perhaps the most important—and possibly the most interesting—part of converting an old building is working with the delicate balance between old and new. Deciding what to keep and what to dispense with, what to leave in and what to leave out, can be confusing. The attempt to create a pristine period piece, to use old elements in a contrived way that does not fit the needs or the mood of today, in the end insults the integrity of the original structure. What is

important is keeping its *spirit*. A respect for the past is important, but it should be a respect that runs parallel to recognizing that what doesn't really work will need to go. These challenges, when met well, can become small architectural triumphs.

The aim of mixing old and new, as architect Arthur Cotton Moore expressed it, is "a dialogue of opposites." It is important to see the two contrasting with as well as complementing one another, for it is the contrast that creates the richness often found in conversions. The sleekness of a new plaster wall can be just as smooth as the original brick wall is rough. And the original beams in a barn that have taken on a honey color because of age and wear, the floors that have a patina and polish gained from the threshing of wheat, and arrises that have been softened by the rub of hay, straw, and sheaves of wheat can sit beautifully under an unabashedly contemporary skylight.

Deciding what in the old structure is possible and appropriate to keep is the first step. In many conversions, exteriors are restored to their original state, leaving the interiors for more contemporary expression. Elements that lend beauty and significance to a building—poles in firehouses, bells in church belfries that can still be rung, and mill wheels turning along the river below a mill house—are almost always worth saving. Original detailing also contributes greatly to the character of the interior: rough-hewn beams, hardwood floors, large-paned windows, even the pipes in former industrial buildings.

If an important element in the building must be removed, a sensitive architect or homeowner can usually find a way to replace it with something new that at least nods to the past. When a church vestibule obstructed the layout of a home, for

◄ The owners of the New York barn actually found it near the Delaware River Gap and had it taken apart piece by piece by the New Jersey Barn Company and moved. Designed as an "energy intelligent" space, it is heated by different zones that are reached by catwalks.

Great Adaptations

37

example, the architect removed it but used the vestibule's outline as the basis of a new addition.

Old parts of a building can often be salvaged with help from contemporary pieces. The owner of another church wanted to save the heartwood floor that dates back to the nineteenth century, but it had rotted in very visible places, like the entryway. So she scattered contemporary decorative tiles in the damaged spaces. Looking like a free-form contemporary design, they do much to introduce a contemporary sensibility into the old church.

Contemporary elements are often the answer for saving such elements as old entryways that contribute a great deal to the character of the building despite their lack of practicality. Many old sliding barn doors, for instance, are too large for people to enter and leave through on a daily basis. But the building is unimaginable without them, so often a smaller entrance is carved into the large door.

When original details are too impractical to keep but too charming to give up, a common solution is to reuse them in a different way. This idea has special appeal because, on a smaller scale, it echoes what the owners have done in converting the building—recycling the old to make it work in a new way. The owners of an 1890s firehouse, for example, removed the rows of slate shower stalls they found on an upper level and used the material to construct a new, sleek fireplace; the planters on the back terrace were made from the wainscoting that had to be removed from the front of the firehouse. In a former barn, oak, ash, honey locust, and poplar slats from the old corncrib were used to make new balusters for the stairway and balcony, and the flooring was made from the old barn siding.

Often, the appeal of completely new elements is that they are strikingly different from what is already there, but they should still flow naturally from the original architecture. So if the forms are not alike, the materials might be complementary, of if the materials are different, the colors might unify old and new. The interior may be very contemporary with echoes of the past, and old elements may show through the new like ghosts in the house.

In many buildings a single, particularly strong element introduces a contemporary sensibility—a sleek, steel staircase, perhaps, or an exterior piece such as the gridded tower that was added to bring together two old Long Island potato barns.

The fun of living in a building that used to be something else can be expressed in new details that comment on the structure's original function. A converted barn in Massachusetts features a new second-story sun deck built in the shape of a silo, complete with bands of steel. And one

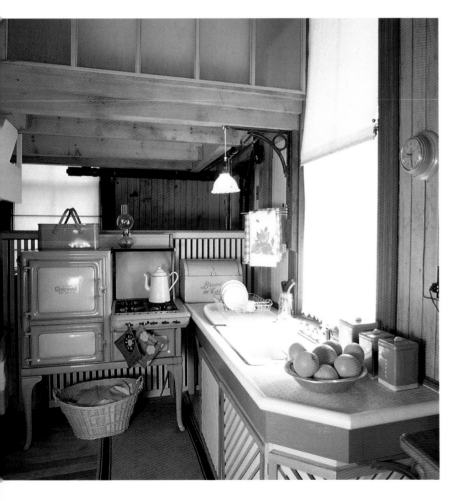

◄ The kitchen of the converted railroad station features not only the paneling and wood beams of the original building, but objects and elements from the time of its construction.

► A converted hat factory in London dating to about the 1890s has the original vaulted ceilings, brick walls, windows, and skylights of the Victorian structure.

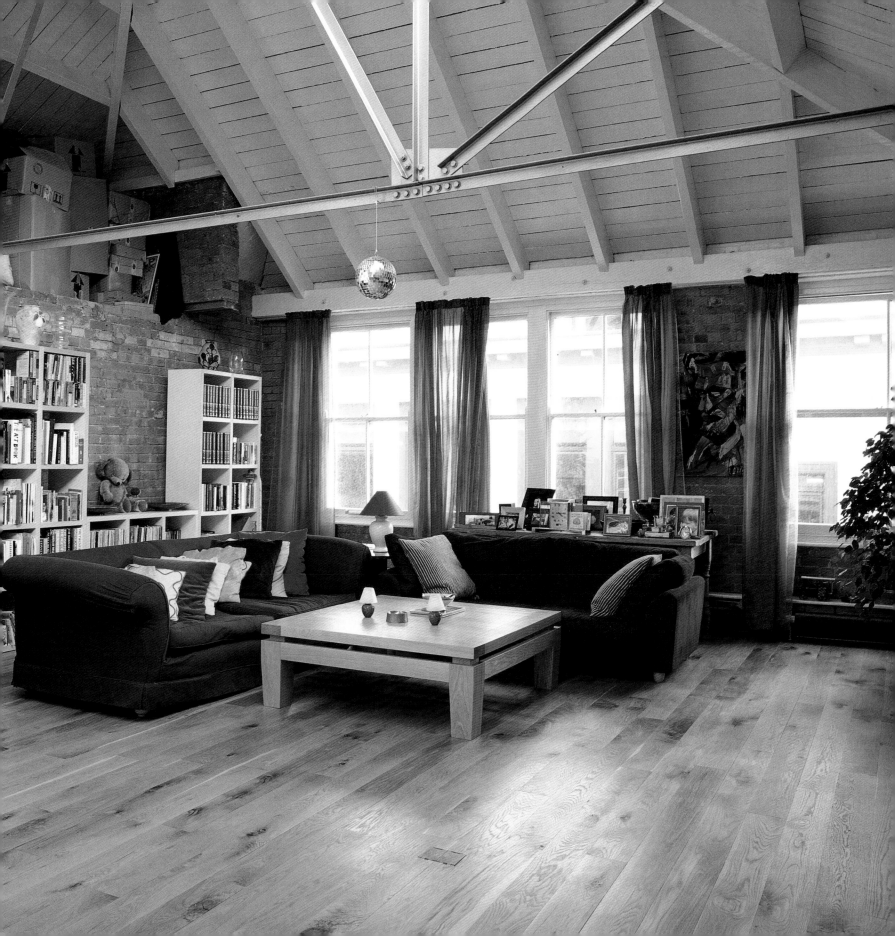

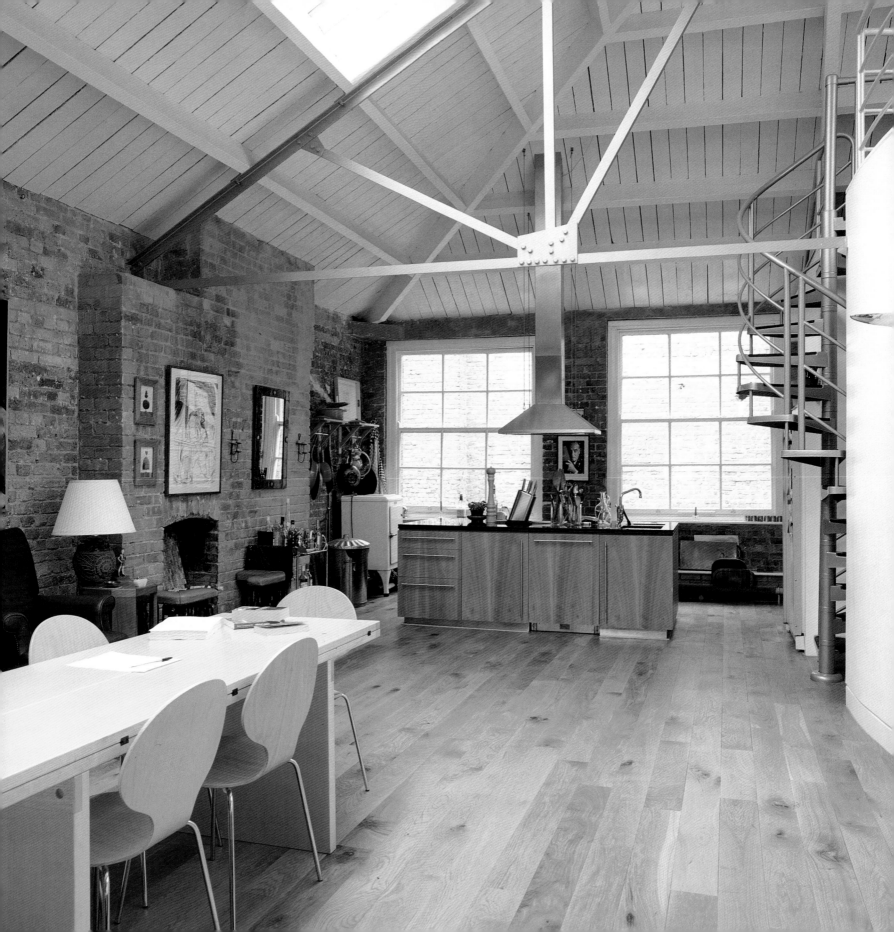

architect had small wooden horses' hooves carved on the exposed rafters of an old stable to remind the new residents of the previous ones.

In talking about a barn that his firm transformed into a home, architect Yann Weymoth summed up the exciting interplay of the present and the past: "We've made the contrast between old and new deliberately clear. And I think both benefit from the juxtaposition of soft and hard, warm and cool, textured and smooth, romantic and classical."

DESIGNING THE INTERIOR

In many of these buildings, the architecture is so interesting, the detailing so compelling, that the interior designs itself. Indeed, sometimes the architecture *is* the design. The drama of the windows or the presence of an intricately carved oak staircase, ornate patterns on a tile floor or a tin ceiling may strikingly dominate an interior. In this case, simple furnishings are best for allowing the elements that make the building special to show, and additions can be kept to minimum—plain ceiling fans in a church, for example, or the irony of a fireplace in a firehouse.

But there are more involving ways to handle the details of interiors, too. One is to extend the character of the building to the design, furnishings, and objects within it. Because barns relay a sense of craftsmanship, for example, furniture from the Arts and Crafts and Mission movements is often used in them; the simple, honest lines of these pieces naturally relate to those of barns. In a Nashville coach house, the rusticity of the brick exterior was taken indoors with "rough" elements such as dark paint, exterior shutters for the inside windows, and wrought-iron staircase rails that serve as curtain rods. And in former industrial buildings such as the Dallas power station that was converted into a contemporary home, steel, glass, and other industrial materials may be used to echo the Machine Age background of the building; the color palette, too, may be more industrial than domestic, consisting of grays, blacks, and metallics.

Again, it would be a mistake to try to replicate the past in an old building, because the result would be a period piece that seems contrived. Designer Leslie Claydon-White expressed this sentiment well when he said, "I do not want my home to look like a museum." So although he chose paint, wallpaper, and hardware to correspond to the period of the mill house he converted, the furnishings and objects are an eclectic mix, ranging from antique to contemporary, American to Far Eastern. And it all works.

Completely contemporary approaches can also work; they gain a certain intrigue from existing against the backdrop of an historic building. In an ancient forge in France, for example, bright neon lighting and daring abstract furnishings strikingly emphasize the aged stone walls and measured bricks of the building. There is a pleasant degree of shock at the contrast, then a sense that old and new can live together comfortably in the same building.

These spaces are often filled with found objects because adaptations are, in a sense, just large found objects, old pieces serving new purposes. The chairs in one converted church, for example, were made by cutting down the original pews, and the sign outside the church was taken indoors and mounted

◄ The former hat factory has an open-plan living space, with the kitchen, sitting, and dining areas in one room. A galleried area overlooking the living area and accessed by a spiral staircase serves as an office, maximizing the space without interrupting the flow of light into the home.

‹ The design of a former 1921 barn in Dalton, Georgia was inspired by converted barns in France and Belgium, with original elements like the beams keeping the rusticity of the structure, but refined colors and furnishings providing another kind of grace.

› Cows used to hang out in what is now the kitchen of the reborn barn; original windows and a heart pine staircase that leads to the former-hayloft bedroom give an architectural character that is not available in an ordinary house.

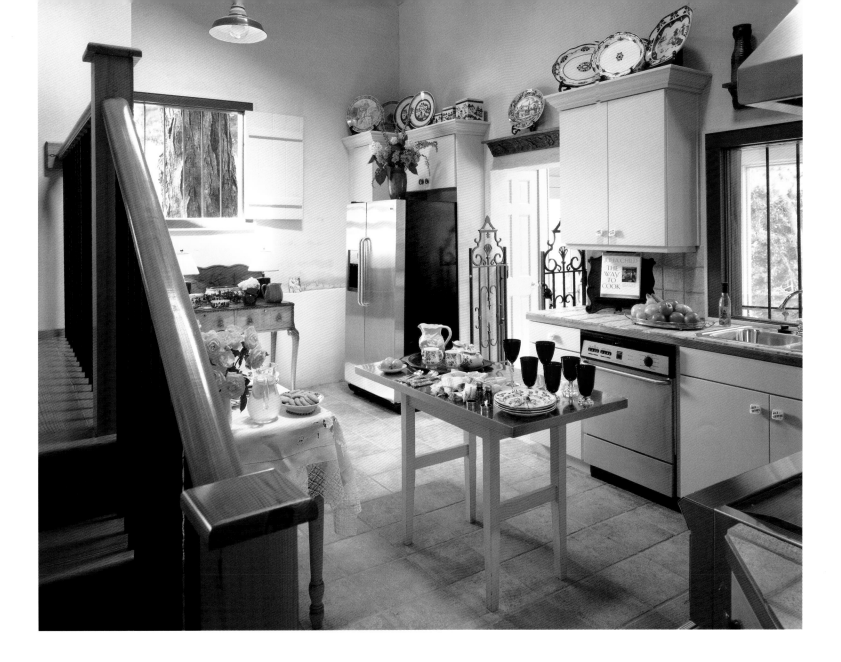

on industrial pipes to make a coffee table. In a Long Island barn, table bases are cast-iron flywheels, and a hay trolley is suspended among the rafters for decoration. Ornate windows and marble mantels salvaged from other buildings, a cast-iron winding staircase taken from a bank, the lights from a railroad car that became a chandelier, an iron cooking kettle that now functions as a bathtub, and the donkey saddle serving as a magazine rack in a converted stable—all of these are examples of found objects that can make the rooms of a converted building complete.

Most owners find that their conversions as a whole, and the specific interior elements in particular, are much like cathedrals—ever-changing and never really finished. Much of the design evolves over time, and owners should not panic over it during the first few months of living in the building. For most owners, this evolutionary approach is a joy rather than an inconvenience because the whole experience is a process, an extension of the sense of discovery that first brought them to their great adaptations.

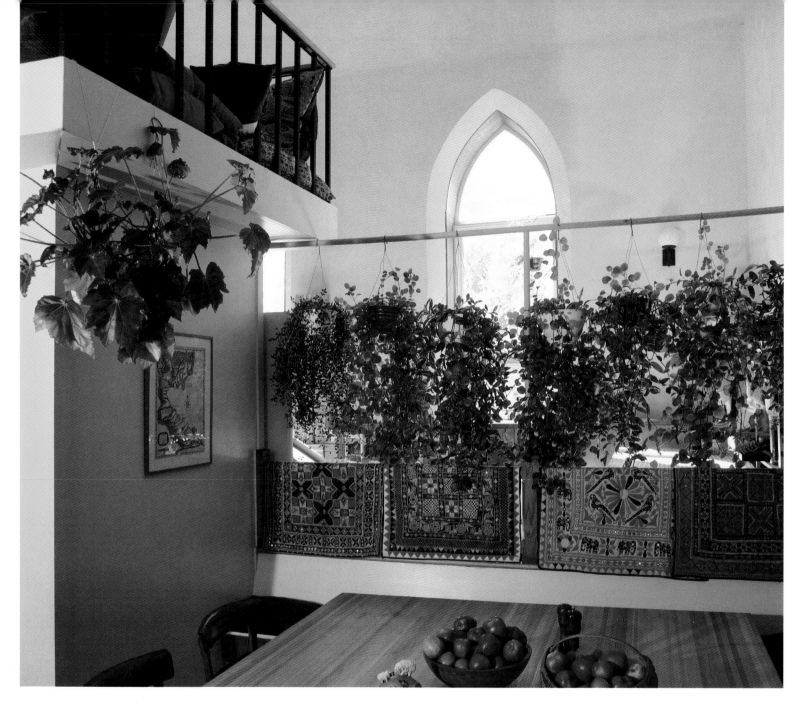

▲ Unusual windows and lots of light are two of the likely advantages of conversion. Another is the ability to design your own space. Since this church in Williamstown, Massachusetts was an empty shell when the owners found it, they created different levels for living within it.

➤ The church still had the original tower and the bell that it holds when the owners found it; the bell still works, operated by a rope for ringing it in the home. Dating to 1834, the stone church was abandoned before it was rescued for living space.

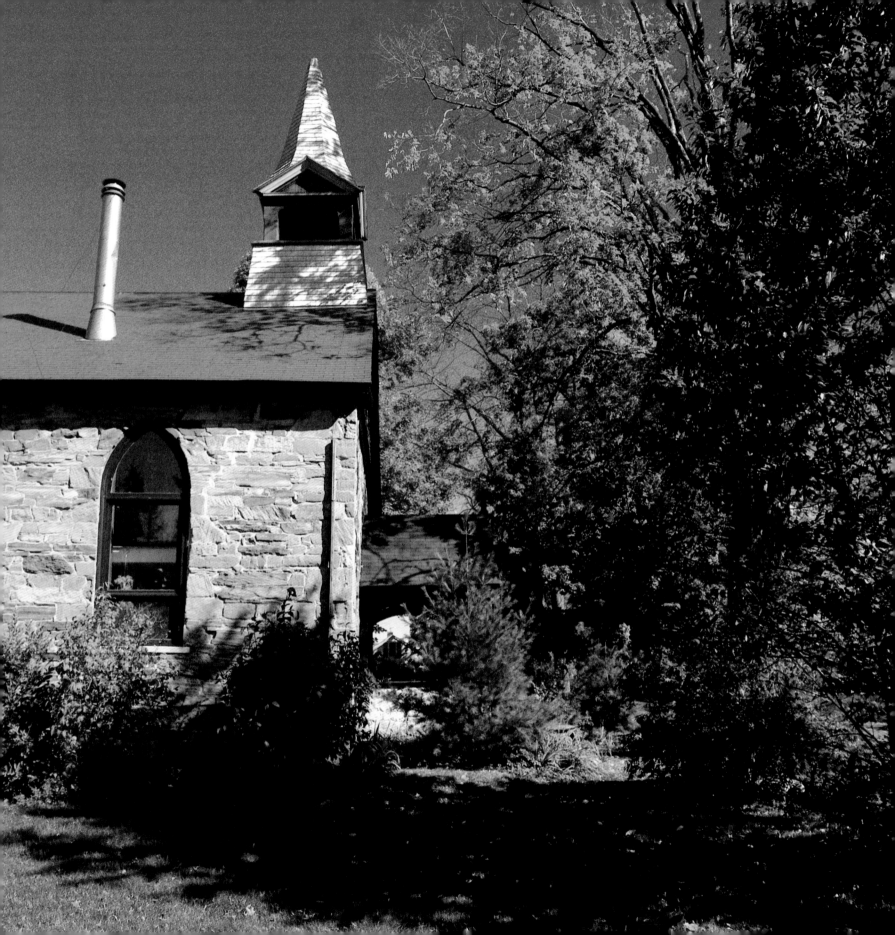

CHAPTER 3

CREATIVE CONVERSIONS: TAKING A LOOK INSIDE

The case studies of conversions presented here are as diverse and layered as the buildings themselves. Whether the structure is as fundamental as a barn in New England or as exotic as a fortress in England, each provides object lessons in how transformation takes place. The results are stunning, but the journey is equally valuable. In effect, these buildings are stories. Enjoy them.

➤ Conversions are never boring; this twenty-ton crane was used to hoist electrical equipment in a former power station, but was kept on to help with the renovations and now lives in the current home as part of the décor.

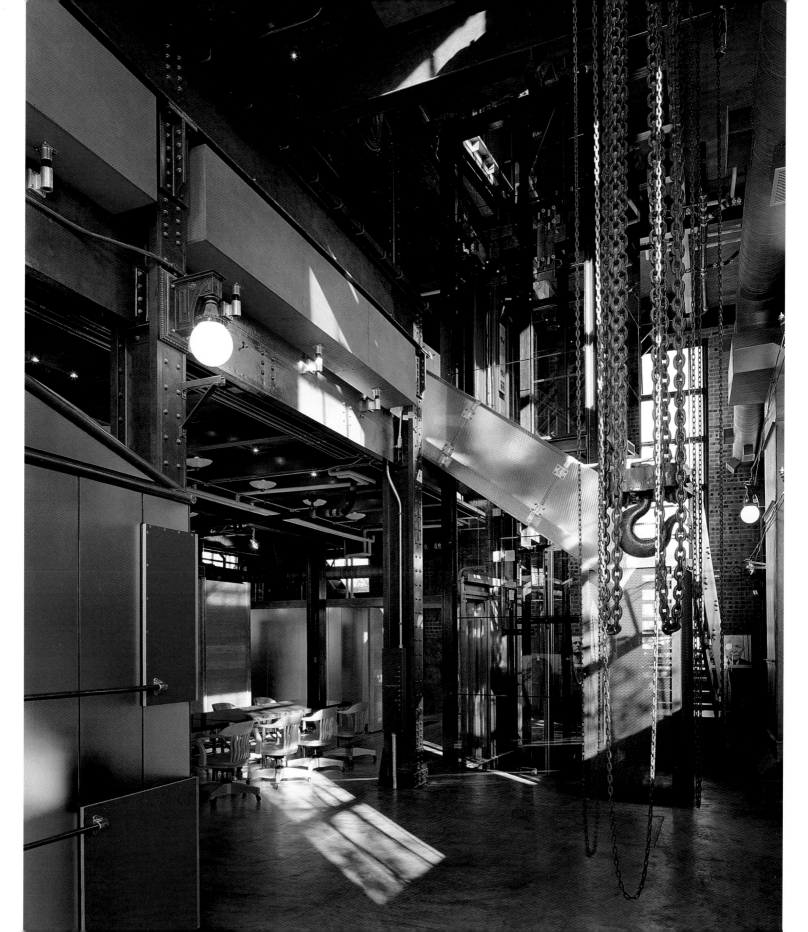

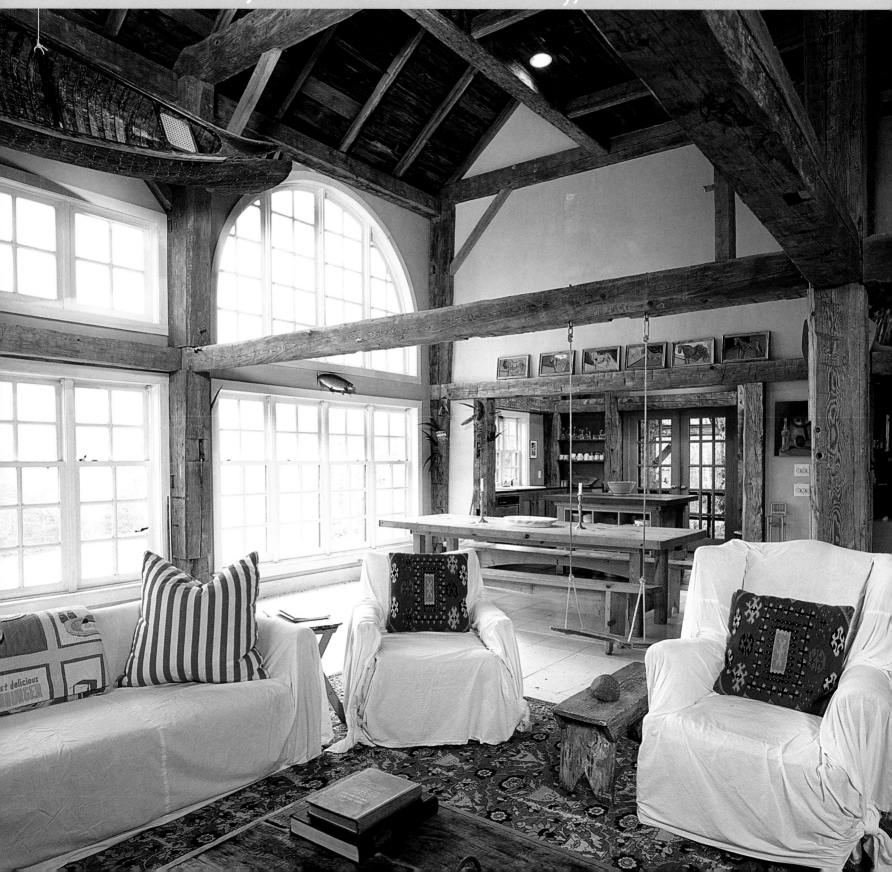

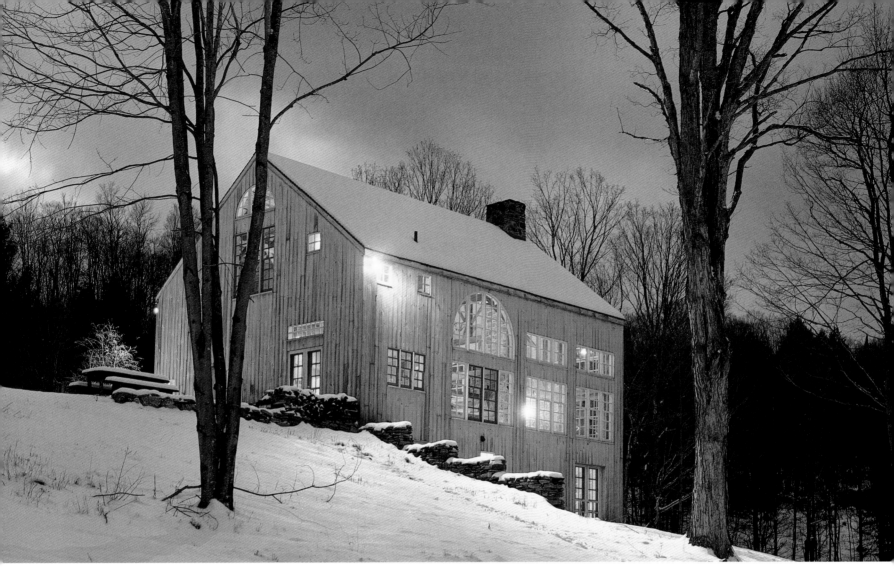

< The barn's ceilings are twenty-seven feet high, supported by original gunstock columns still visible inside the home.

∧ New spruce siding, which matches the floors inside, helps to update the classic barn. Cedar shingles were laid on top of the old rusted tin roof.

When architect Peter Woerner came upon a barn in Vermont that he could not turn his back on and decided to make it into a home, his first objective was to show off as much of what was left of the 150-year-old structure as possible. What was left was worth saving—and showing: a frame that went out of style in the 1830s composed of a tin roof, a continuous forty-foot beam that runs the entire length of the barn, hand-hewn wood gunstock columns that stand sixteen feet high and support the frame, and an intricate system of interior beams that cross and join in perfect symmetry.

While the approach of many architects to barn conversions is to build a new frame inside the old structure, Woerner took the opposite tack and brought the outside *in*. He enclosed the old frame and ceiling inside a new "envelope" of exterior walls and a roof so the entire pristine frame is visible within as a free-standing structure, making it possible to see

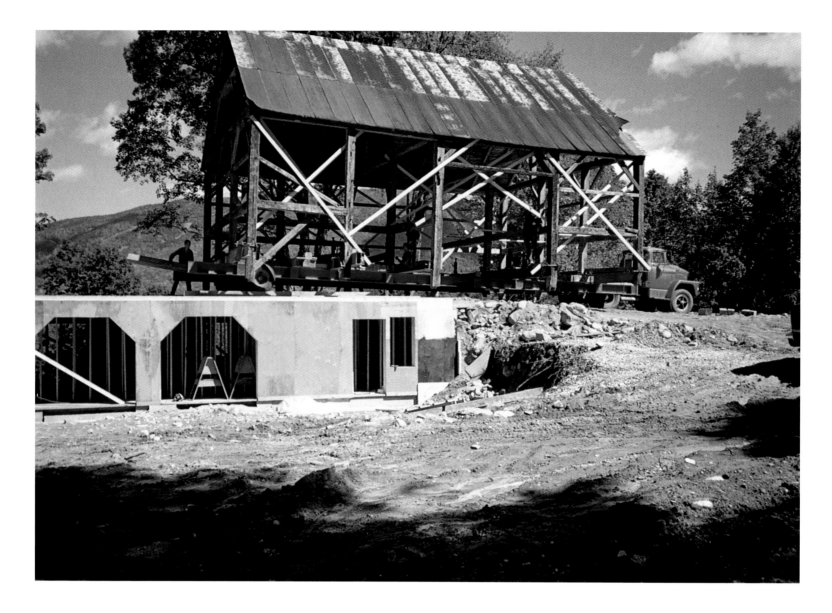

and live with the original elements inside the barn house. When one looks up, there is the original—and rusted—tin ceiling and the beautiful old columns with intricate detailing, exposed all the way down the structure.

The barn, which stood on land belonging to some friends of the architect, had probably not been used since World War II, judging by the profuse vegetation that had grown up all around it. In fact, it might have rotted completely in another ten years. Like many old barns, it was abandoned after the economy changed in the postwar years. And like many old abandoned barns, it required a good deal of work to make it livable.

▲ After being turned ninety degrees, the original structure was backed with a truck onto a new foundation, which contains a lower level.

➤ In the genuinely country kitchen, French doors open onto a flat grassy area that provides an outdoor dining room in warm weather.

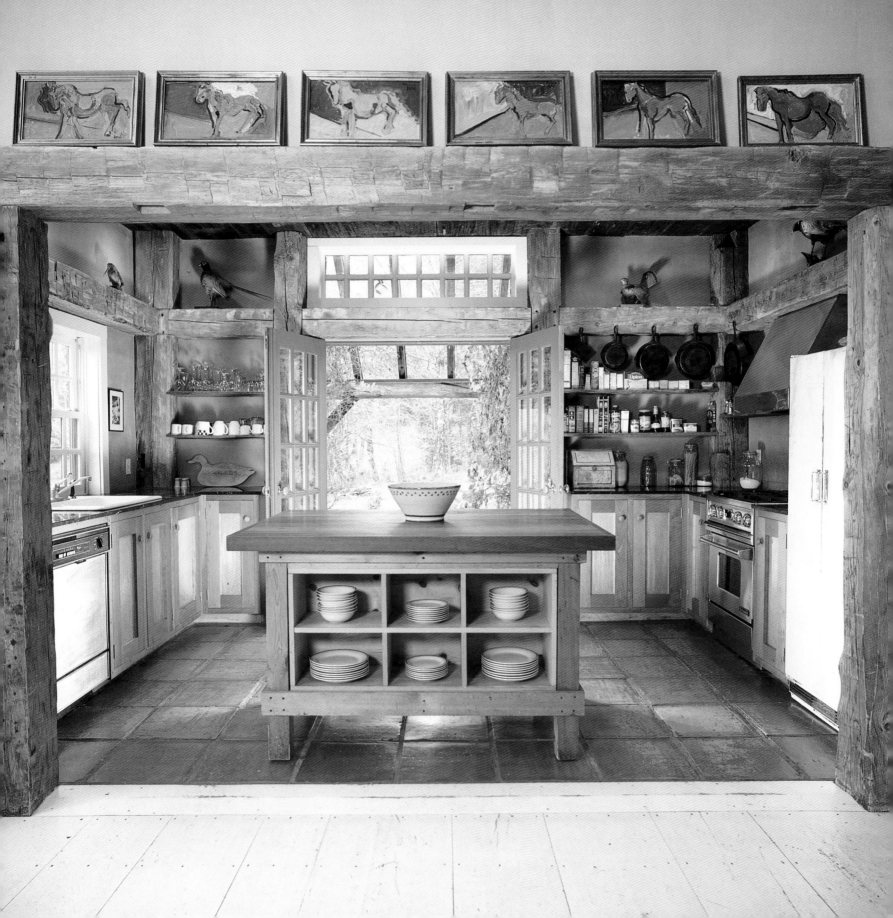

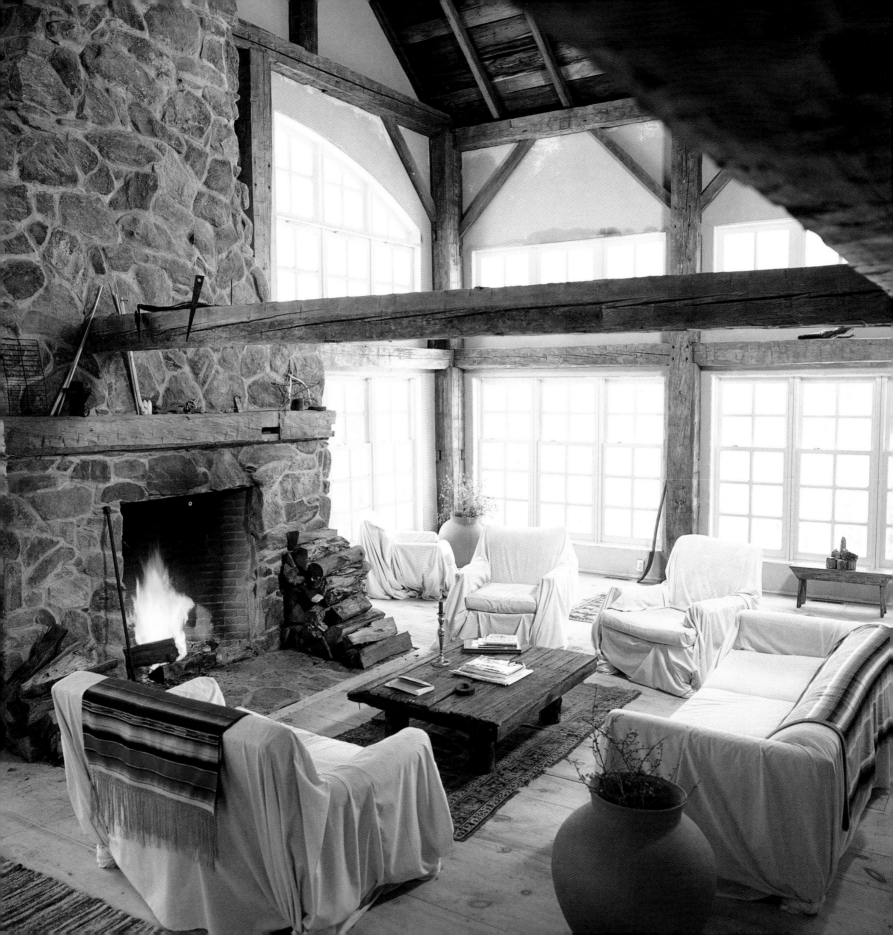

When Woerner found the barn, he was growing tired, he said, of producing slick, perfectionist projects, and "wanted to get his hands dirty." He did. First he had to clear away the dense woods around the barn to be able to work there and get any kind of view. Then he undertook the ordeal of moving the structure—just ninety degrees. There were a number of reasons why moving a thirty-by-forty-foot structure with a delicate frame actually made sense. With barn conversions, it is usually necessary to dig under the barn to create a new foundation, since the original foundations were not constructed with living in mind, and they allow the barn to shake. By moving the barn, Woerner could simply turn it onto a newly laid foundation. And because the land sloped downhill to one side, there was room for Woerner to add another, lower story to the house, in the new foundation. In addition, with the barn facing ninety degrees in the other direction, the view was better, something that was not taken into consideration for the sheep who were living there before Woerner.

To move the barn, Woerner had it set up on steel beams, turned ninety degrees, and driven with a truck onto the new base—which was now the first floor. He made the foundation one foot wider and longer than the frame so that he could wrap walls around it, creating the new envelope. With the newly created lower level, the barn became a traditional "bank barn," where one can enter either on the new lower story or on the original first floor where the bank rises up to meet the original entrance to the barn.

The new lower level holds two bedrooms and the garage, and the main "public" rooms are in the original barn space above. Inside that space is the beautiful original barn structure—exposed beams, ceiling, and rafters. But the frame is not all that Woerner brought inside. He brought in the spirit of the original structure as well. The new elements

reflect it—rough plaster walls that maintain a rustic feeling; windows that, even in their contemporary candor and over-sized stretch across the structure (necessary in such a large building to keep things in scale), are simple and ordered in a way that honors the architecture of the barn; a stone fireplace that is so much in character it looks like it just formed there.

The interior is as honest as the frame itself, relaxed and unpretentious, but impressive because of its soaring volume. Woerner wanted to retain the feeling of loftiness, so he left the main living area open to the rafters. But lower ceilings installed over the transitional entryway and other areas like the kitchen create warmth and keep the building from overwhelming its inhabitants. In addition, original seven-foot beams run over head along the length of the barn, so there is space all around but a comforting feeling of enclosure just above. Atop it all hangs a sleeping loft, enclosed by walls and windows that give it the look of a little house and make it popular with children, who love to play there.

Even the furnishings seem to be a natural outgrowth of the barn structure: The coffee table was made from a sled, found nearby, that was used to carry tools and supplies around the farm; a ladder that came with the barn and probably went to a hayloft was left in place and now goes delightfully nowhere; a swing hangs from one of the beams; and paintings, toy trucks, and various curiosities sit on the rafters, completely at home.

In making a ramshackle barn into a real home, much had to be disposed of, but what Woerner held on to was a sense of honesty inherent in barns. The rough textures, the weaving together of simple materials, and the straightforward structure all meet to convey a true spirit of craftsmanship, and a human element made apparent by that sense of craft.

◄ To continue the rustic feeling, some of the walls of the home are finished with the old siding that had to be stripped off the exterior of the barn.

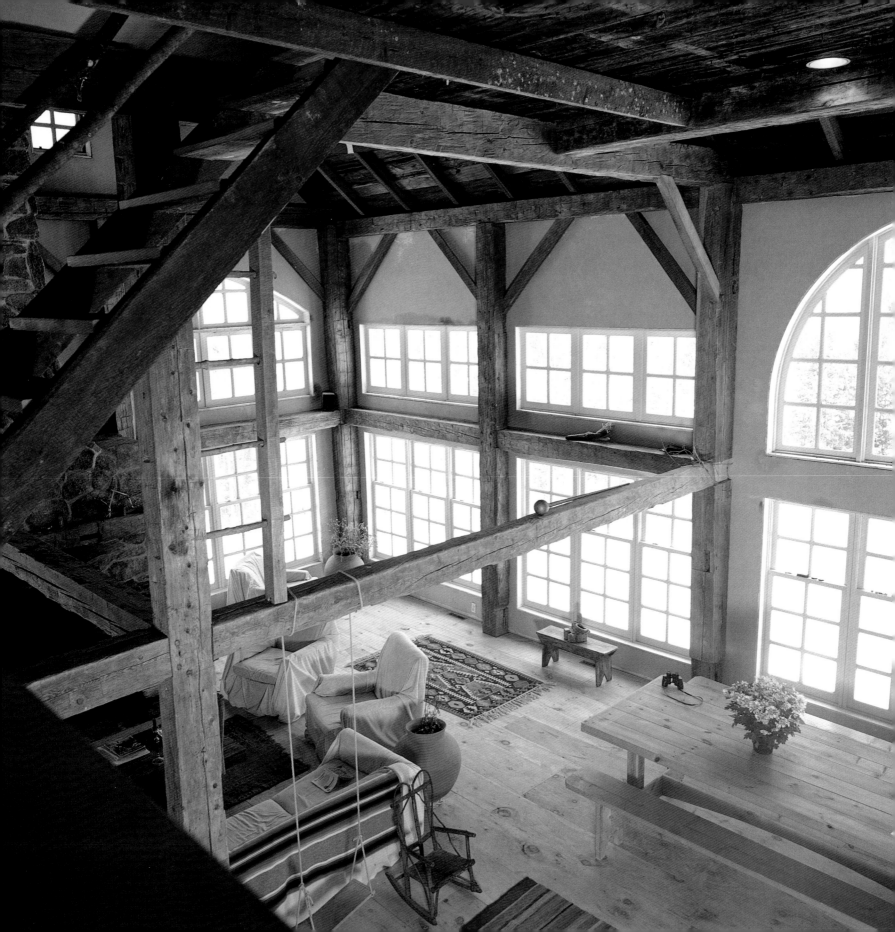

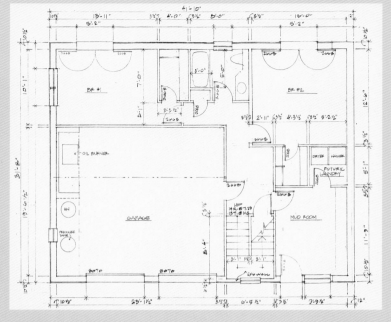

LOWER-LEVEL PLAN

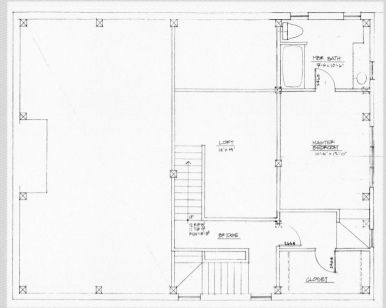

SECOND-FLOOR AND LOFT PLAN

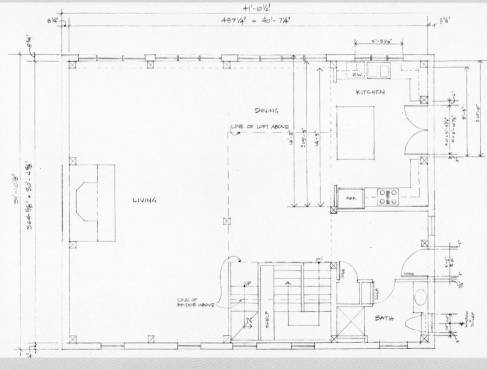

FIRST-FLOOR PLAN

◄ A loft above the main living area is surprisingly private, since there is so much room in the structure that it is barely noticed.

▲ The new lower level, along with the loft, contains a total of three bedrooms for the barn house.

► The kitchen and bath are fit into the corners of the building so that the remaining space could be kept open. These corner rooms have lower ceilings than the main living area for a warm, domestic feeling.

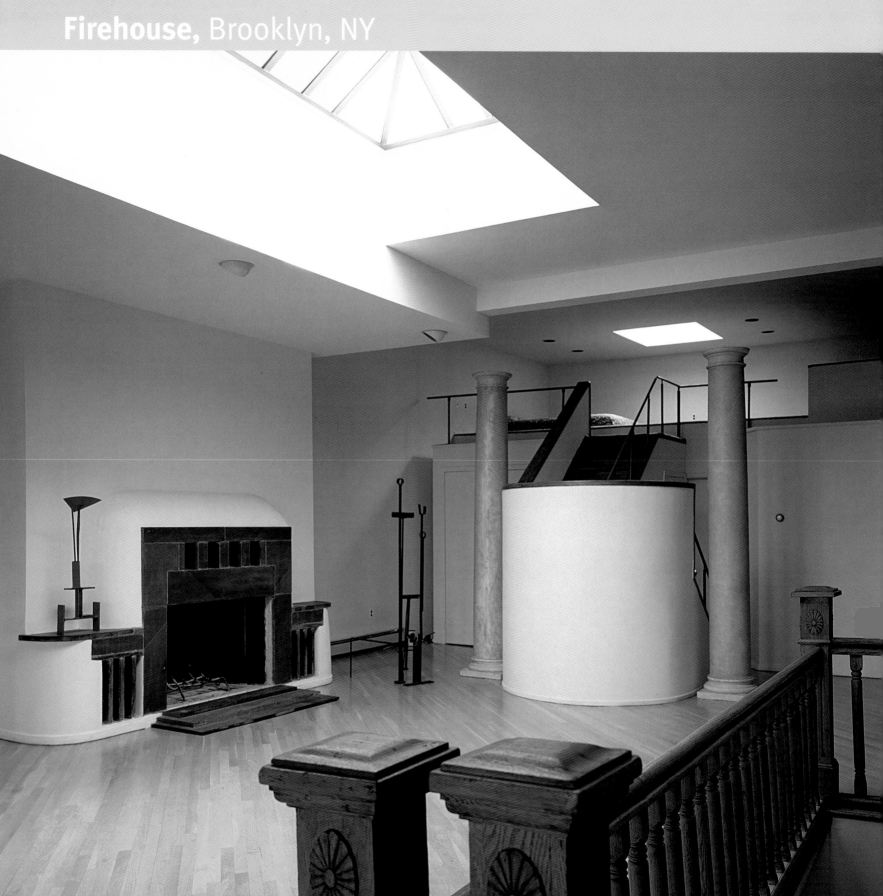

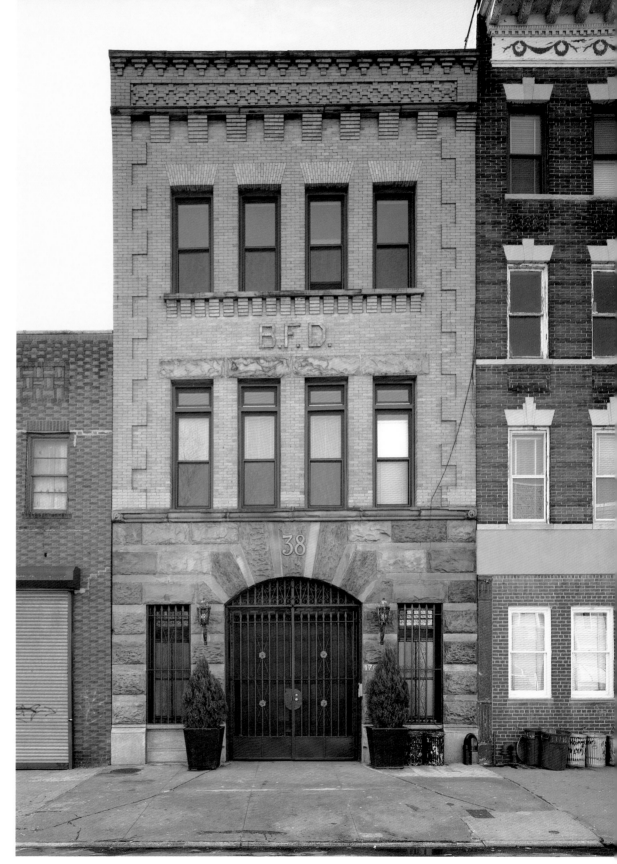

‹ The carved oak staircase and glass skylight are shining original elements from the firehouse. The new rounded architectural element hides a staircase, and a new fireplace was made from slate found in the building and installed in the shaft that was once used to dry the fire hoses.

› The 1890s firehouse sits on the last block of a main street in Brooklyn. The ironwork in the front was added for security and decoration.

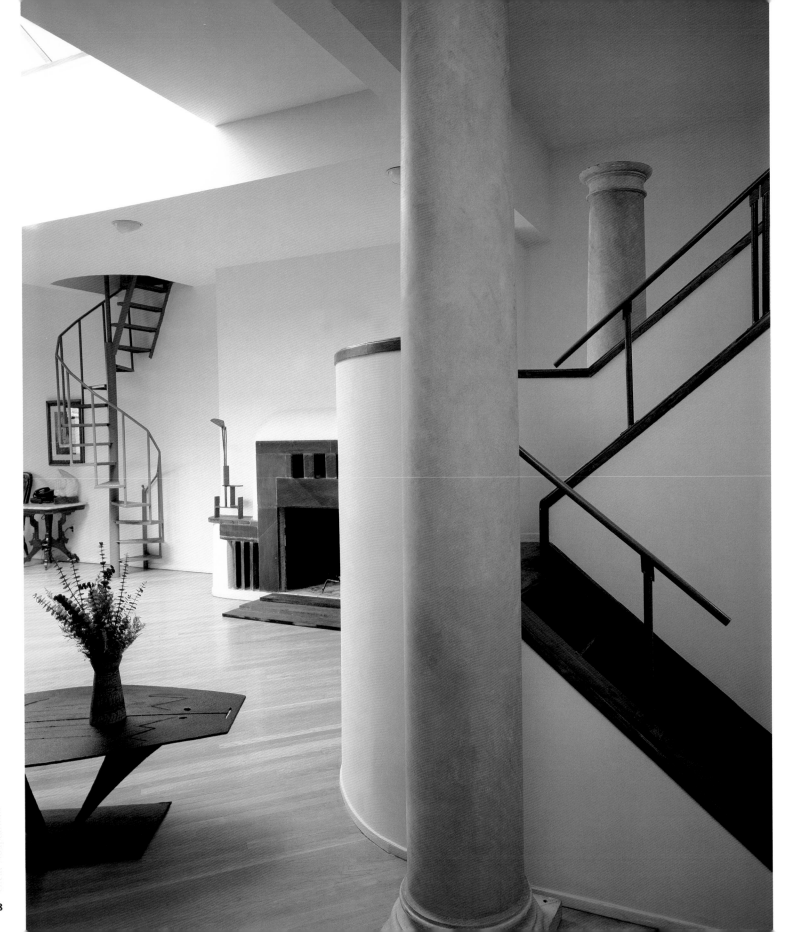

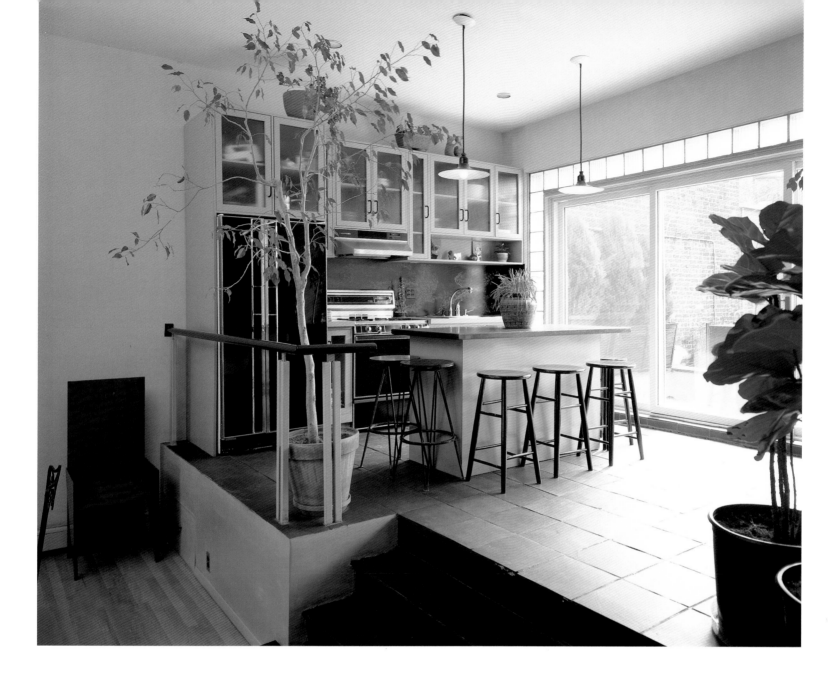

◄ A new steel spiral staircase leads to a small bed-room above the top floor of the firehouse home.

▲ Slate that was taken from the shower stalls of the firehouse now covers the kitchen floor and continues out to a new back terrace, which is decorated with planters made from the wain-scoting of the building.

"We just saw space," is how Janet and Walter Kenul describe their reaction—and attraction—to a firehouse in Brooklyn that stood abandoned and rotting and waiting to be saved. Space was about all there was to see in the hundred-year-old build-ing, with the exception of rotting beams, falling plaster, and broken windows. Even the brass pole was gone, stolen by scavengers. The firehouse had been sitting lonely for ten years, except for visits from vandals, who tore up what little they could find on the interior and covered the exterior with

graffiti. The rest of the damage was done by rain that poured in through broken skylights.

Today, the old firehouse is a beautiful, comfortable, contemporary home that still looks to the past in a friendly way. And it is not just the big front doors where the trucks used to rush out that remind the owners of what the building used to be. Longtime residents of the neighborhood who remember the engine company with fondness come by to recall school trips to the fire station, and some of the old firemen themselves drop in from time to time to see what has become of the place.

When the couple set out to find a building to transform, they were looking for room to expand and a special structure that would suit their needs and visions. As artists, they wanted a place to work and show their art, as well as to live. When they found and fell in love with the firehouse, they went to the city registry to get information on the owner, but could not track him down. By coincidence, they later visited a realtor who had been hired by the owner, and who put them in touch with him.

Next, they did what is typical—and inevitable—for many who convert buildings: They bought the building only to gut it, because so little of the interior structure was of use. As it turned out the politics of getting approval for codes, regulations, registrations, and all the other paper work required for altering the building was harder than working with a sledgehammer to knock down walls or carrying the rubble away in a wheelbarrow, which they did for months to hollow out the building.

An architect was called in to tell the Kenuls what they *couldn't* do, but they orchestrated the rest of the conversion. Walter Kenul had a good deal of carpentry experience, and the couple relied on trade-offs with friends and acquaintances—the slick cabinets that help define the kitchen were made by a friend who took their jeep in return, and many of the other new elements are material representations of favors that were owed or exchanged. The whole project took three and a half years; after the first two years the couple moved in and continued the conversion.

The exterior was restored using hydrochloric acid, to clean off the graffiti, and the favors of friends who knew welding to make a gate for the entryway. The large "38" signifying the number of the engine company and the brick "BFD" ("Brooklyn Fire Department") are still charmingly in place.

On the interior, the Kenuls basically followed the building, letting themselves be guided by its lines. The exposed-brick wall on one side of the building and the carved staircase that runs alongside it are the only original pieces that could be left in place. But anything of interest that had to be torn out—original doors, windows, and the trim—were used elsewhere throughout the house, creating a sense of continuity with the past.

The first floor, once the home of the horses that pulled the fire carriages in the early days of the firehouse, now holds a large apartment; eventually the Kenuls plan to "live into" the space, using it for a studio, workroom, or gallery. Up the oak staircase, which ascends through the whole building, is the main floor of the home, with an entryway, dining room, and kitchen. Here one begins to see how the owners have created their own architecture with sculptural elements and smooth surfaces. The area is a study in slate, a material that the Kenuls found by the pound in the fireman's shower stalls on the top floor of the building. They tore out the stalls and used

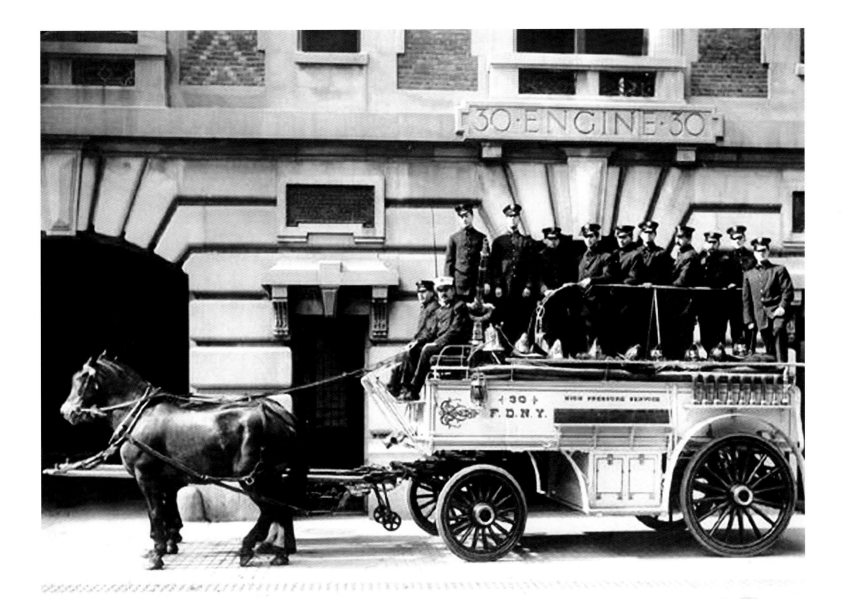

↑ A fire brigade from 1904, the same era as this
firehouse, shows carts pulled with horses.
Dalmatians were known to calm the horses,
so they became related to firehouses.

the slate to cover much of the surface area in the house—the kitchen counter, the floor of the terrace opening off from kitchen, even the dining table. Though the slate itself is probably more than a hundred years old, its cool black surface takes on a sleek contemporary look when placed among the other contemporary elements in the house. Other pieces of the old structure, used in new ways, are everywhere in evidence: The new terrace off the kitchen holds planters made from the wainscoting that was torn off the front of the building; original frosted-glass windows and doors were repainted and used for cabinets and doors to other rooms opposite the dining area.

Upstairs, the living room and the loft bedroom are washed by natural light from the close spacing of the original windows and the new skylight above, which approximates the one that was broken. Here, the straightforward lines of the firehouse melt into sculptural space: The new walls curve and undulate, and the loft that holds the bedroom is reached by a rounded stairway (a contribution from an architect who used to work for I. M. Pei). And the ceiling drops and rises in different places—both to visually separate the living area from the main bedroom and to allow a small bedroom on the third story (reached by a new steel spiral staircase) to have a dropped floor.

The element that best sums up the house sits against one rounded wall—a fireplace made from the abundance of slate and installed in the shaft once used to dry the fire hoses. In addition to helping keep the large space warm in the winter, the fireplace adds a nice irony. Building on what Janet Kenul calls "the protective spirit" of the firehouse, the Kenuls have created their own expression of a home. They hold art shows in the space, and the pieces made from

found objects—a mirror fashioned from columns and fence tops, a sculpture she made from firefighting hooks discovered in the basement—reflect the spirit of "found art." So does the house itself: "This is just another form of our art," Janet Kenul says. "It's the biggest piece of artwork we've ever done."

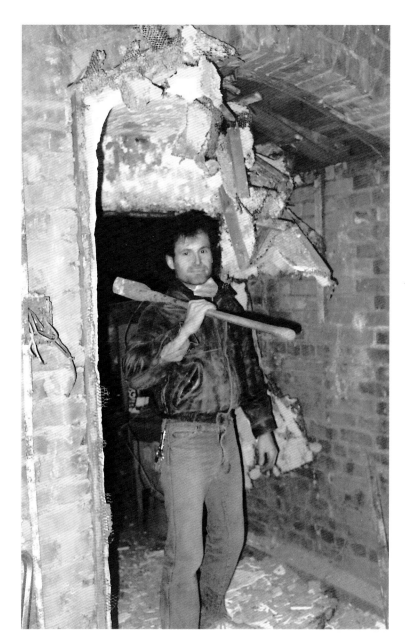

◄ The dining room tabletop is also made of slate. The sculpture visible in the mirror was made by owner Janet Kenul out of firefighting hooks she and her husband, Walter, found in the basement. To the left are original doors and cabinets fronted with frosted glass that were torn out of places where they could not be used and restored.

► Walter Kenul's carpentry experience was helpful in the tough early days of renovation.

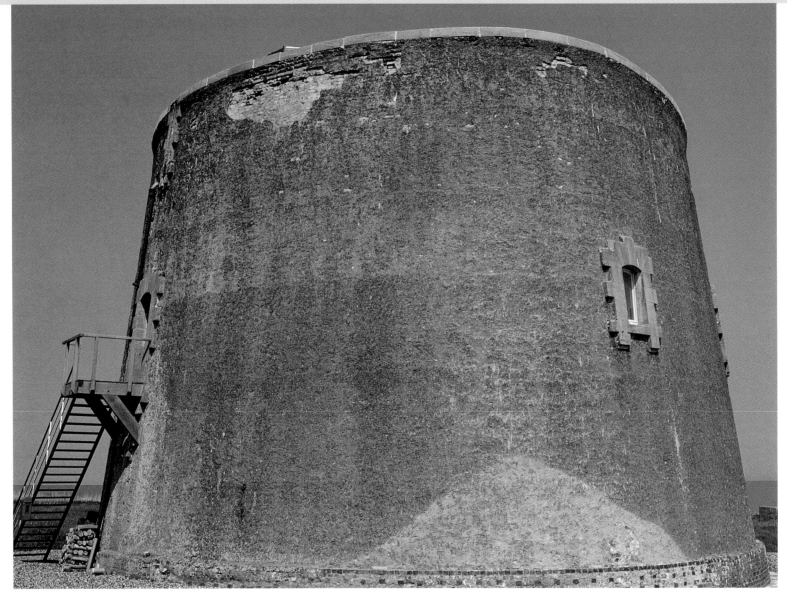

John and Suzanne Fell-Clark were buying fresh fish on the Suffolk coast in England one day when, as Mrs. Fell-Clark tells it, "John pointed to this huge pile of gray bricks and said that it looked interesting." That was the beginning of an adventure, for the pile of bricks turned out to be a Martello tower, one of 103 built and only forty remaining. When the couple went down the shore to explore it and climbed up to look into a small window, they decided they wanted to make the 750,000 bricks into a home.

The Martello towers (named for Mortella, a cape in Corsica where a similar tower was attacked by the British navy in 1794) were built between 1805 and 1810 to ward off the Napoleonic invasion that never happened. After that, they were used as lookouts against smugglers from Holland and then, during both world wars, attackers. When World War II ended, the towers were sold off. The Fell-Clarks bought theirs from a farmer who owned the surrounding land.

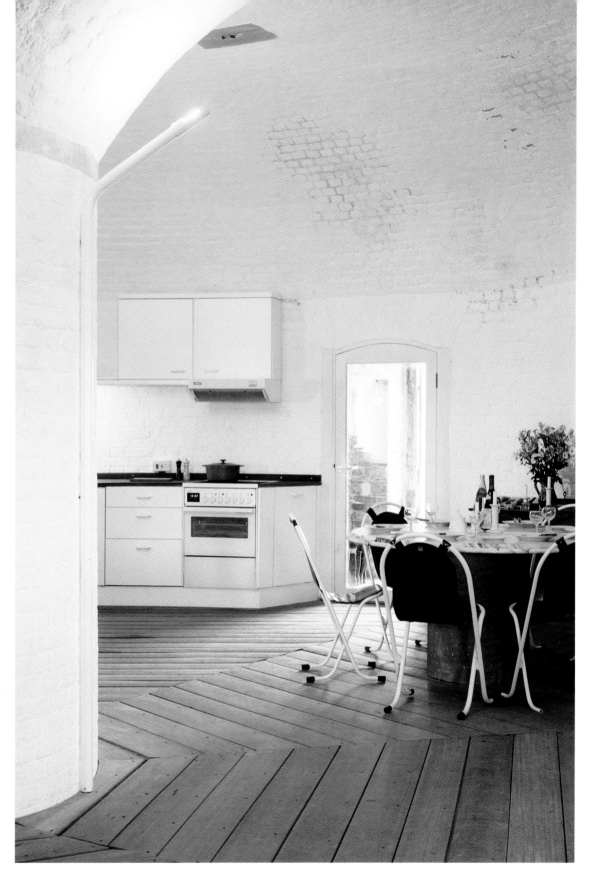

◄ Martello Towers are officially recognized as ancient monuments. In fact, the novel *Ulysses* begins in one.

▸ Because the home is essentially round, interior design was sometimes a challenge. A minimalist approach was taken so that the fine original elements would be allowed to show.

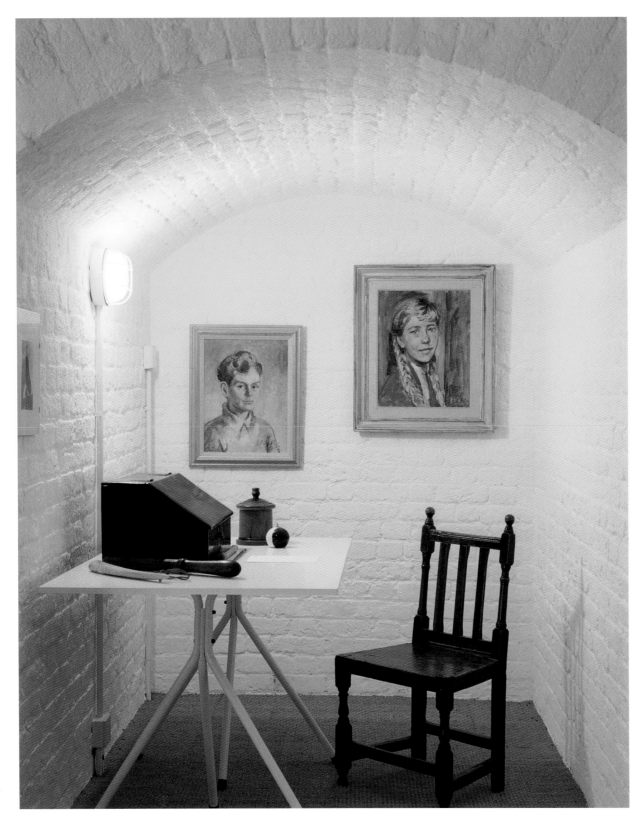

Great Adaptations

The building *looked* like it had been attacked—on the inside. A leaking roof left pools of water lying everywhere; the water had rotted the main floor, which was falling in, and much of the brickwork. What was left was a very impressive shell—round walls made of layers and layers of brick, some of them nine feet thick.

The first step toward making the tower livable was to dry out and waterproof the inside. Over three months' time, huge dehumidifiers sucked out one thousand gallons of water. Then, to keep it dry, the entire building had to be regrouted. The original design helped in this regard; ventilation shafts throughout the building, originally built to keep cartridges and shells dry, help the air to circulate.

John Fell-Clark, a designer, drew up plans for the house—a challenge since the tower has no corners. After an architect translated his plans into a final draft, the conversion began, headed up by a builder who was also the local undertaker. Though the original windows in the building are charming, there are only five of them and none are on the first floor. The sun reflecting off the sea and into the house provides some light, but not enough. Installing new windows in nine feet of stone would have proven enormously difficult—and would certainly have compromised the character of the building. So to lighten the place up, the entire inside was painted white.

The owners wanted to "get the full circular feeling of the tower" and allow the architecture to show, so they kept the interior simple and added on as little as possible. Not that English Heritage, the strict historical commission that oversaw the conversion, would have let them do it any differently; they did not even allow nails to be hammered into the bricks—they had to go in the mortar between them.

Although the ceilings in other parts of the tower reach up to twelve feet, on the first floor they drop down to seven feet in places. Here, the two bedrooms have been placed in what were once storage alcoves for powder kegs; they are tucked into the house like ship's cabins, compact and unobtrusive. And the gunpowder room became another kind of powder room—the bathroom for the first story. One of the only separate rooms in the tower, it was made to be closed off to contain possible explosions.

The second story, which originally held the officers' sleeping quarters, was left open, and furniture is tucked away as much as possible so that the building can show without interference. Cabinets and beds that pull out at night are built in along the curving walls. The dining area, kitchen, and main bedroom are up here, among an original stone fireplace, 180-year-old flagstone floors—a material used to contain possible explosions—and the massive central column that reaches up to the vaulted ceiling and supports the entire roof. The new staircase consists of materials, that, like many used in the house, were ingeniously scavenged. The banister and handrail consist of scaffolding poles painted white and framed, then filled in with stainless steel yacht rigging. The joints in the poles make for their own distinctive design. The lamps that illuminate the central column and bring light to the whole floor are also made from scaffolding poles—with a lightbulb at the top. The dining table is a slab of marble placed on top of a drainpipe. Even the outside entry stairs were fashioned from old fire escapes.

The roof is an environment unto itself, more comfortable for living than one would expect at the top of a tower. Along with old cannon barrels sits a glass house that makes it possible to use the space when it is cold. The house was put up with a crane in the face of strong gales and it is amazing

◄ The interior of the tower is most striking for its arched forms and whitewashed brick walls, so the furnishings are unpretentious—finds from local sales, family heirlooms, and antiques.

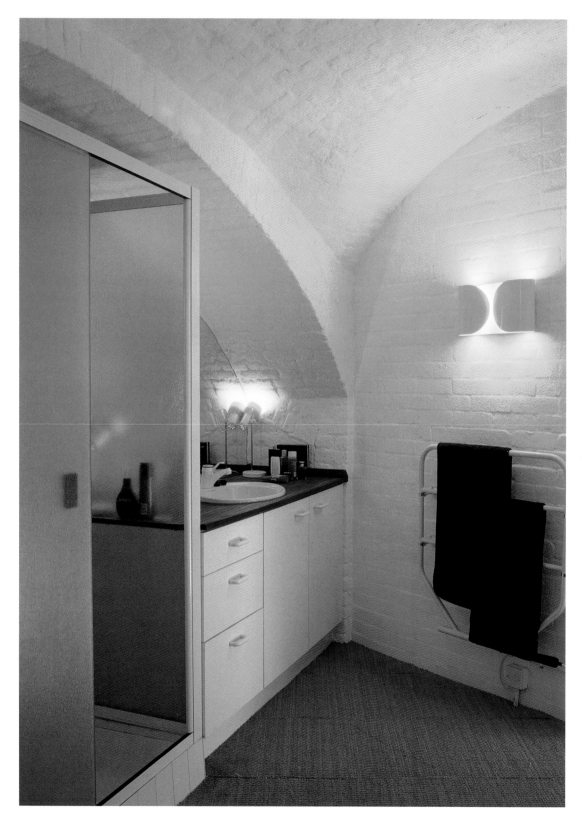

‹ Even practical considerations like
heating were kept covert so as not to
interfere with the architecture; cables
under the floor keep the space warm.

› Looking out of the windows of the
tower is an event since most of
them are preceded by several steps,
designed for keeping watch.

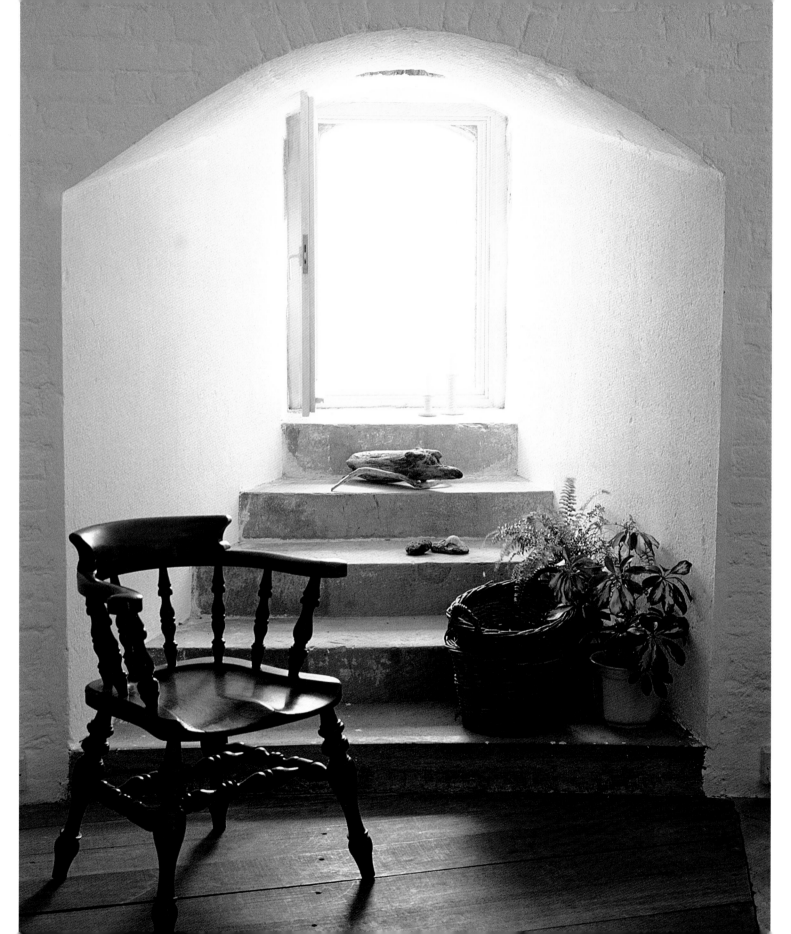

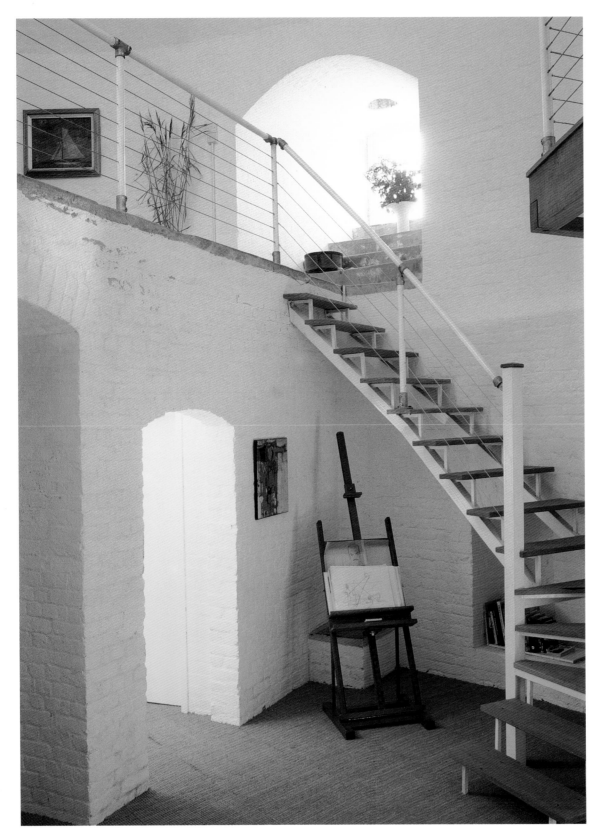

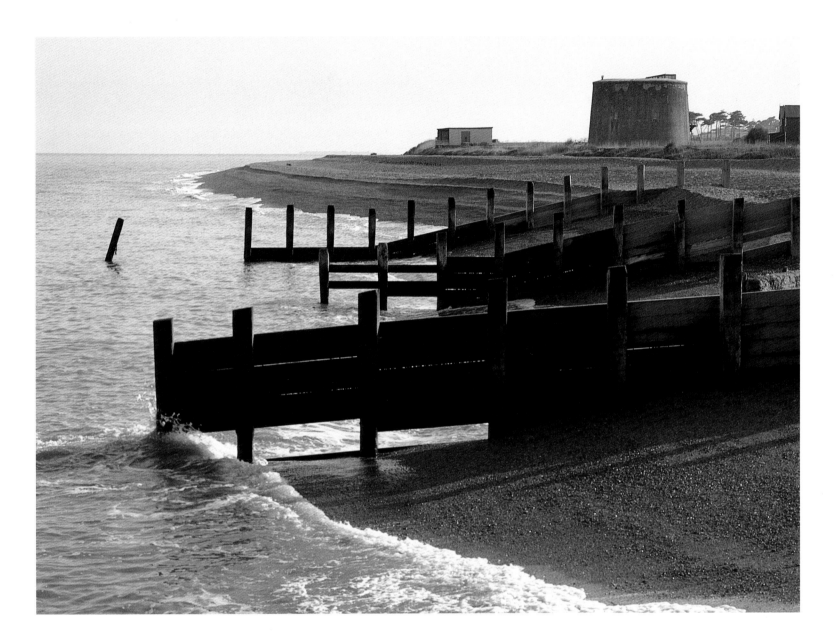

‹ The stairway, newly constructed from unorthodox materials such as scaffolding poles and yacht rigging, brings the home a contemporary finish, which complements its intrinsic roughness.

ᴧ The owners, John and Suzanne Fell-Clark, said they were looking for "something unusual" in which to live. "Here, we feel invisible to the rest of the world."

that it survived—and remains, even in very high winds. Up there, the owners can see around for miles, and most of what they see is ocean; they have few close neighbors, and the village is down the road.

When the Fell-Clarks enter their home through the original oak door with the huge iron bar across it, they feel as though they have escaped to a safe place. Upstairs, when there is sunlight, ripples reflected from the waves show on the vaulted ceiling. And although the owners can hear and see the North Sea from there, they feel singularly protected from it—and everything else.

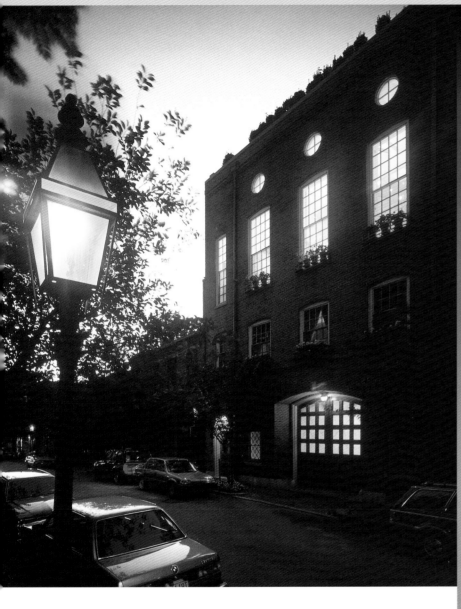

‹ The entryway floor design was drawn by an artist and translated with five different types and color values of wood put together by two craftspeople.

⌃ In what was once an alley lined with stables, garages, and servants quarters, sits this structure, the top two floors of which held the ballroom. The original double-hung windows and the new porthole additions make for a light-filled residence today.

➤ "The home works for two people as well as sixty people," says architect Graham Gund, who designed it for a couple who wanted intimate spaces, such as this skylit stairwell, as well as dramatic open ones that allow for major entertaining.

Visitors may still get the urge to dance in the ballroom that architect Graham Gund turned into a home for a Boston couple. The vast expanse of wood floor in the living area could still be glided across, and although the space has been transformed into something new and certainly contemporary, its monumentality and sense of drama remain.

The ballroom was constructed in 1905 in the upper half of a building whose lower floors housed servants' quarters and a garage. This kind of detached "wing" was not unusual in turn-of-the-century Boston: A single wealthy family would own the building to provide space for all their needs outside the main house. The plain brick structure sits on historic Beacon Hill in a former alley—a quiet block-long street that nevertheless is not far from the bustle of the city center.

Most of what Gund saw when he first walked into the ballroom was raw space—soaring ceilings two stories high and a forty-by-forty-foot floor. But the room, which was designed to be lit up only at night, was dark and dreary during the day; double-hung windows at the front of the building were the only source of natural light. And though it was grand, it was relatively straightforward: an English Baronial-style room with a fake wood-beam ceiling, simple plaster walls, wood floors, plain wrought-iron chandeliers, and an overscaled fireplace. Not much of this was appropriate for a home. So Gund opened up the dark dropped ceiling to let in more light and volume. The original walls and floors were in disrepair and had to replastered and relaid. And the chandeliers, though charmingly anachronistic, would not fit into any design scheme for a contemporary home. Only the large fireplace was saved.

Gund's main challenge was to make the huge space comfortable for living by breaking it into smaller areas, while keeping the open spirit of the original ballroom. Instead of installing a full ceiling between the two stories, he kept the whole central space open, tucking rooms into the corners and sides of the building that are all accessible from a new "catwalk" running around the second-story level. The maple handrails of the catwalk are designed like trellises so that everything is visible through them. Then to scale down the volume for comfortable living, Gund designed a little area set off within the larger one that holds the living room. The partial enclosure is made from two huge curving contemporary walls on either side—maple panels inlaid with ebony in a pattern that echoes the grid of trellises. The outdoor feeling of the trellises, the openings in the walls that resemble doors and windows, and the balconies along the catwalks all bring to mind a courtyard, evoking the same feeling of intimacy and protection within the great space that a real courtyard does in the outdoors.

‹ Skylights and expansive windows are everywhere throughout the home. "The light really dances here," says one of the residents.

› The vast space in the ballroom is scaled down to human proportions with the help of a trellised "catwalk" that runs around the building and two walls that define the living area.

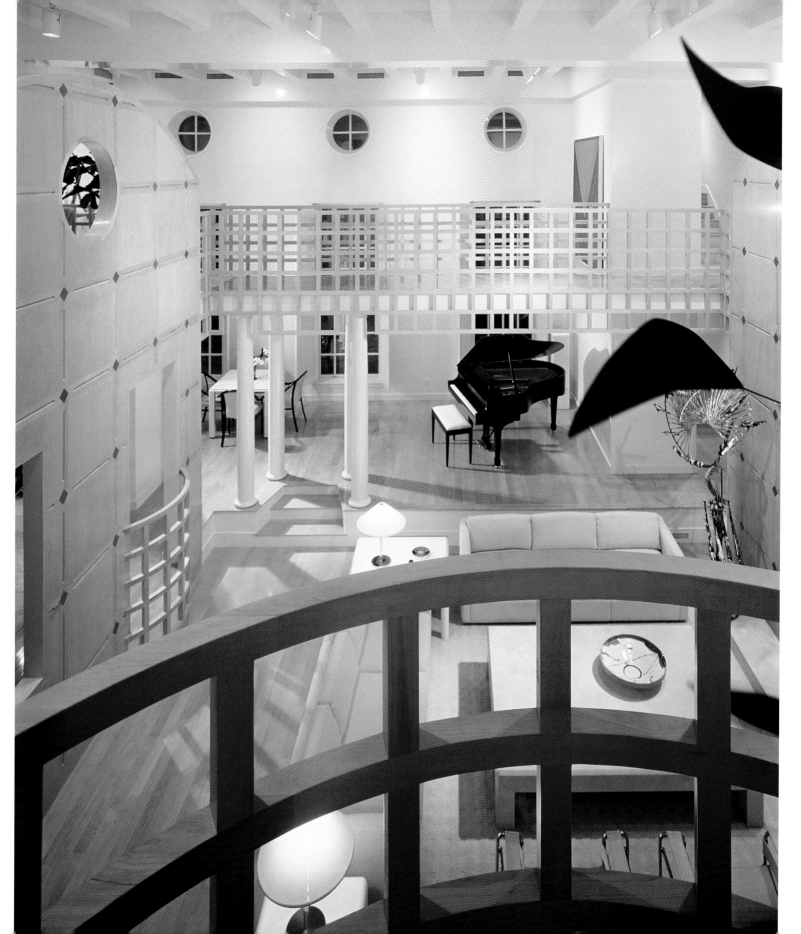

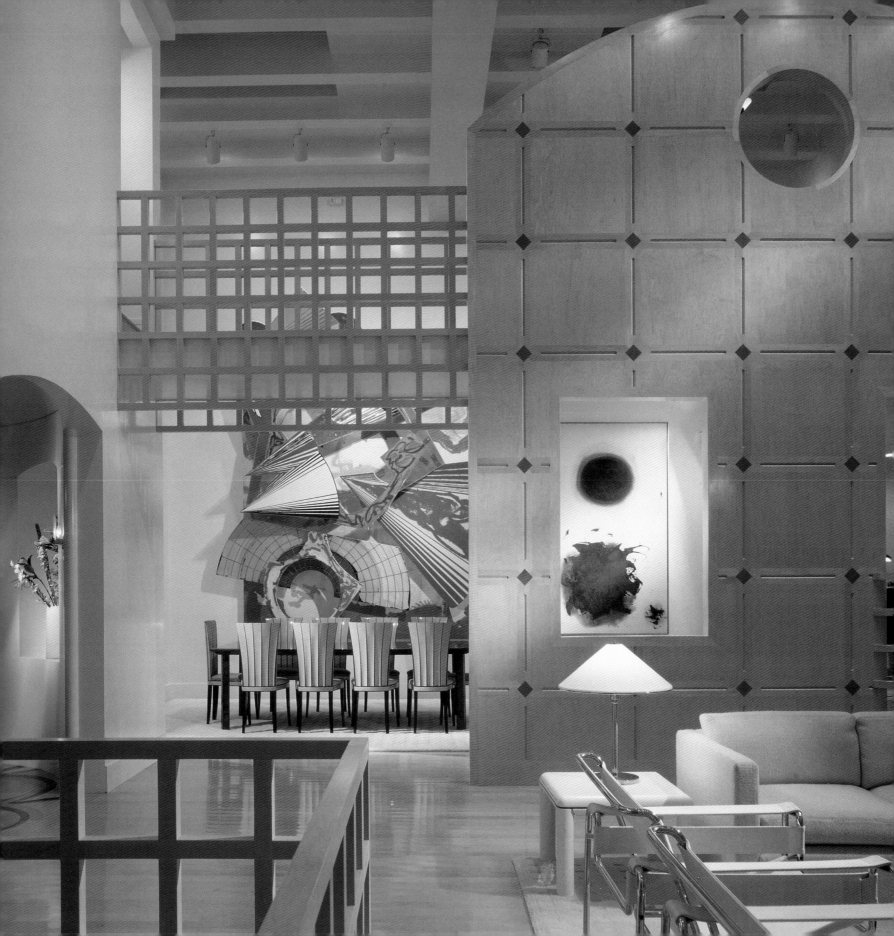

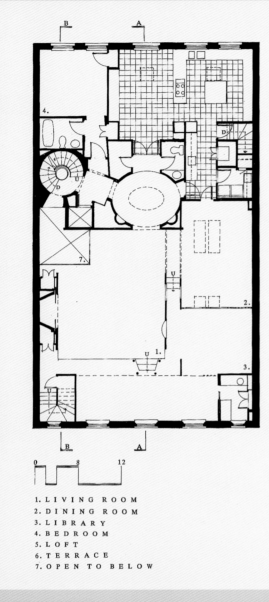

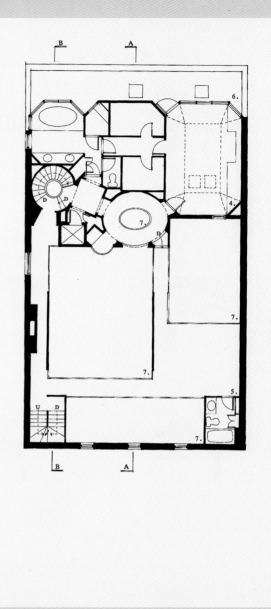

0 8 12

1. LIVING ROOM
2. DINING ROOM
3. LIBRARY
4. BEDROOM
5. LOFT
6. TERRACE
7. OPEN TO BELOW

LOWER-FLOOR PLAN

UPPER-FLOOR PLAN

◄ Across from the enclosed space sits the dining
area, where a three-dimensional work by Frank
Stella heightens the drama of the space.

▲ The big, two-story living area opens out onto
smaller rooms at both levels.

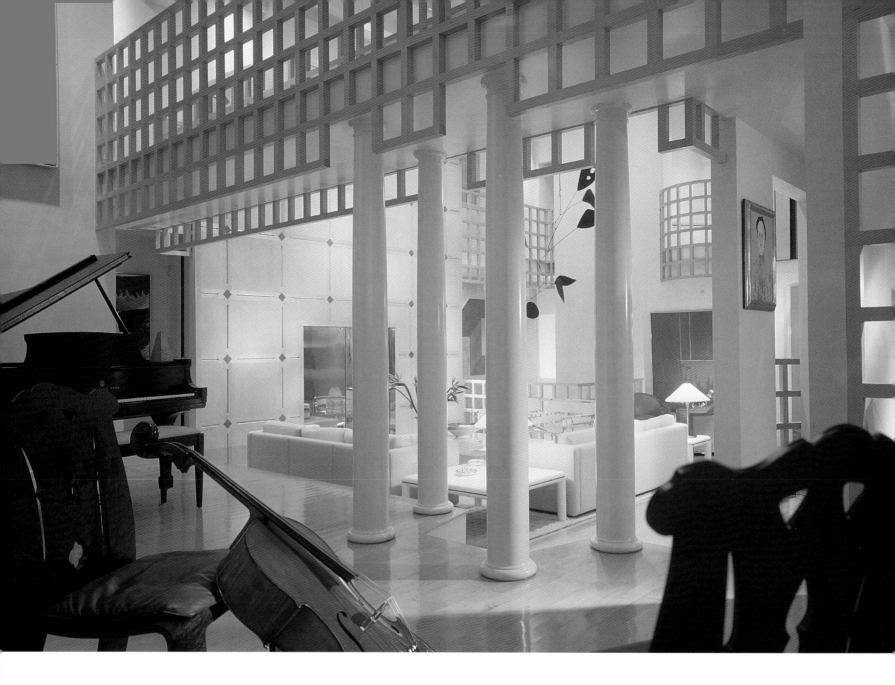

The other priority of the conversion was lightening up the space, which Gund achieved with a series of porthole windows at the front of the building and skylights in darker areas such as the entry hall. The light shines in gridded patterns on the floor of the main room through the panels of the big original double-hung windows in the front, which are picked up by the gridded designs in the rest of the home. Gund also used light-colored materials throughout—off-white and pale finishes, maple for flooring and the trim of architectural elements. The result is a surprisingly bright space where, as the owners say, "the light really dances." And it seems even brighter in contrast with the dark brick closeness of the nineteenth-century street on which it sits.

Standing on a balcony overlooking the space, the residents can survey its past and present grandeur. The sweep of space, the stature of the new white columns bordering the steps leading into the living room, the grand piano sitting alone on expanses of wood floor evoke the particular sense of celebration and suspense that only a ballroom can. One can almost imagine the orchestra playing below, and the couples swirling in time.

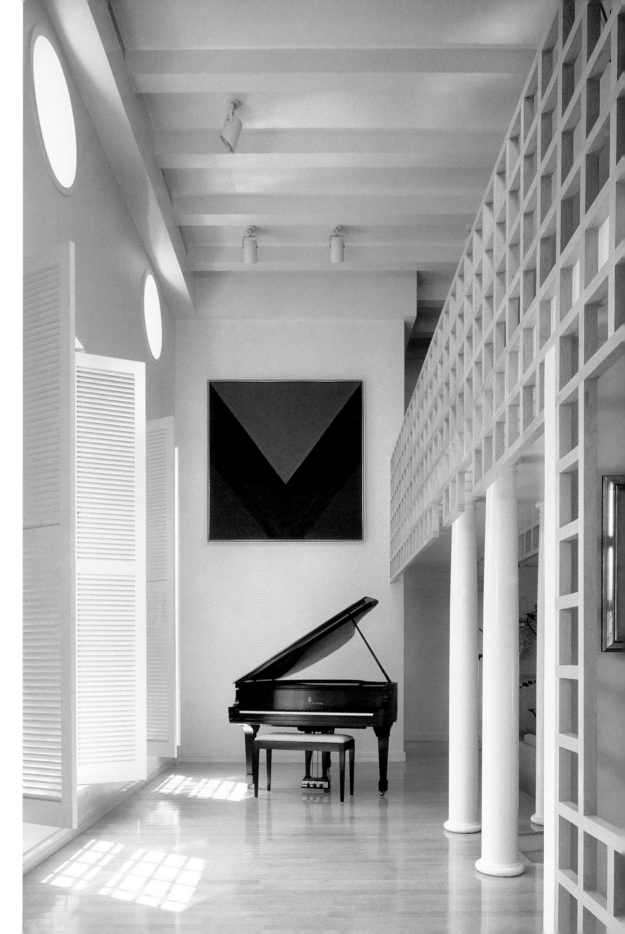

< The careful placement of architectural elements and objects creates an artistic effect. As one resident says, "We don't have a panoramic view outside—just the narrow street—so we had to create our views inside the house."

> The "house within a house" created by the freestanding walls and "catwalk" gives a comforting sense of enclosure.

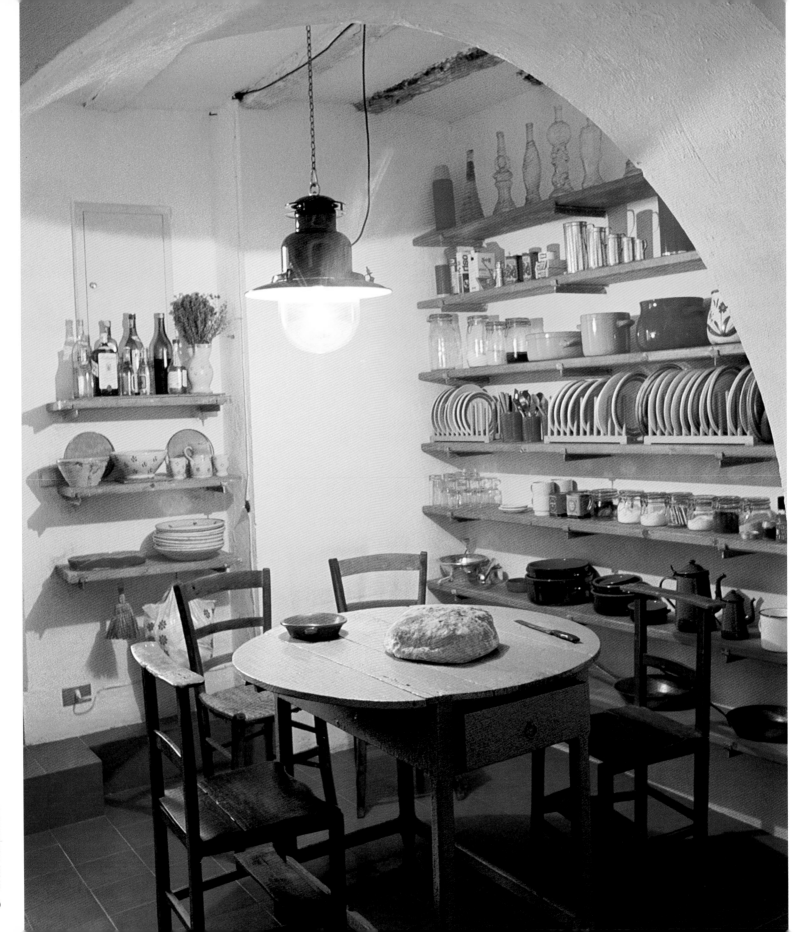

‹ The kitchen table is a traditional piece painted for contemporary expression, and the chairs are pews that were rescued from the church across the street and cut up.

⌃ An unassuming little building in a remote part of Italy was made into a cool, white, bright space for living.

› A shower was placed in the meeting of sculptured walls. Elsewhere in the bathroom, the mangers where the pigs fed were covered with the same red tile, and the sinks were placed on top.

A pigsty may seem a singularly unlikely structure to convert, but this country home in Peschici, Italy, was transformed from what was a relatively significant little building in the life of a remote rural village. For just twenty years ago, the pigs were Peschici's street cleaners and occupied a position of some importance. In the intervening years, the village invested in street-cleaning machines, and the building is now happily inhabited by people.

In fact, the former pigsty, with its original storybook doors and windows, is only part of the two-story home.

The second story has a past of its own: It was built into the old fortification wall of the town as a residence long before the present owners, a couple from England, took over both it and the pigsty and connected the two with an interior stairway. Although they moved into the very walls of the city, the couple received less than a warm welcome at first, as the townspeople were not used to strangers. But the new residents have found their place there—a bright, cleanly designed one that hints of pigs only in the most charming ways.

‹ Arches are a dominant theme on the second level, which was built into the fortification wall of the town.

› The new stone spiral staircase winds down from the second level to the pigsty, fitting in so closely both physically and in terms of design that it seems as though it has always been there.

A second-floor balcony was added to the outside of the fortification, but the rest of the exterior was cleaned up and left much the same as when pigs and an occasional donkey called it home.

More substantive changes were made inside, but the plans for them were not easily communicated. Although the owners speak Italian, the particular dialect of the village was beyond their understanding, so the local architect had to convey his thoughts to them in sketches. These were transformed into a design that really works for the house, but the owners weren't sure of that at the time. What they got, however, was worth their trust: a curious staircase, narrow and winding, built into the thick walls to connect the upper and lower floors; a new bedroom and bath whose lines join with the original ones to bring out the best in the pigsty; and an evocative sense of the country roots of the place.

Although the architect capitalized on the cozy, cavelike atmosphere of the original building, the space manages not to seem closed. Both upstairs and down, the ceilings are low and the walls eccentric, since the pigs did not need much height, and the rooms built into the fortification wall needed to be arched for support. So white paint was used throughout to open up the space and give it a bright, clean look. Local red tiling covers much of the surface area—walls, floors, counter-tops—and brings out the country spirit of the structure.

Many of the interior elements have an almost organic feel: the winding staircase that continues the intimacy of the original structure so well that it is hard to believe the stairs were not always there; the bedroom and bath carved into the low, curving walls of the former pigsty; the shower built into a meeting of sculptured, undulating walls that remind one how special the structure is. The four-by-six-foot mangers that once fed the pigs were completely covered in tile, and now support the bed and bathroom basin. There is even a trap door in the second-story floor that was once used to throw food down to the animals, kept as a reminder of the building's origins.

The furnishings reflect not only the building's history, but its environment as well. The dining room chairs were cut from pews rescued from the church across the way—in fact, the priest traded the centuries-old treasures, some of them praying benches with kneeling posts on the back, for plastic chairs the owners were happy to part with. And there are indications throughout of the village's local industry—a fisherman's lamp in the kitchen, lobster traps hanging from the ceiling as decoration.

This is a country cottage with a difference: Its former occupants not only give it a unique history but a special charm as well. And its new owners have retained its character so well that it is the perfect embodiment of the rough honesty of a rural village lost somewhere in Italy.

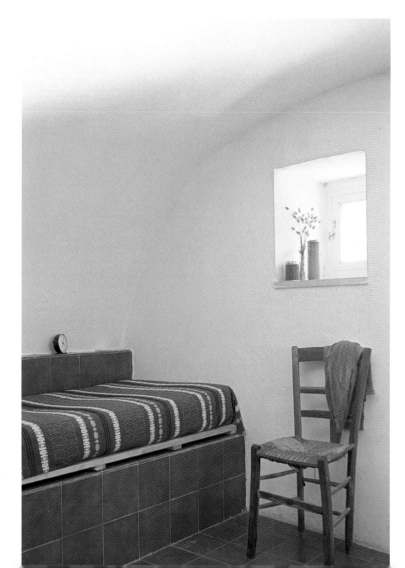

◄ Beds in the former pigsty sit on the mangers that been tiled over.

► Original beams speak to the rusticity of the space, and elements that are sculpted, like the walls and fireplace, give it a unique elegance.

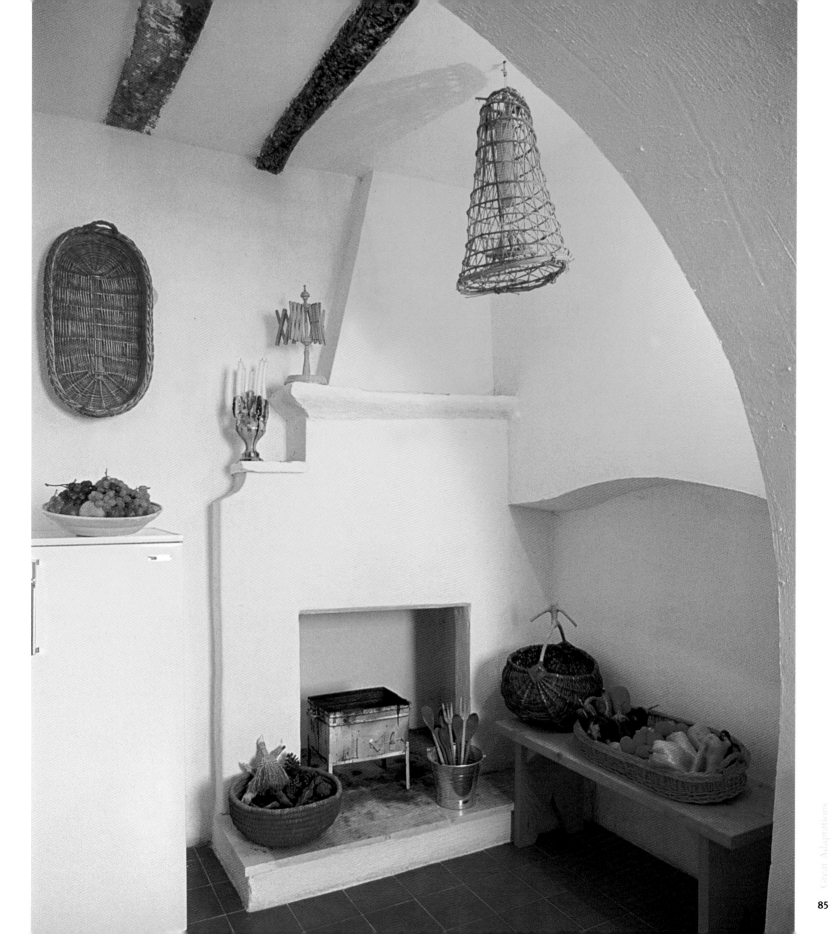

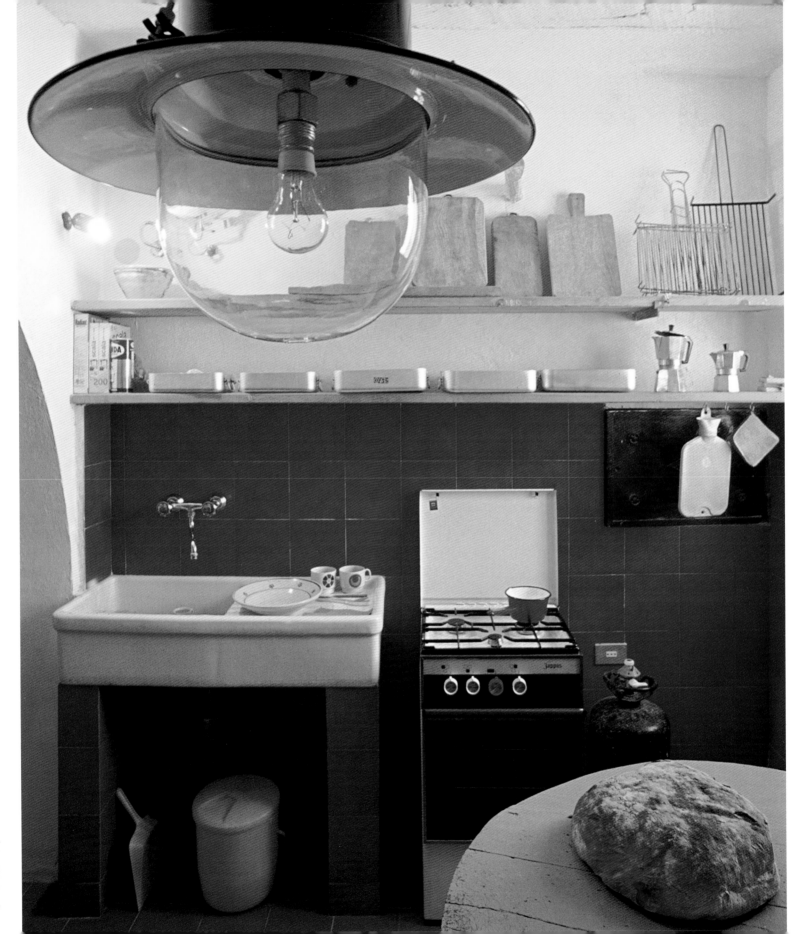

< The kitchen is a study in red tile, which domi-
nates the interior. Locally made pottery is
throughout the home.

▲ Conversions are often found in beautifully
remote locations; the village of Peschici, in
the spur of the boot of Italy, is a timeless sea-
side town.

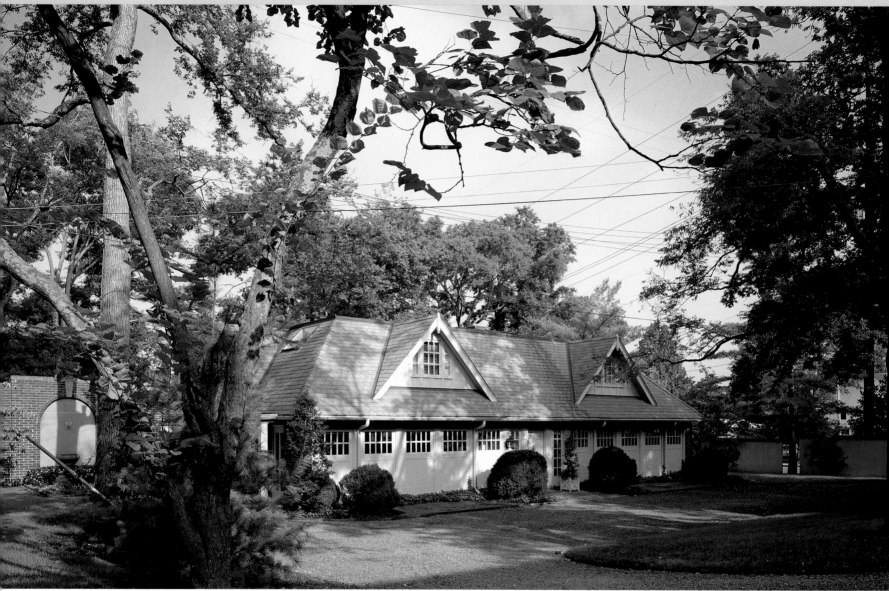

The temptation on driving up to the Armistead home in Nashville is to keep on going, right into the building. For the home is a former garage and, charmingly, still looks like one. A garage may seem a mundane starting point for a conversion, bringing to mind concrete, white parking lines, and exhaust. Not every garage, however, is built in Elizabethan Tudor style, or listed on the National Register of Historic Places. This one is special. Its architecture is distinctive because it speaks not only of another use but of another day as well. It was built in 1915

for the Belle Meade apartments, a gracious piece of Tudor-style history that sits in a residential section of Nashville, and its exterior matches that of the buildings that surround it.

The straightforward, practical personality of a garage—even as distinguished a garage as this—seemed like the perfect answer to the owners' wish to "simplify and unclutter" their lives. Mrs. Armistead grew up in the apartment buildings, which have belonged to her family almost since they were built, and she like the idea of doing something new to a place so old.

Great Adaptations

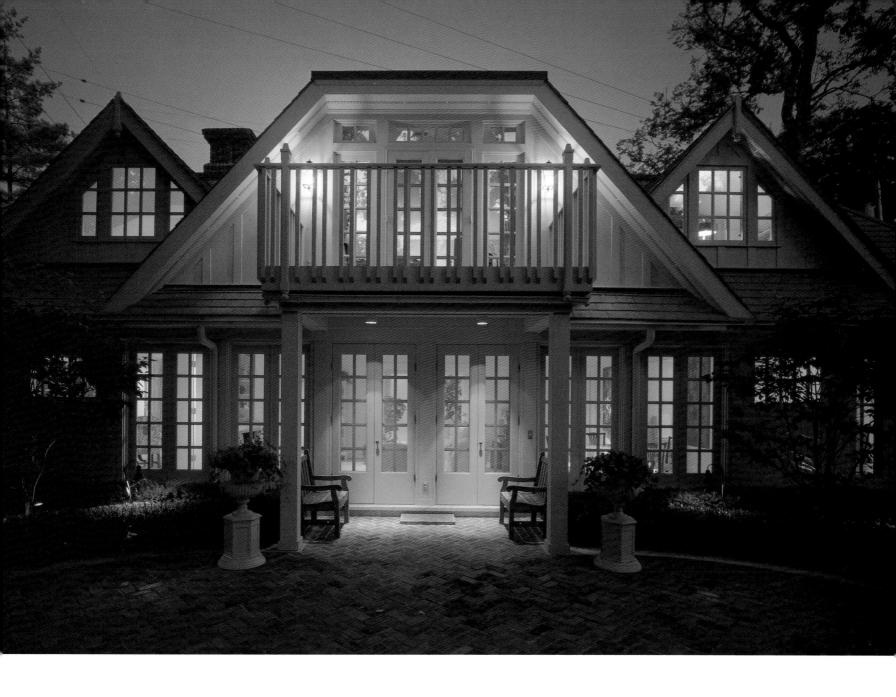

◄ Because of the building's age and architectural distinctiveness, the National Register of Historic Places required the front to remain basically unchanged. It still looks very much like a garage.

▲ The back view of the former garage is a portrait in light, due to the architect's additions of walls of windows.

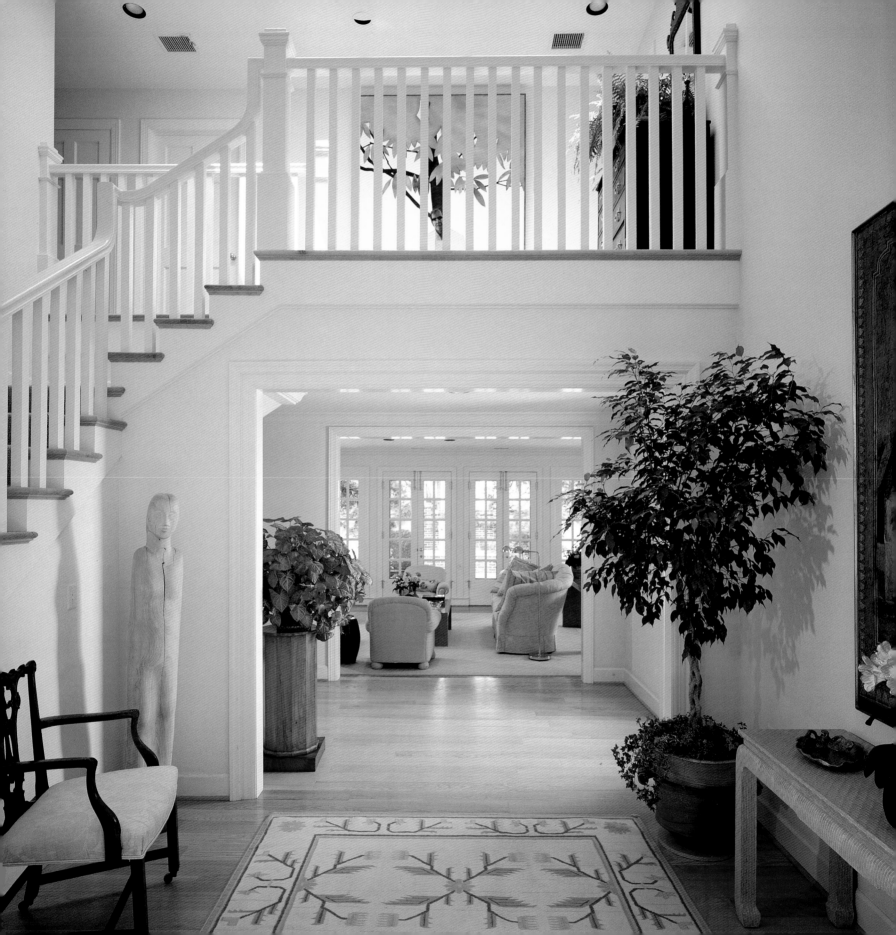

Architect Bryant Glasgow and architectural designer Sharon Pigott came in to restore as much as to convert, for the historical registry had very specific guidelines about what could and, more often, could not be done to the building. Their basic requirement was that the public views, such as the front exterior, look as they did when the structure was built, leaving the more private areas for contemporary expression and innovation.

The building had been abandoned for some time and was in severe disrepair—water leaked through falling plaster, and daylight streamed through holes in the roof. The second floor had been the servants' quarters, so it was designed to be habitable and was therefore easier to convert, but the garage below had uneven slabs of concrete for floors and large, beautiful—but dilapidated—doors for walls. The entire building lacked insulation and heating and cooling systems.

The first step was to clear out the garage, which was filled with junk and some more valuable items—such as Rolls-Royces that were stored there and never used. Low beams had to be removed to open up the space.

The architects' basic approach struck a balance between the building's historic qualities and the owners' contemporary tastes by keeping the exterior ordered and traditional and making the interior a contemporary place, open and filled with light. The materials were an important part of integrating the old and the new. The idea was, as Glasgow says, to "put back materials that resembled what had been there before, but in a way that would bring the building up to date." That meant using wood, brick, and lots of glass. The wonderfully patterned doors were replaced with whole fixed walls of windows that were designed in the same paneled configurations as the old doors. So the façade of the building looks much as it always has, respecting the demands of the registry and the ethics of historic preservation. And the windows fill the hole with light, as well as retain the spirit of the garage. Even the windows on the sides of the building, which do not directly imitate the doors, take cues from them—in the kitchen, they cover only the top half of the wall but consist of sectioned panels of glass that make them look like small garage doors.

The new roofing material is an approximation of the old, and matches the grand Tudor roofs of the Belle Meade apartments.

◄ The two-story entrance hall introduces newcomers with light and spaciousness; a skylight brings in natural light from above. Skylights repeat throughout the home, keeping it bright.

► The new windows in the kitchen resemble small garage doors.

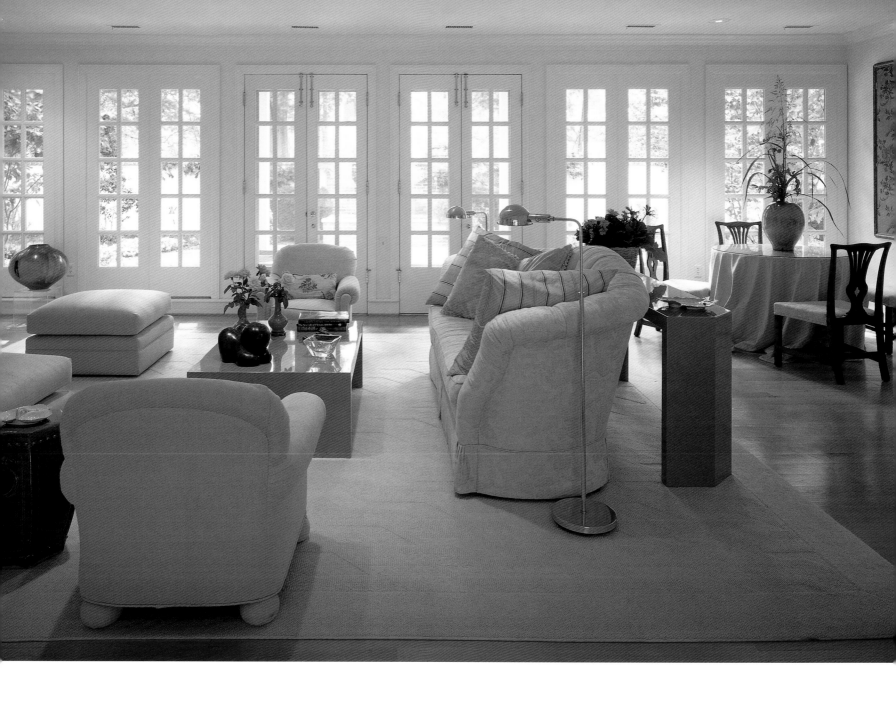

◄ The interior of the home is a triumph of windows, which copy the design of the original garage doors. The clean, evenly paced pattern of the windows is carried through in the interior design, where glass and light colors are used to keep the space uncluttered.

▲ A cream-colored design scheme lightened up the shadows of a formerly shadowy space.

▲ Light was not a major consideration during the original construction of the garage; to compensate almost no draperies were used in the house so that light always comes in everywhere through the new marvelous windows.

➤ The garage before conversion shows classic lines and a building suffering from a good deal of dilapidation.

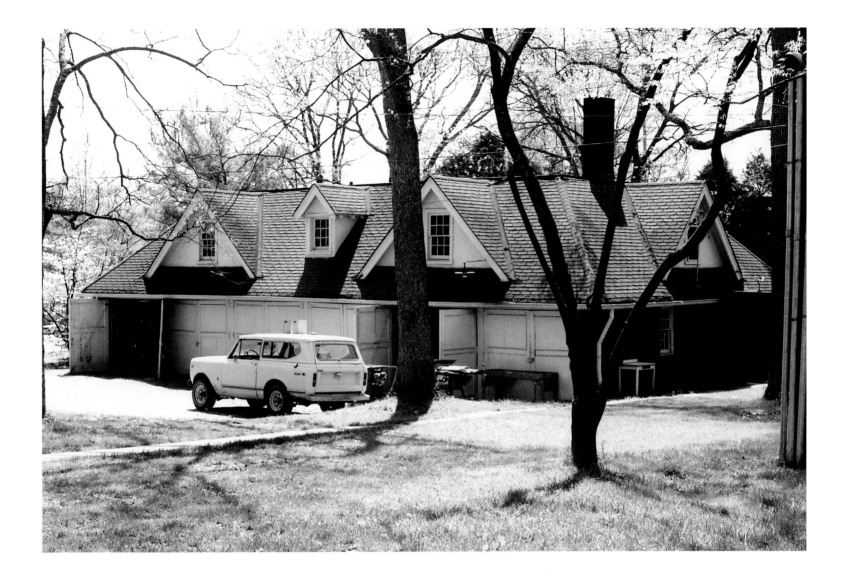

The only major change to the exterior was made in the back, where a second-floor balcony supported by columns opens up the master bedroom and gives a strong regional air to the Southern house. A long line of French doors, rather than garage doors, opens out into the garden; they are also in the same style as the original doors.

Inside there is light, whiteness, and an order and straightforward symmetry that parallels the linear "garage door" windows and falls in line with the overall simple character of the structure. New beechwood floors were laid on

top of the old concrete, and a contemporary stairway of slatted wood, descending from the former servants' quarters to the garage, continues the clean, evenly patterned lines of the space. Light, neutral walls, and pickled flooring further a feeling of spaciousness, and contemporary art and native crafts mix with the antiques to extend the sense of old and new living together.

The Rolls-Royces have lost their home, but the Armisteads have found one, and it is eminently more comfortable and livable than anyone would expect of an old garage.

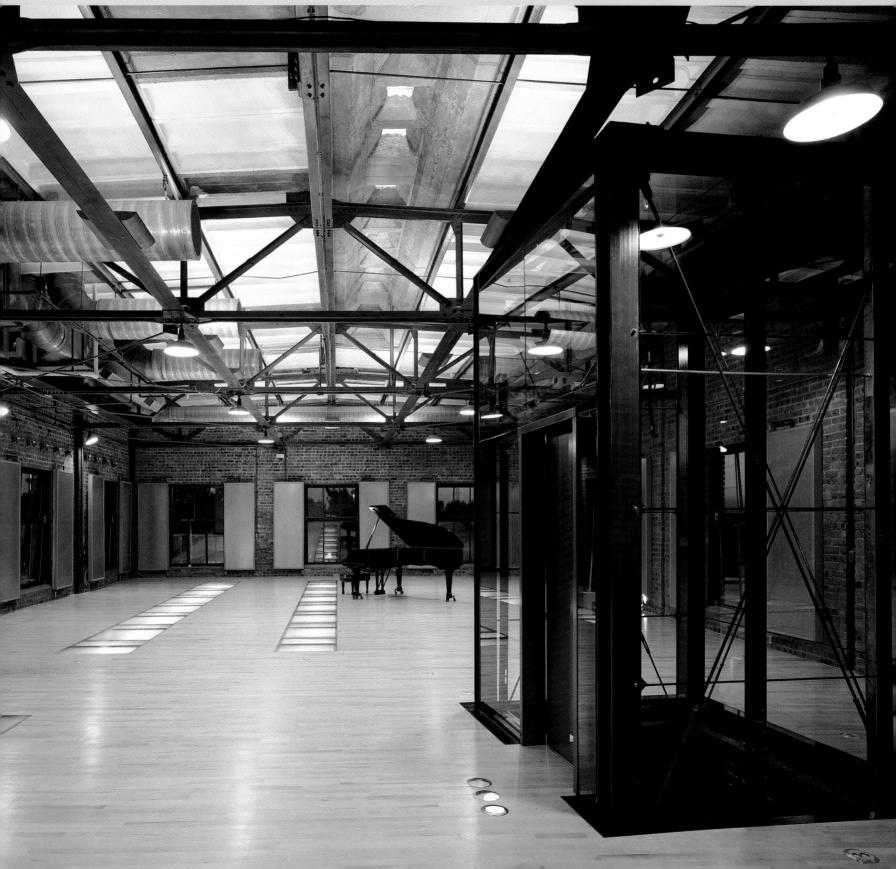

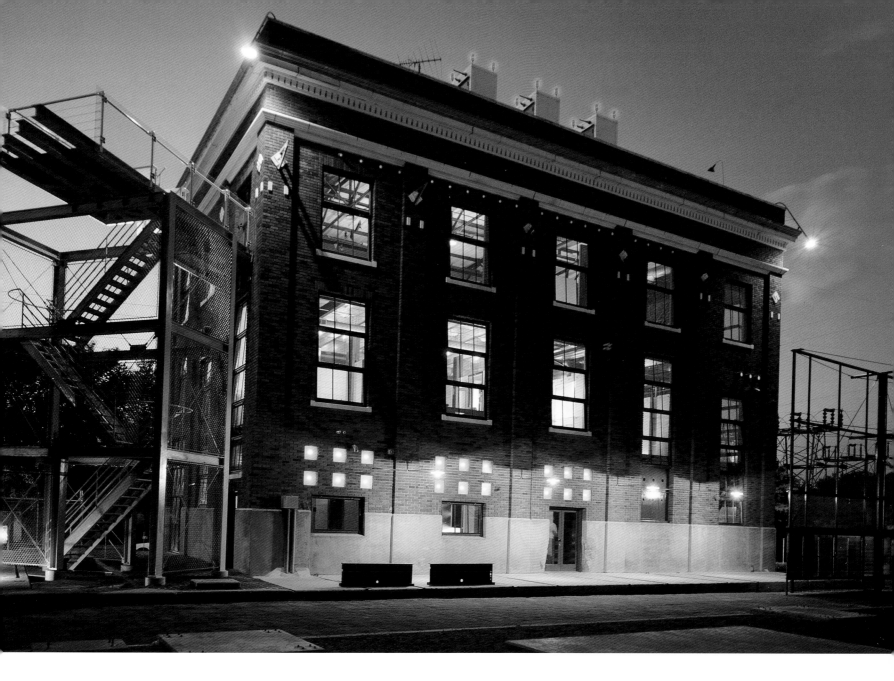

◂ The third-floor ballroom has sources of light from above, where glass was installed in the ceiling in place of old louvers to create industrial skylights, and from below, where glass was used to fill the holes in the floor created when the old conduit boxes were torn out.

▴ Lit up at night, the power station still looks like a dramatic source of electricity.

In a city like Dallas, where the word "old" is used pejoratively, it is somewhat remarkable that a 1920s electrical substation should be turned into a home. Of course, it would be remarkable anywhere, and architect Gary Cunningham's treatment of the conversion for a high-profile couple makes it all the more striking. The project does fit a word used positively in Dallas: "big." Everything about the home is big—the massive brick and limestone-detailed exterior; the building's 6,000 square feet broken into three floors; the twenty-ton crane that

Great Adaptations

was used to lift electrical equipment and now hangs right outside the dining room. And, true to its roots, the house is powerful. Cunningham has charged the place with energy, literally exposing its electricity and inner working. Trenches where wiring runs were left in place and glassed over; electrical lines can be seen passing through here and there; and the connections, colors, and complexity of the electrical process are everywhere in evidence.

The North Dallas Power and Light Substation was one of five identical buildings that took power from the main plant downtown and broke it up into different levels for various uses, whether for homes, businesses, streetcars, or street lights. Because the substation took masses of raw power and refined them for so many uses it was intricate and multi-layered—there were electrical rivers and routes that traveled to different places to produce different types of power. And as Cunningham says, "It was not as simple as just power in and power out; there were steps up, down, and sideways, changing color as they went." His conversion certainly reflects the complexity of the building's original use.

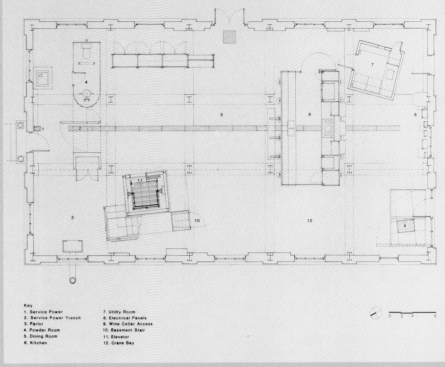

FIRST-FLOOR PLAN

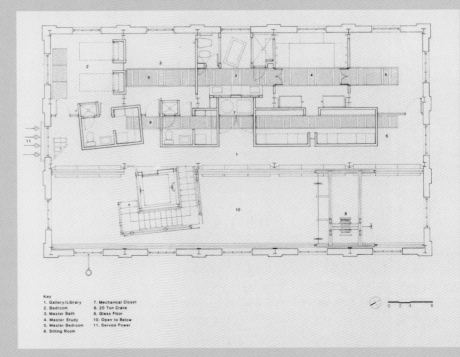

MEZZANINE PLAN

◄ Limestone-aggregate concrete block boxes were newly built as separate pavilions for the more private functions of living, which allowed the shell of the building to remain untouched. The boxes are only eight feet tall so as not to interrupt the flow of space, but are glazed with glass to the thirteen-and-a-half-foot ceiling above for acoustical privacy.

▲ The building before conversion was so full of debris that it took five months to clean it out.

► The 6,000-square-foot space makes for an urban mansion that includes a library, an art gallery, several sitting areas, a butler's pantry, and a wine cellar.

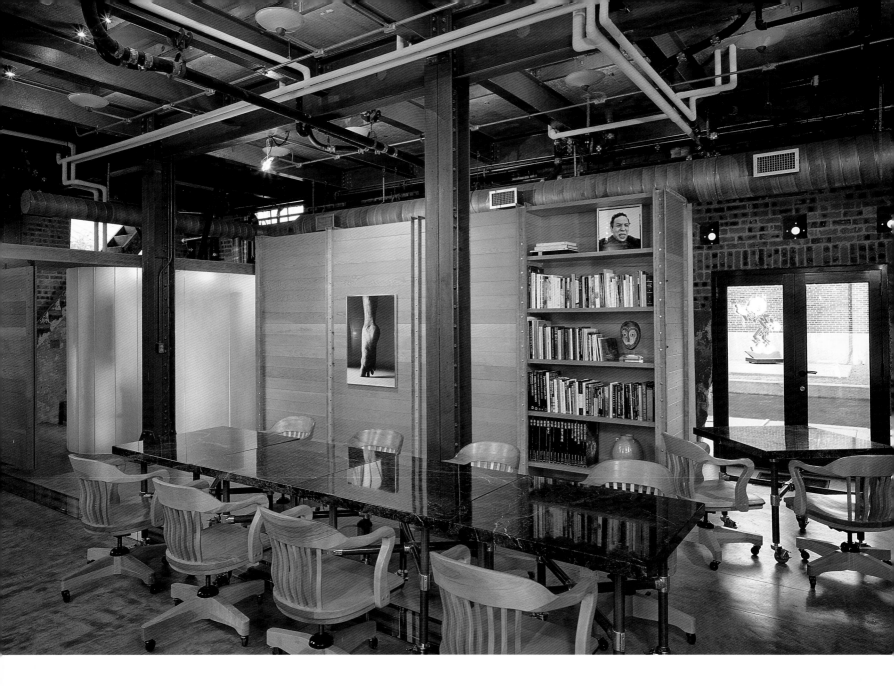

After it "brought progress to Dallas," as an old ad pro-
claimed, the building was taken out of commission in the
1960s. There was a tremendous amount of waste in it when the
conversion began. Cunningham intended to formulate the
design of the building while it was being cleaned up, but what
was uncovered during that process ended up determining the
design. "What began as a clean up," Cunningham says,
"became an archaeological dig." Strange electrical chaseways
and porcelain isolators were discovered beneath layers of pigeon
dung; interior columns of raw steel were sandblasted, revealing

an amazing burnished color; brick walls were cleaned, uncover-
ing a warmth surprising in such an industrial structure. It was
at this point that Cunningham and his clients agreed that every-
thing in the building should be exposed, saved, and shown.

The design became an ongoing process, decided as new
properties of the building were discovered. The exterior was
cleaned, and the structure of the building was left pretty much
alone. Stairs and windows are all original. And the high brick
walls, fence, and huge masonry enclosure that once served to
muffle noise coming from the power station now provide

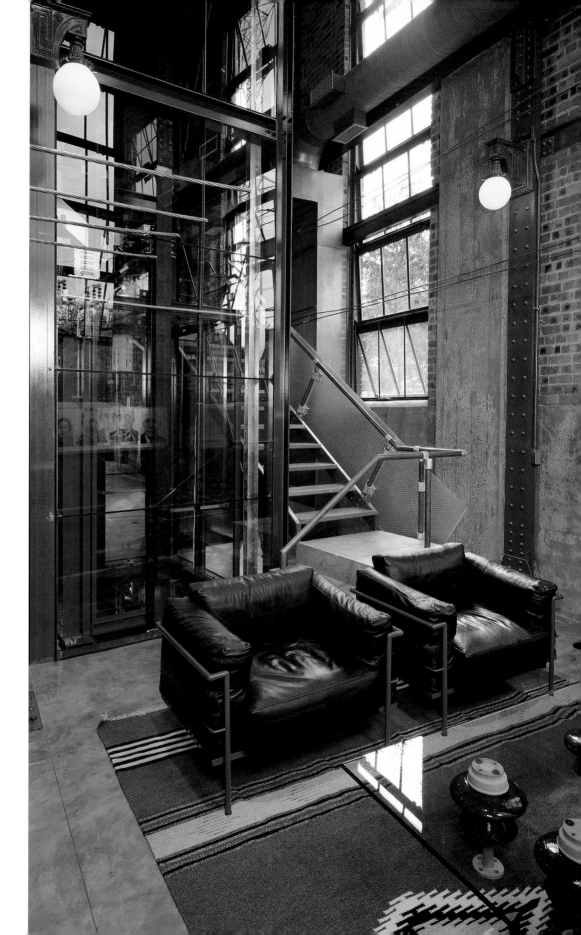

◂ Visible through the dining room back door is a vintage neon sculpture that once advertised the wonder of electricity.

▸ While it is startling to find tables and chairs among the industrial and electrical components of the building, the space is actually divided up like an old-fashioned house, with a parlor in addition to the living room.

security and block sound coming the other way—from the mixed residential and commercial neighborhood in which the building sits. Inside, the building looks like a museum of electricity, starting right at the front door, where a glass awning shows off a series of electrical power lines extending from a power pole. From here, these lines of power, which currently serve the house, can be traced the length of the building through a glass shaft. Ironically, the building had no incoming power because it made its own, so the new power for the house was placed in an existing raceway, which ends in a series of intriguing switches. A glassed-over trough runs under the dining room table, containing copper-clad electrical lines backlit by fiber optics. Overhead are exposed conduits and dozens of lights that have been placed in electrical isolators.

New plumbing and wiring, too, remain exposed. Even the process of conversion has been left on display, layering the original history of the building with the recent history. When a door had to be punched through a wall or workers had to tear into a piece of concrete, the broken bricks and jagged edges were left as they were and glazed with a clear finish. With all this exposed construction, Cunningham was faced with unusual architectural decisions. "Because everything was so visible," he says, "every detail was up for discussion and had to understood—how wire was run, how pipe was put in, how that pipe turned, how a plumber made a joint." He took advantage of these exposed elements to take symbolic risks, crossing the defunct electrical wiring with the new plumbing fixtures. This visual cross of electricity and water provokes much excitement, because it is, as Cunningham says, "dangerous emotionally."

When the maze of concrete and stone conduit boxes was jackhammered and taken out of the first floor, a series of large slots was left in the ceiling—and in the second-story floor. Rather than fill them in, Cunningham installed glass panels, which filter in natural light during the daytime and are lit from below at night, creating a sense of continuous space. Any elements that couldn't be left in place were used elsewhere. The steel beams cut out to make room for the elevator, for example, were made into seats for the roof garden.

New materials are industrial rather that residential. A new topping of concrete was laid on the first floor; doors, storage closets, and stair treads were made from industrial-grade fir; and the stair rails were assembled from steel pipe and connectors. And just to make sure that this idea was taken all the way, Cunningham installed a powder room of sandblasted glass and a masonry coat closet. The elevator was stripped and encased in glass to show off its inside mechanisms; when it reached the third floor it meets a concrete pavilion that once held explosive batteries and now contains a bathroom.

In direct contrast to the industrial design, the layout of the house was based on Texas mansions of the 1920s. So there is a parlor off the stairs on the first floor, and the dining room, kitchen, and library are just beyond. The second floor holds three bedrooms, leaving the third for a grand ballroom.

For Cunningham, both the joy and the challenge of the project derive from its complexity, its layering of old and new, the fact that "there was a history there and a lot of ghosts." The building, he ways, "isn't glorious like a church, and it isn't a great historical building, but it had the very important purpose of bringing electricity to a city." That purpose—and the spirit, integrity, and logic of the building—is never forgotten in this unique conversion.

> In addition to a view of Dallas, the roof offers a bowling lawn and sculpture garden with works made from pieces found in the building.

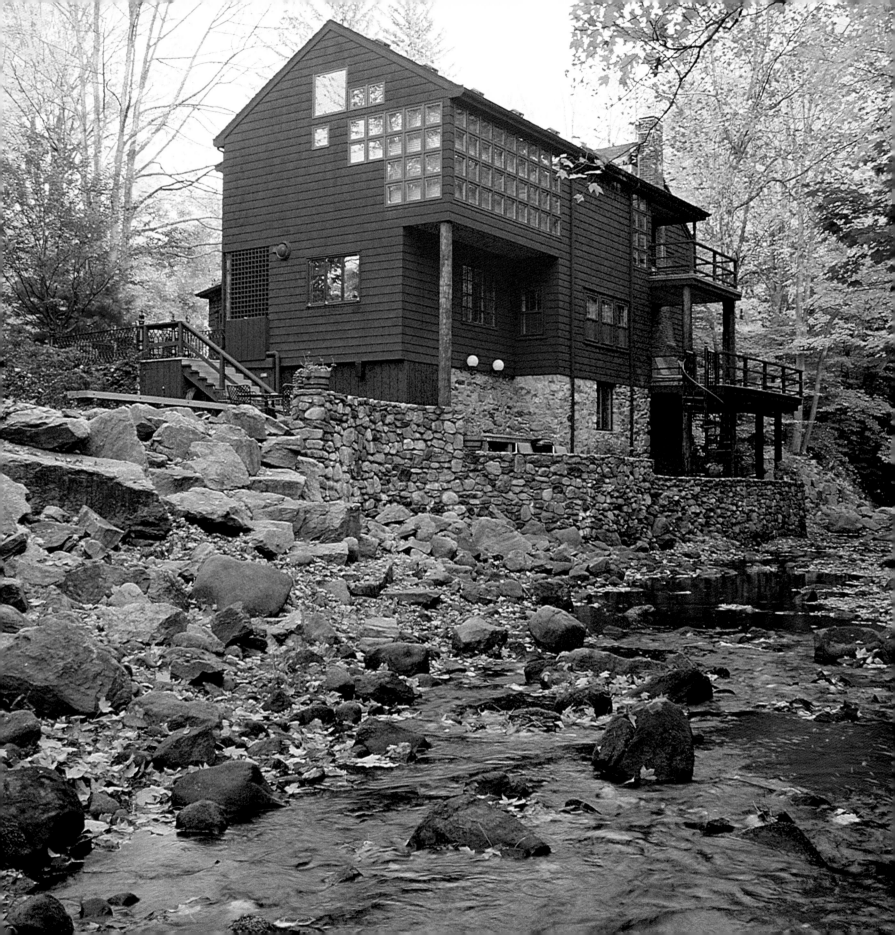

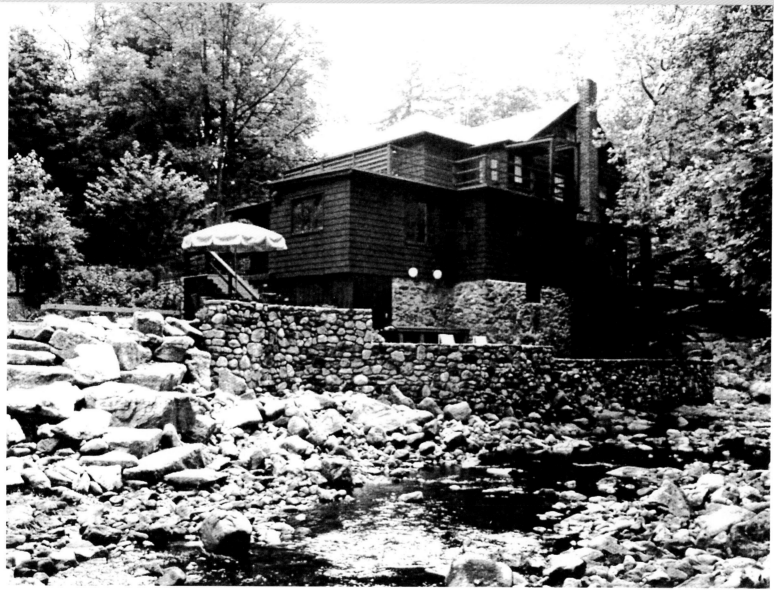

⌃ The old sawmill was later a cotton-batting mill, a spindle mill, a doorknob factory, a tobacco warehouse, and a landscape designer's studio.

⟨ For its newest use as a home, the building has entire walls of fifty small windows to make up one vista of the river below, and the disparate rooms were made into a more unified whole.

Most residents of converted buildings live with a history, but Evan Hunter and Mary Vann live with many. Their home on the Silvermine River in Connecticut was originally a sawmill built in the 1770s, but it has since been a cotton-batting mill, a doorknob factory, a spindle mill, a landscape artist's studio, and a home to others, most recently an artist and his wife. The Hunters have continued what seems to have become a tradition of creativity in the house. Evan Hunter is the famed writer of mystery novels (and, under the pseudonym Ed McBain, police stories), and Mary Vann is a novelist. The house is a layering of many lives, with charming and distinct contributions from them and from the building's various uses.

What is most striking about the home is the spirit of the mill retained throughout in original elements: the curios, low-ceilinged rooms; the exposed beams of ancient wood (some of which bear carved Roman numerals, so that the builders would place them correctly); and the old shaft and turbine, which can just be made out by peering into the damp darkness behind a door underneath the building. The old floors slant charmingly from age, so furniture is propped up on one side with shims; as Mary Vann explains, "You just have to do things like that in this house."

The building was first converted into a studio and home by landscape painter Frank Townsend Hutchens in 1912. A 1914 issue of *Suburban Life Magazine*, in which the story of that early conversion is told, says that Hutchens found the place "not only a haven of refuge but a constant inspiration." It was probably the river flowing by and the surrounding trees of which he was speaking, the fact that the old mill sits practically *in* the water and almost becomes a part of the woods.

The wood floors Hutchens had installed throughout the main part of the house are still there, as are the other ele-ments that made it homelike—intimate rooms, a fireplace, a nineteenth-century door frame that he brought down from Maine. But his most evocative contributions are the cast-iron balconies. Neither mill-like nor New England in character, they come as a delightful surprise every time one looks at the building. Hutchens brought the balconies from New Orleans but did not leave an explanation of the legend on them that says simply, "W. W. Storey, 1861."

There are signs of other lives throughout. When part of the siding was taken off during the Hunters' own renovation, the old red-painted wood that was the original mill siding was discovered underneath with names and dates carved in it. A chiseled stone reading "Mabel's Rock Garden, 1932" was found near the garage where Mabel, whoever she was, must have tended her garden, as was a brass bird that was probably molded in the kiln down the river by an artist who worked at the mill (today only the lines of the kiln's foundation are left). And the rustic wood-lined kitchen, a study in craftsmanship, was left by the most recent artist resident and his wife, as were his wonderful drawings of the mill house. There was even history to be found in the ground; when the old foundation was dug up to make alterations, broken shards of pottery and an old pipe without a stem from the building's mill days were uncovered.

Now the Hunters have added their contributions to the building—theirs and Richard Bergmann's, the architect who altered the house for them and enlarged it by 30 percent. The couple's main consideration was how to close off the house from the road on one side and open it up to the river on the other. Because it was built as a mill, views were not taken into consideration: From nowhere within could one see the river flowing just outside. In addition, the house, on just 1.3 acres

> The post-and-beam structure of the mill is evi-dent in the living room, where original beams and columns dominate. A new expanse of glass was installed here for a first-floor view of the river.

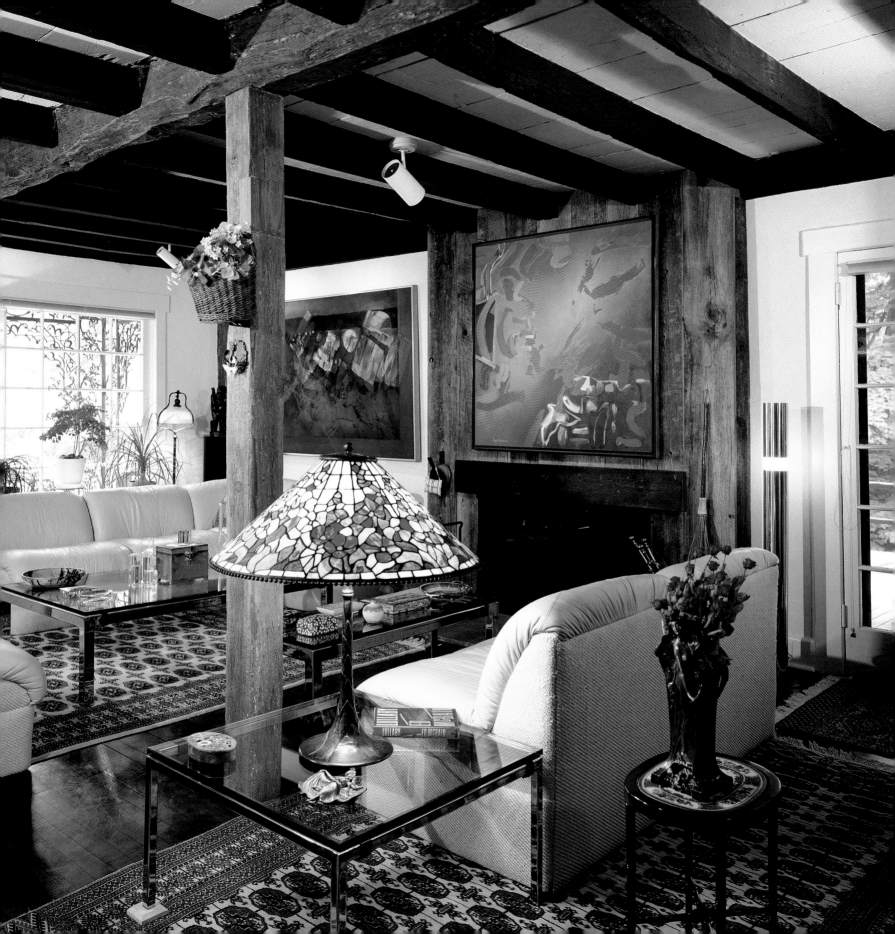

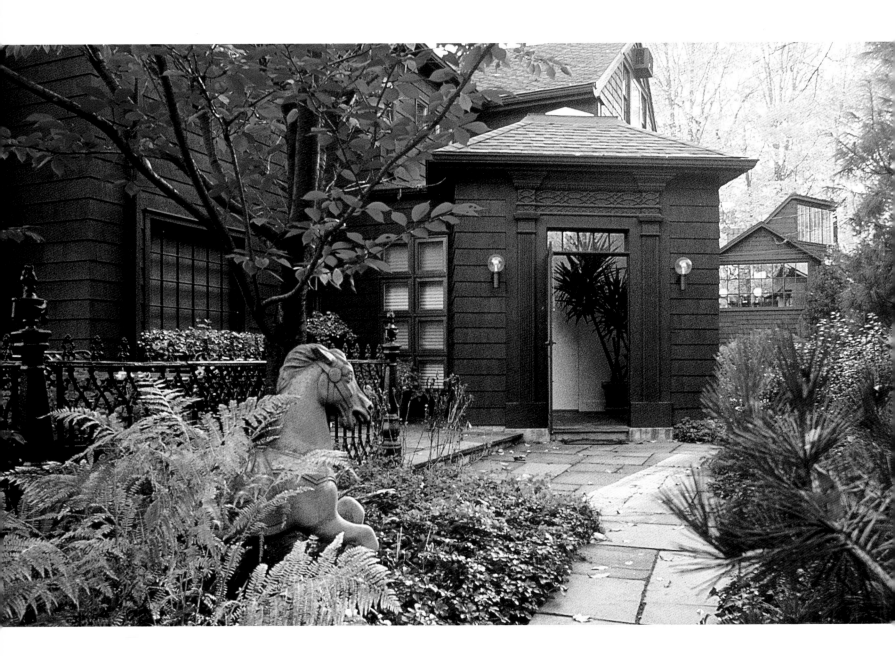

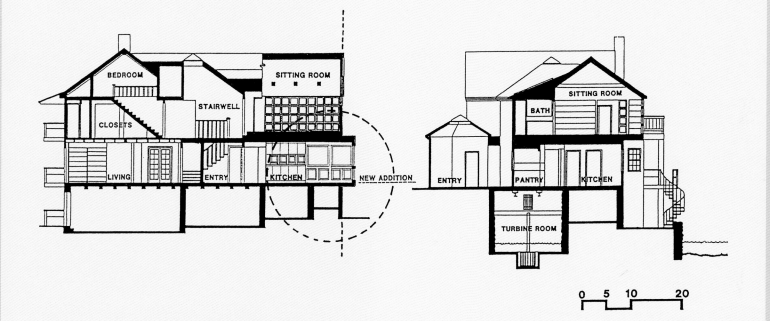

RIVER-SIDE SECTION STREET-SIDE SECTION

◄ The little windows are repeated in the new
 entryway where, with the help of a skylight,
 they bring light into what was previously a
 dark building.

▲ Views of the house from the river and street
 sides, with the placement of the original tur-
 bine room underneath. The house made its
 own electricity until 1910.

of land, sits very close to the road and there is nothing to buffer the noise and provide privacy. Finally, after the building's many incarnations, no one really knew where the front door had been—and few guests could find the present one, tucked awkwardly on the side of the house.

To solve the problems—and add some much-needed room—Bergmann built three additions. The first is an entryway, complete with the little windows that he used throughout to recall the mill's original factory-like windows. Bergmann extended it from the old entryway, and the door was moved so that it was more accessible. Onto the living room he added a den, which is faced on the outside with a six-foot-high stone wall. The stone is in keeping with the spirit of the building and makes the road seem far away. Above the wall is a thirty-foot skylight that generously lets light into the dark building.

The Hunters' major addition was the sitting room upstairs that overlooks the river through dozens of two-by-two-foot windows. Once an outdoor balcony, the sitting room now provides fifty little views of the waterfall that add up to a dramatic composite. Bergmann used smaller windows instead of a big expanse of glass because, he says, "If you stand next to floor-to-ceiling glass with water rushing by you, you can feel unprotected. Besides, there is the notion of framing smaller views rather than open panoramas."

To support the addition from below, Bergmann used telephone poles, rough-hewn enough to look natural with the mill. Other changes included the creation of a master bedroom from two small rooms that overlook the river, staining the cedar-shingled exterior dark brown in the spirit of mill colors, and generally updating the building from a state of disrepair.

Although the entrance side of the house faces the road so closely that it makes one feel as though the world is going by,

remarkably there is another world just a few yards through the house where the building nearly meets the water. Here one can hear the constant rush of the river and feel the power that drove the mill, but also the tranquility of the flowing water. As Mary Vann says, "We are close to everything in one way, but I can really get kind of lost here in the woods."

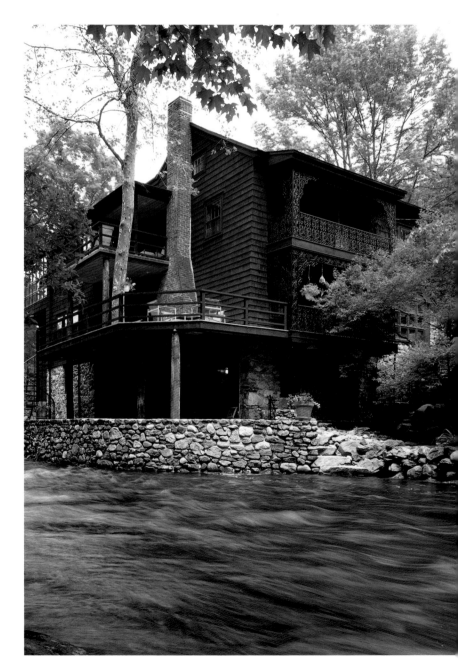

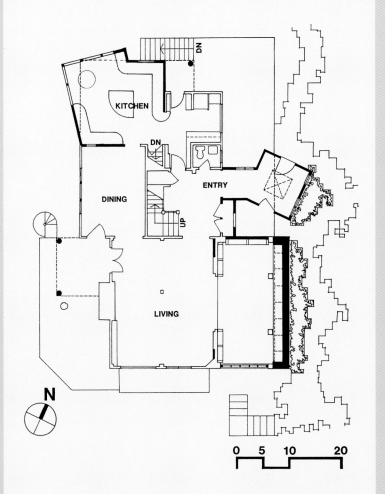

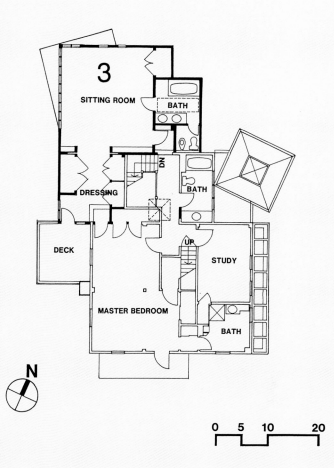

3

FIRST-FLOOR PLAN

SECOND-FLOOR PLAN

◄ After all these years, the site and the building have become interwoven; a large sycamore tree grows right through the second-story deck.

▲ The most important and lived-in rooms face the river for communion with it; the more private rooms and entryways face the back of the house.

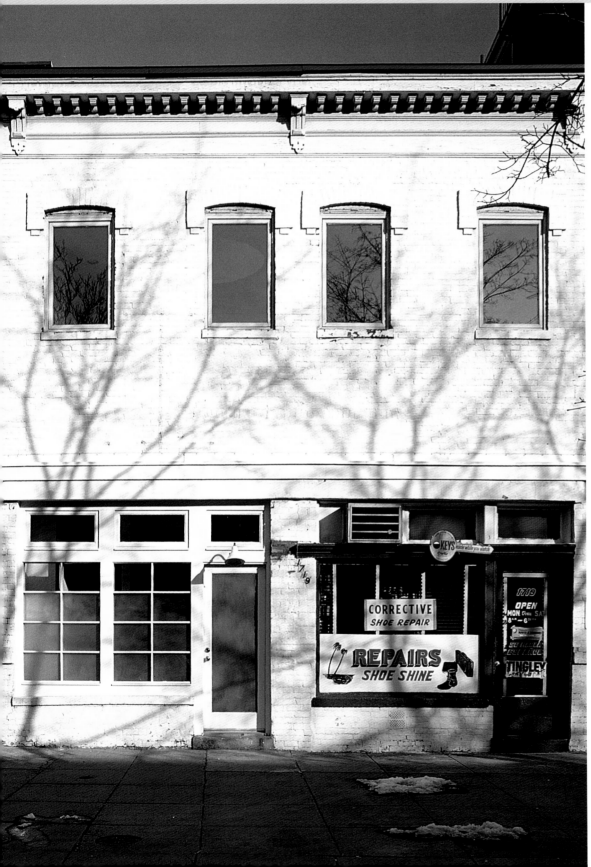

◄ The converted commercial building near Dupont Circle in Washington, D.C. offers an unusual arrangement of residential space.

➤ The space is vertical rather than horizontal, so the rooms are taller than they are wide, as can be seen in the entry hall. The ceilings on each floor are twelve feet high.

Architect Mark McInturff's conversion of a commercial building in Washington, D.C., is a study in light and drama. When the shop on the ground floor of the building—most recently selling futons—closed, the couple who inhabited the upper floor asked McInturff to help them expand downward. He responded with striking sculptural elements such as a curved staircase, new light sources like the skylight that tops the building—and a regard for the straightforward nature of the original structure.

What McInturff had to work with was a plain turn-of-the-century storefront, typical of many from the era and recalling the small-town quality that once characterized much of Washington. He wanted to honor that lack of pretension by keeping the inside elemental—clean but not overly clever, interesting but informal. The structure was small and slightly eccentric—at least for a home, since most of the space is vertical—and it needed light and order to make it livable. So, listening to the owners' request for a "loft-like" home,

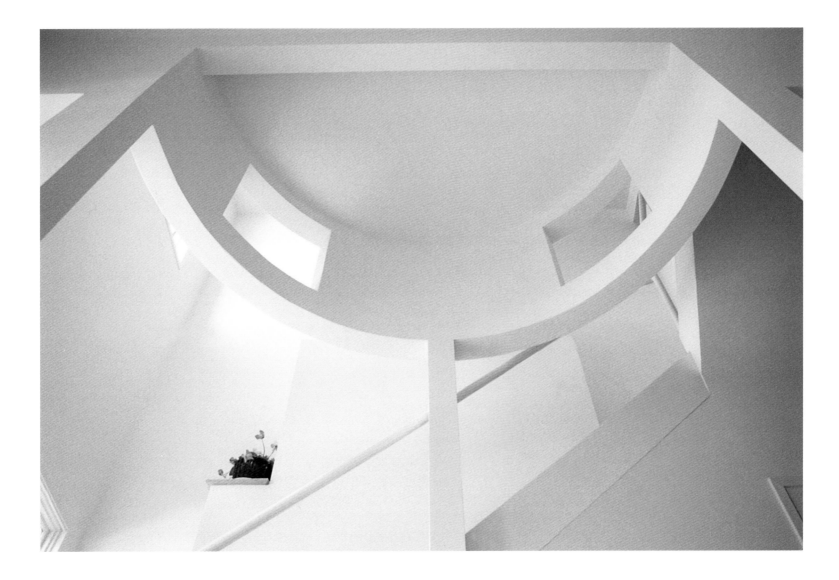

‹ The important measure of this space is in cubic, rather than square, feet. More than 3,200 cubic feet are contained in the building.

⌃ Paneless windows occur throughout the house to create views from within the home and help counter the perception of vertical space in the structure.

McInturff kept to plain wood floors and white walls, open spaces and natural light to fill them. The basic design has what the architect refers to as a "Shaker simplicity," but his solutions to architectural problems, achieved with the introduction of new elements, add interest and definition to the space.

The shell of the building was about all that could be retained; most of the interior elements, including doors, windows, nearly all the flooring, and the plumbing and the electricity, are new. McInturff's stairway connecting the first and second floors became the central—and most exciting—element of the home. It winds up, opening into an impressive vertical space and a skylight above. A tower-like balcony at the top of the stairs provides a lookout to the interior landscape.

Here on the second story, which holds the dining room, the light comes in from everywhere—from the skylight that sits right above the tower and echoes its circular shape, from the new windows whose patterns echo those of the shop windows below. It floods down to the first floor, opening up the small space.

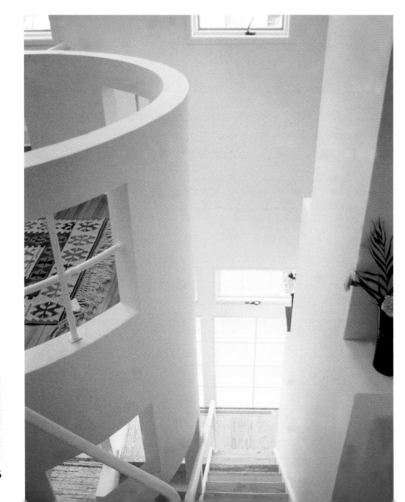

In the entry hall there is another carryover from the original building—high ceilings that recall the stores of yesterday that stretched up with rows of merchandise. Glass in neat patterns by the door of the entry hall brings to mind shop windows, but here they have been sandblasted for privacy.

It is the paneless interior windows, however, that really affect the perception of space. They start in the entry hall and recur throughout the house: in the tower at the top of the stair, stretching down the line of the hallway and into the living room on the first floor. The windows, McInturff says, "keep the eye guessing," making the small space seem larger.

The mind is kept guessing, too. On the one hand, the windows suggest separate rooms by visually enclosing discrete areas of space. But on the other, they are open and look out onto the other "rooms," and there is the reality of the flow of these spaces with no walls between them—the entry hall extends upward to the dining room, for instance, but it also extends outward to the living room on the same story. So there is separation and continuity at the same time, allowing the *idea* of many rooms but the reality of one big open one, and expanding the home in a way that few other solutions would do.

The series of interior windows that extend from the entryway into the living room are skewered together with a long continuous light fixture—"like a shish kebab," McInturff says—to provide a rigorous order for the small space and also to unify it, again, even as the windows themselves divide it up.

The project was completed for only $50,000, but the decision to stick to basics was philosophical as well as budgetary. In a conversion whose keynote was simplicity, McInturff found elements that created interest while remaining simple: light, layering, and a sense of drama that has won many awards for the little house next to the shoe shop.

> In this home, an "upside down" plan was carried out, which places the more public areas like the living and dining rooms on the upper floor.

< The top floor captures light and views for living and dining that are not available on the lower story.

Great Adaptations

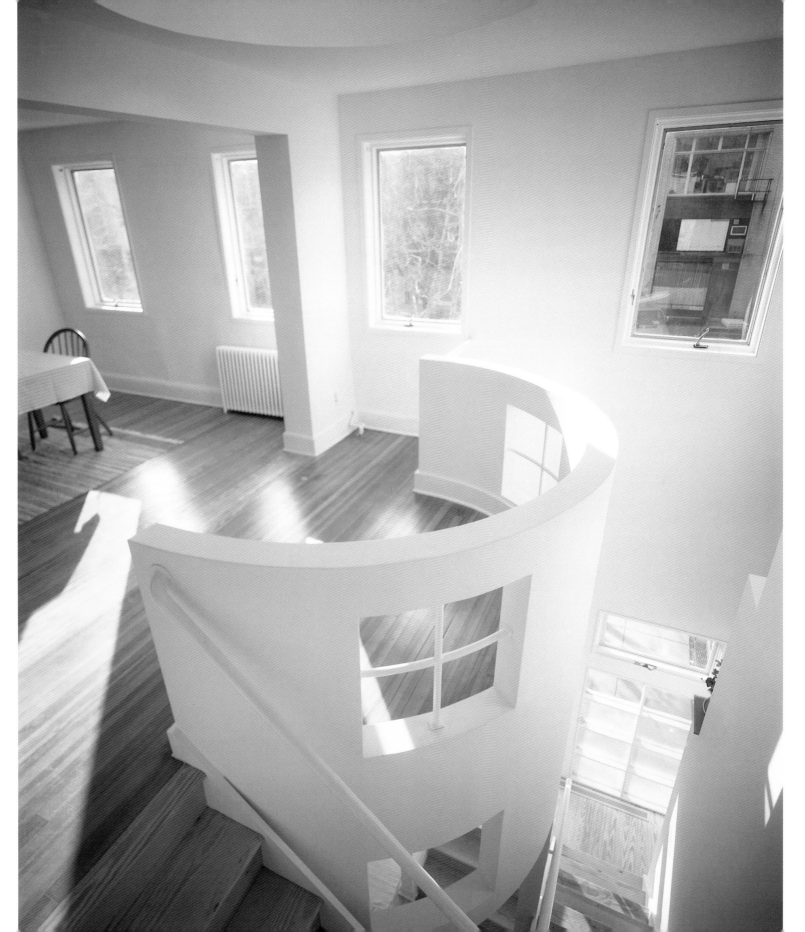

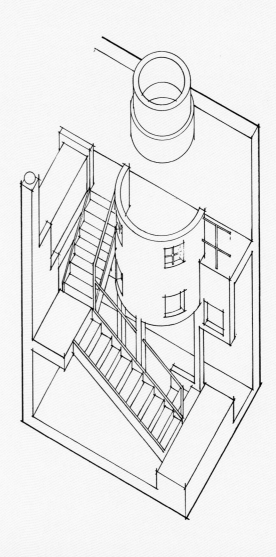

ENTRYWAY DRAWING

‹ The circular form of the balcony shoots all
the way through the building, from the entry-
way shown here, where its curve begins
overhead, to the second floor, where it forms
a lookout point.

▲ The prominence of the staircase in the
design of the building is evident in the draw-
ing, which depicts the rounded banister and
the skylight that echoes it.

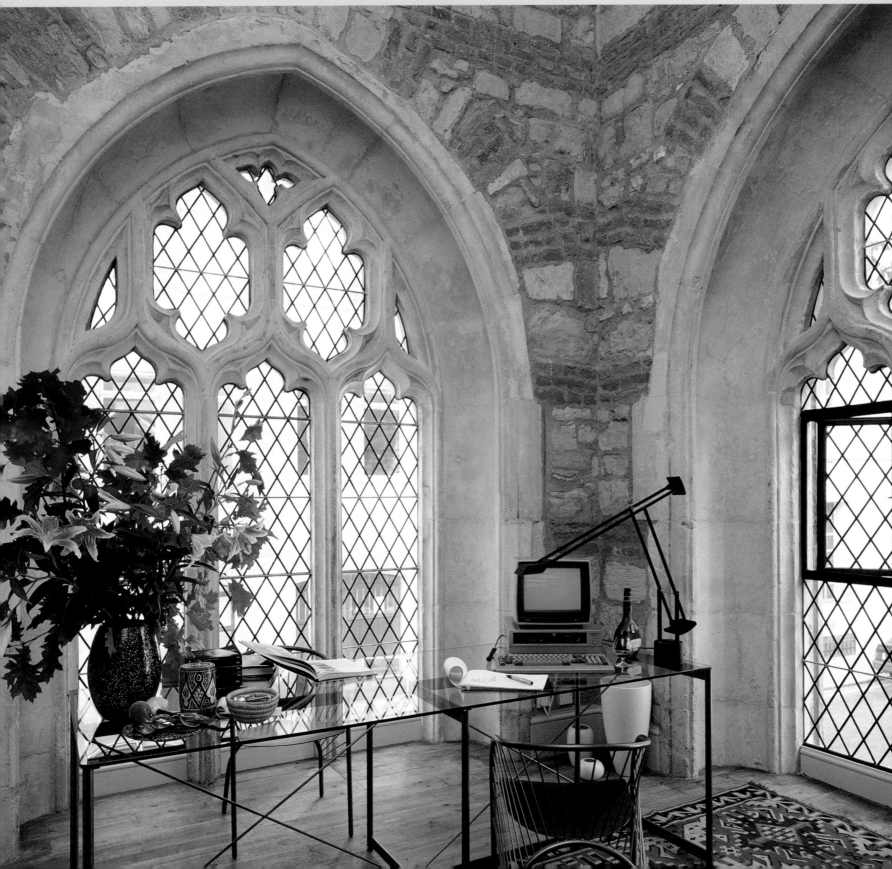

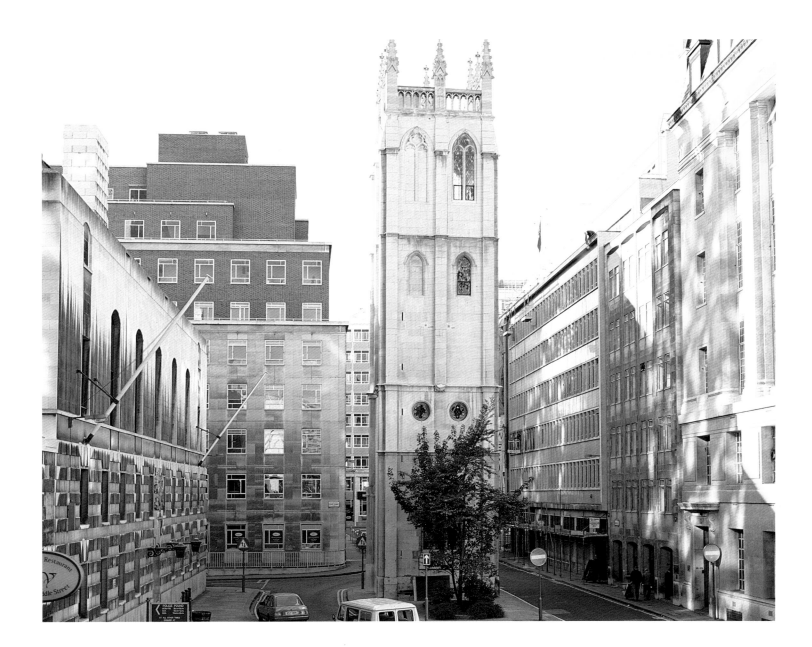

◄ Not many offices have floor-to-ceiling windows, much less leaded-glass church windows designed by Sir Christopher Wren.

▲ The tower of St. Alban sits in the center of the street as well as in the center of London. The tower was all that was left of the church after a raid in World War II.

When the residents of a converted bell tower in London refer to their home as being in the center of the city, they are speaking of a place that literally sits in the middle of the street running through the oldest settled area in London. Looking like a drawing taken from an architectural textbook and placed on the street, the tower sits all alone yet in the middle of everything. It splits the street so that traffic flows on all sides at its base, and the buildings that make up the financial district of London surround it.

But it is not only the tower's location that is central to London—its history is, too. It is built on the site of the first Roman garrison fort, which later became the location for the Saxon royal palace. In the eighth century, the King dedicated a chapel there to St. Alban, the first English martyr. When that building began to fall apart, it was replaced by another that was later destroyed in the Great Fire of London in 1666. In 1682 Sir Christopher Wren, although he was in the throes of reconstructing the St. Paul's

▲ A sense of the medieval is brought to the dining room by a historic tapestry on the stone wall.

➤ The view from the terrace is framed by spires, gargoyles, and stone cutouts in the railings. Up here, the old financial district of London can be seen, as well as the most historic parts of the city.

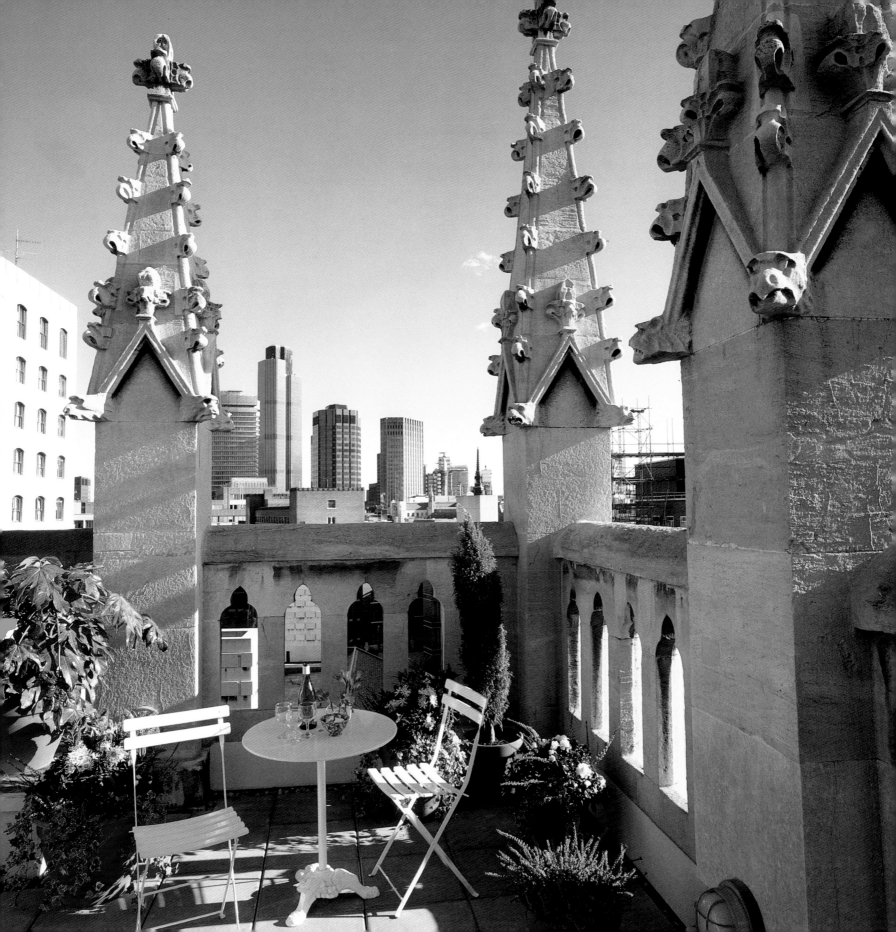

Cathedral, agreed to design a new church and bell tower for the site.

The Gothic architecture of the church and tower was a true departure for Wren, but he used it to honor the remarkable past of the site. The tower stands seventy-two feet tall and contains 976 square feet within. Its walls are five feet thick at the base and diminish as the tower rises.

The church was tragically leveled during a night raid in the Second World War, and the bell tower is all that remained. Today, the Tower of St. Alban stands as a Gothic monument to a long and lively history.

In converting the building recently for an American family, Frederick Smith Burns, the architect, had to work with a magnificent-looking piece of architecture of little functional value. When he took it on, the tower was falling into dereliction. And its particular structure did not make its conversion into a residence any easier. As home only to a bell, the tower, of course, did not have any need for—nor did it contain—a roof, any floors, or evenly placed windows.

Construction was a challenge. The extreme narrowness of the tower meant that its six floors had to be inserted from above. "We put on a roof and worked downwards," says Burns matter-of-factly. As if the structure of the building were not enough to work around, its history asserted itself in the middle of the project, temporarily halting work: Human bones were found under the ground floor, and the Museum of London carried out an archeological dig before work was resumed.

There is one room to each floor of the tower. Each is about fourteen feet square, but because the walls get thinner as the tower gets higher, every successive floor is slightly larger than the one below it. The building has a shoulder-width stone staircase spiraling up to connect the floors. It is so narrow that furnishings and large objects had to be hoisted up through a series of trap doors in the ceiling and floor of each room.

The inside is designed with echoes of church interiors and the richness of medieval colors. When guests enter the ground floor, there is traditional tiling to greet them, painted in an ancient process and patterned in geometric shapes that have been used by centuries of church restorers. The wallpaper here is in a Gothic pattern, and the stippled blue ceiling is reminiscent of medieval church vaults. The first floor is an office, wonderfully dramatic with its floor-to-ceiling Gothic windows. The second floor is a dining room, and the kitchen is on the third floor. There are no windows at all on this floor, so the space has been used well for storage, since cabinets would interfere with the glory of the Gothic glass found throughout the rest of the house. The bedroom on the fourth floor is an interesting effect in blue. It was created by applying paint in ten different glazes, then adding two layers of wax crayon, which give a hint of red and lend a three-dimensional quality to the space, making it seem bigger. In the living room on the fifth floor, light streams in through the grand yet delicate windows that frame the room. At the very top is a roof terrace that looks out on London. It is beautifully sheltered by the stone lace of the finials that form the high parapet.

The tower is not just a remarkable home, it is a reminder of an incredible history and of the brilliance of Sir Christopher Wren. To view it from the street is to understand the inscription on his tomb in St. Paul's, written by his son: "If you seek his monument, look around."

> The bedroom on the fourth floor is as formal as the rest of the décor, but the walls were covered in blue paint and crayon in an unconventional treatment.

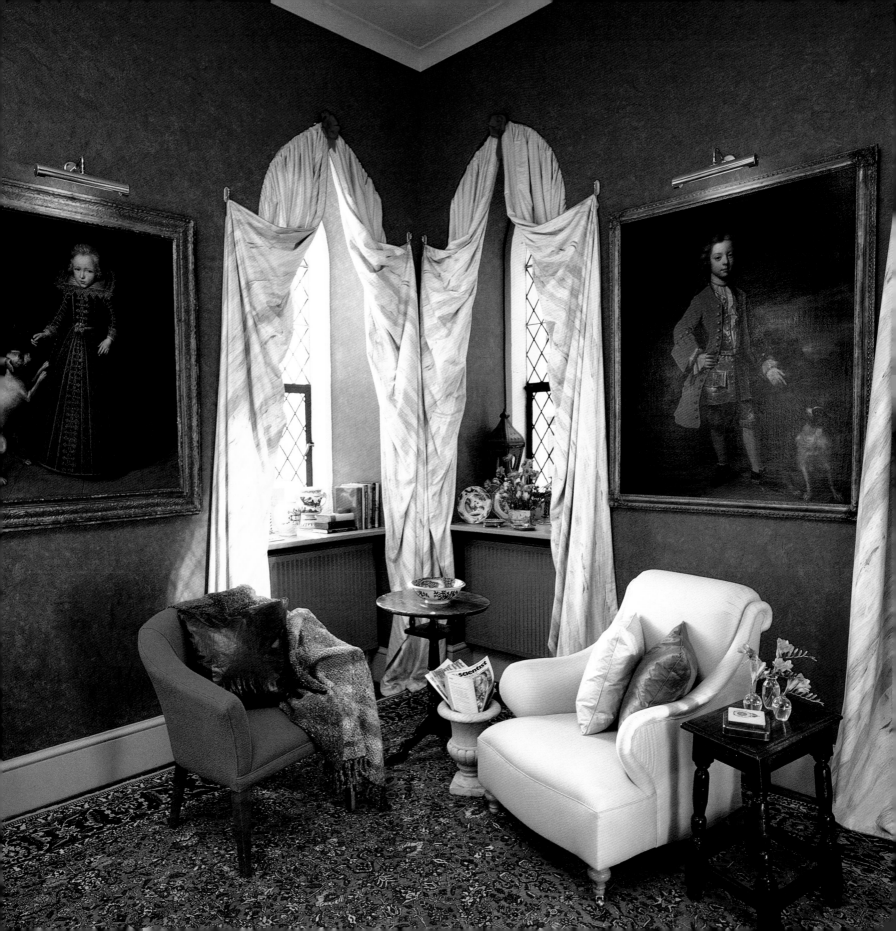

▲ The distinctive windows are on all sides of the tower; because of its site, there are views from all four sides of the structure.

➤ Draperies are pulled aside in the fifth-floor living room so that the windows and the orange walls, which are a daring departure from the design of most living areas, could remain the focus of the room.

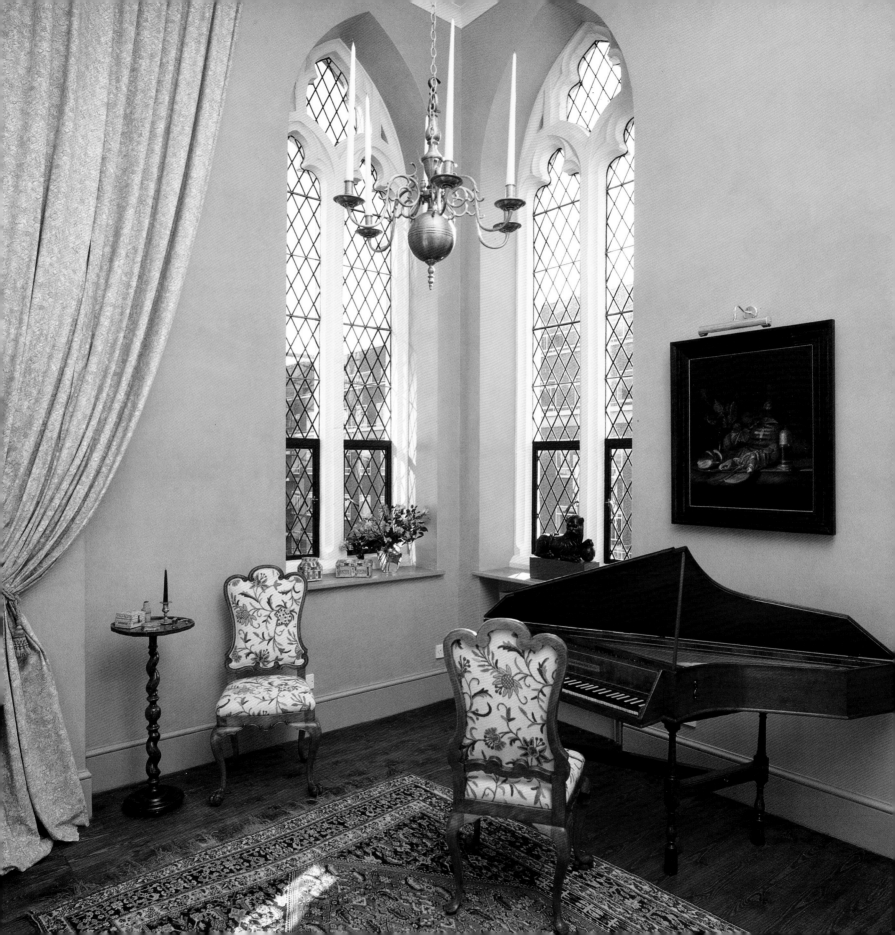

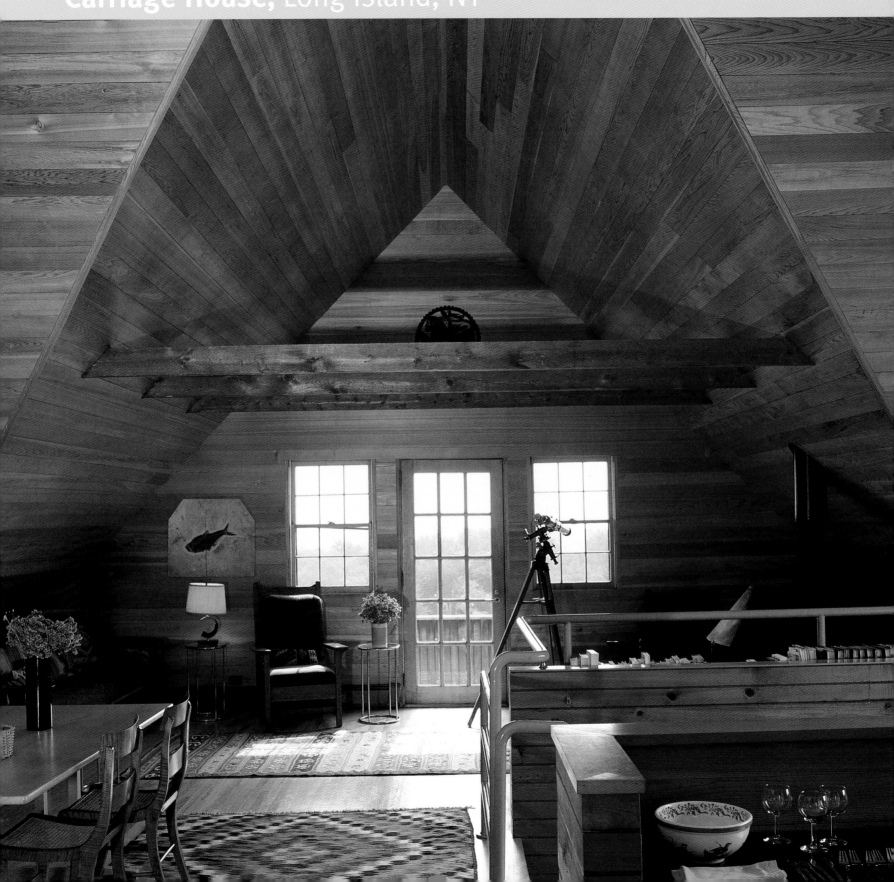

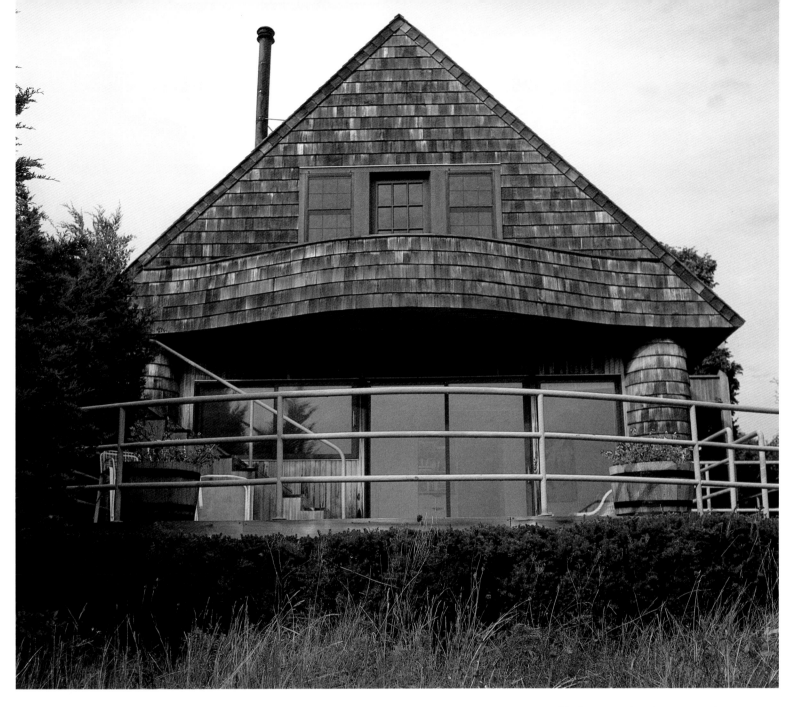

▲ The former carriage house on eastern Long Island features a series of balconies and decks that allow the outdoors to be experienced as much as the indoors. This view is from the back of the building.

◄ Exposed rafters and expanses of wood, in turn, bring the outside into the house.

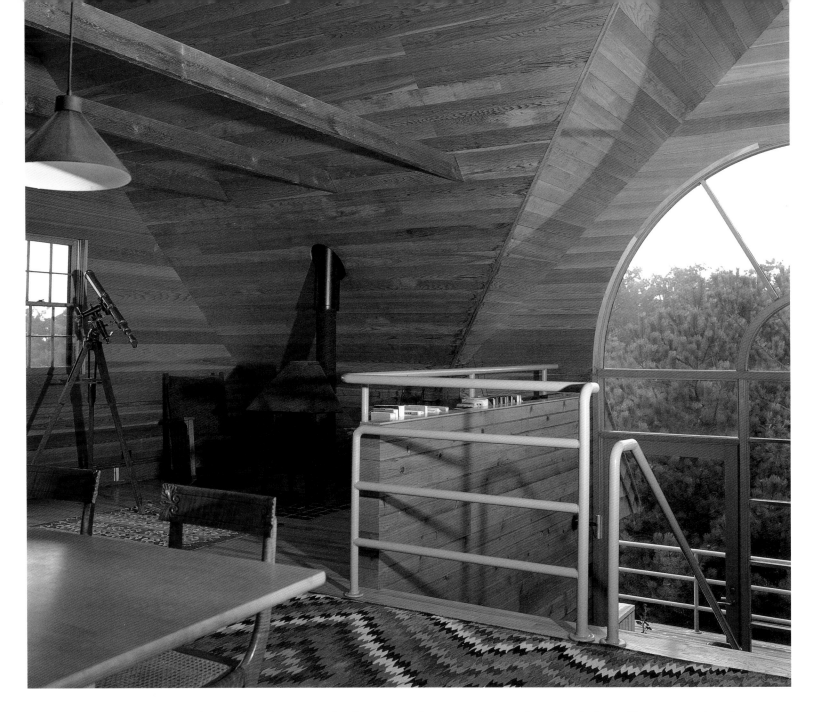

Susana Torre's conversion of a carriage house on the Long Island shore is a portrait in contrasts. In an eighty-year-old building that Torre describes as "at once typical and atypical," she has brought together old and new; smooth and rough textures; large, open elements and small intimate ones.

The structure was typically utilitarian—built, above all, for function—as its sensible gable roof and plain square shape testify. But it is not typical in the proportions and forms of the interior. It's obvious, Torre says, that "someone had given a great deal of thought to it." Steeply pitched roofs create wonderful slants and angles, and there are surprising corners and nooks as a result.

The carriage house was designed in 1910 by New York architect Grosvenor Atterbury; the present owners recently moved it to the seashore from an estate a quarter-mile away, where it was threatened by a planned housing development.

Great Adaptations

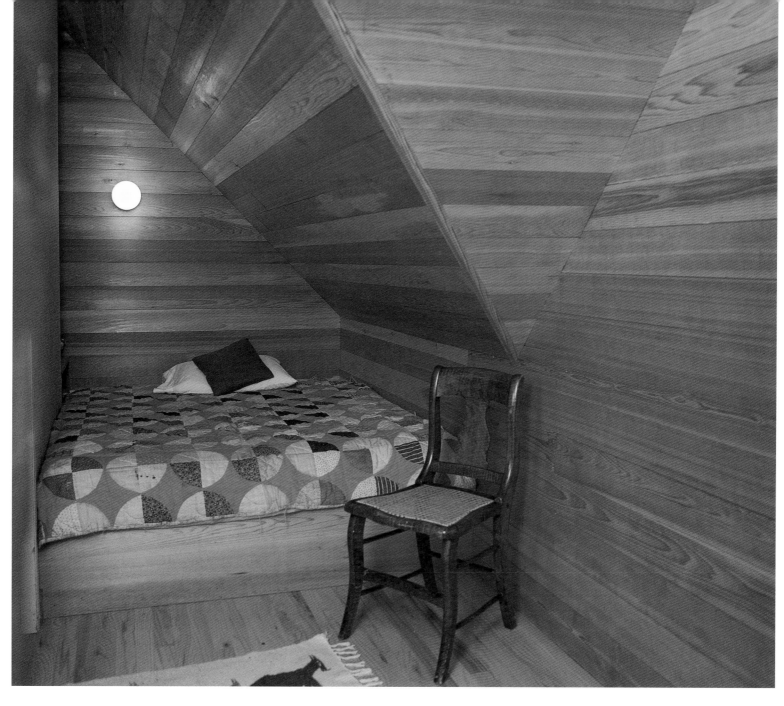

◄ The dunes and the sea are visible from the windows and upper balconies of the second floor.

▲ The meeting of the building's four dormers creates the distinctive angles and slants of the second-floor ceiling. This sleeping space is tucked into one of the nooks created by those dramatic slants, making guests feel safe and protected.

Most of the dilapidated interior had to be gutted to convert the structure. Torre strove to keep her additions in character with the building's Shingle Style architecture, which flourished on the Eastern seaboard when the carriage house was built, and is perfect for the building's new sandy setting. Traditional cedar was used for the shingled siding and the latticed archway at the entrance, and many of the other new elements relate to the style as well. The huge arched window at the back of the house is a contemporary interpretation of a Shingle Style form, and the new "eyebrow" balcony on the south side of the structure is also a typical motif, echoed here by a similarly shaped balcony below it. Inside, the pivotal design of the stairway—the sharp turn from one flight of stairs to another—recalls the turning interior layouts of the old Shingle Style homes.

But Torre's use of Shingle Style elements is where the similarities between old and new end. Boldly contemporary elements are layered with old ones in a play of contrasts. First, there is the shift in scale between the expansive arched window at the back of the building and the small, intimate spaces inside created by the sloping of the original walls and ceilings. This new, westward-facing "sunset window" works surprisingly well in the small building; rather than overwhelming it, the window opens it up and adds a sense of spaciousness.

Then there is the striking difference between the dramatic lines of the second story ceiling and the playful elements that Torre has added beneath it. Once the hayloft, the second floor now holds the kitchen, living and dining areas, and a few guest beds, in an "upside-down" plan that takes advantage of fine views of the ocean. The original ceiling soars and then slants in powerful angles throughout this space. But below it are new elements reminiscent of a child's tree house. The white "little house" that holds the kitchen was fit in between the angles of the ceiling, and beds were tucked into nooks on either side of it that remind one of secret hiding places.

The "little house" is a contrast in itself. With it, Torre is playing with the idea of what is interior and what is exterior, keeping the distinction between the two ambiguous by making the little structure look like an outside element—and so bringing the outside in. In fact, the entire effect of this area is of the outdoors; the grand slope of the ceiling and the exposed rafters is like the overhang of great trees, and the original brick chimney reminds Torre of a tree trunk growing out through the roof.

Another source of contrast is Torre's mix of textures. The beaded pine boards that had covered the stable ceilings now line the walls of the entry and the stair hall. These, and the areas of original exposed brick and plank floors, are intriguingly rough next to the sleek, contemporary finish of the stair rail, the smooth cedar paneling of the upstairs ceiling, and the modern white of the little house's exterior.

The theme of contrasts is distilled on the outside of the house: On one side of the building are the old stable windows and the outlines of the big doors where the carriages entered; on the others are new, undulating balconies and stretching windows that open up the building to contemporary sensibilities as well as to the outdoors. In pointing up the differences between the new and the old, Torre is inviting those who enter the building to listen to the dialogue between them—to comprehend the reality of the present while listening to the secrets of the past. They are secrets well worth being told.

> The original windows of the carriage house
 are small, so architect Susana Torre
 designed a dramatic "sunset window" at the
 western-facing front of the house.

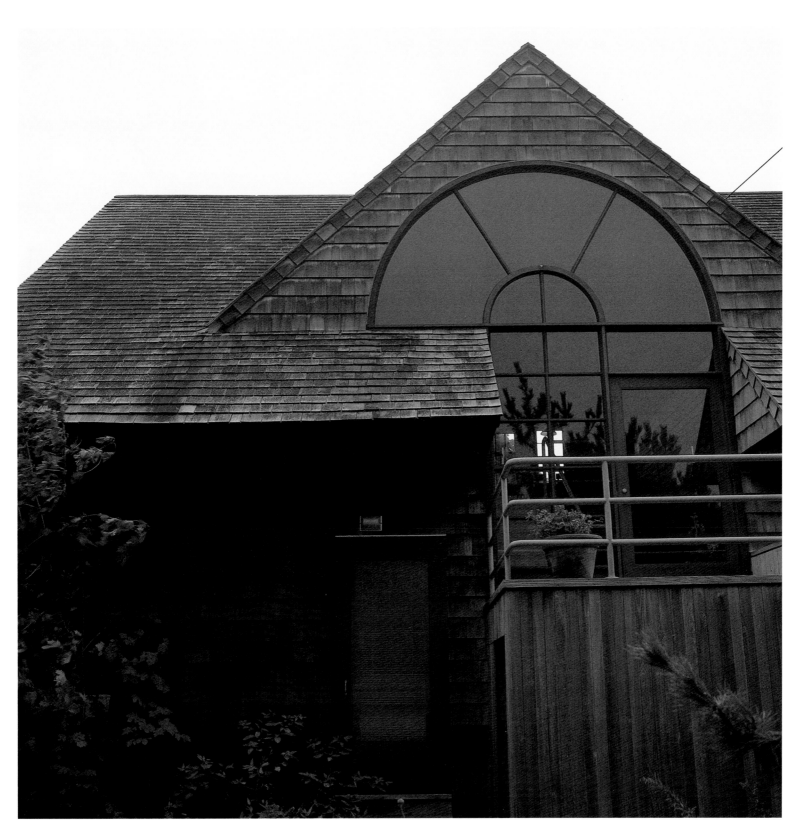

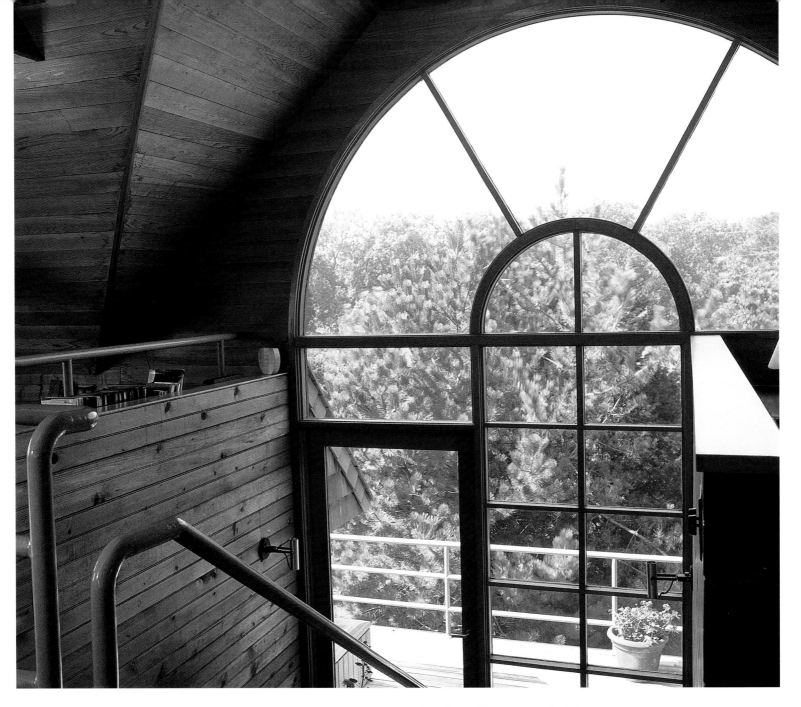

∧ The door in the large arched window serves as a separate entrance for guests staying on the upper floor.

➤ A "little house" within the house gives a sense of domesticity. The main bedrooms of the house are on the first floor, leaving the second for living and dining areas where the light and views can be enjoyed.

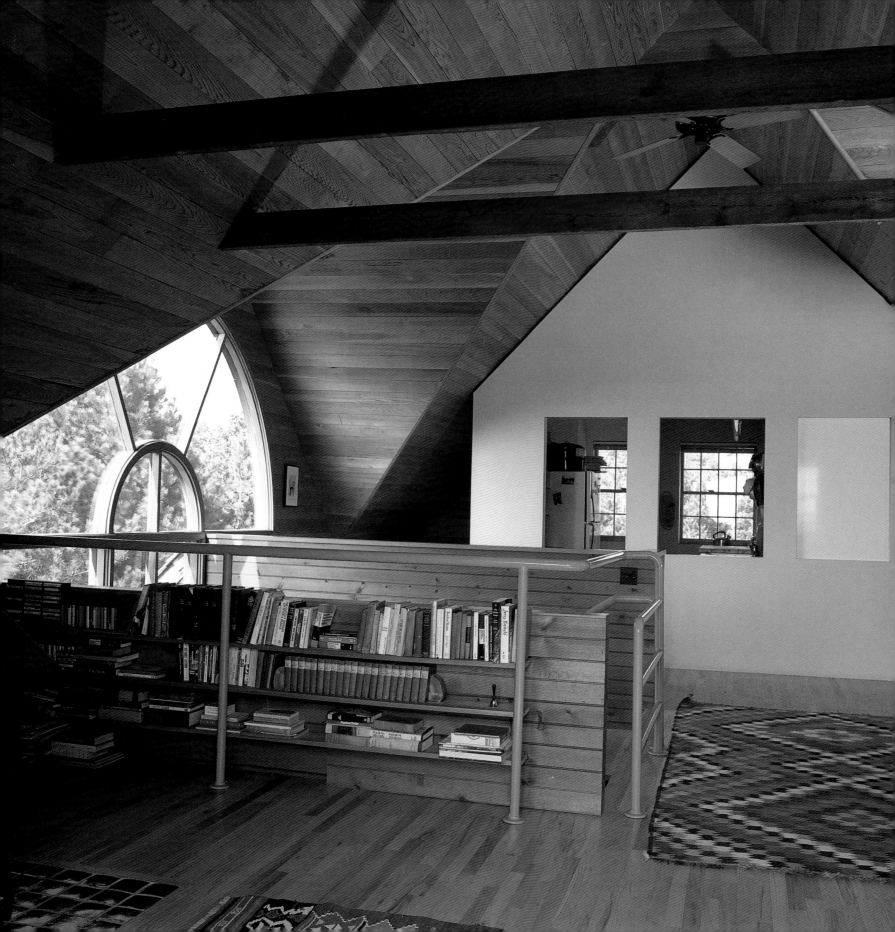

Library, Baltimore, MD

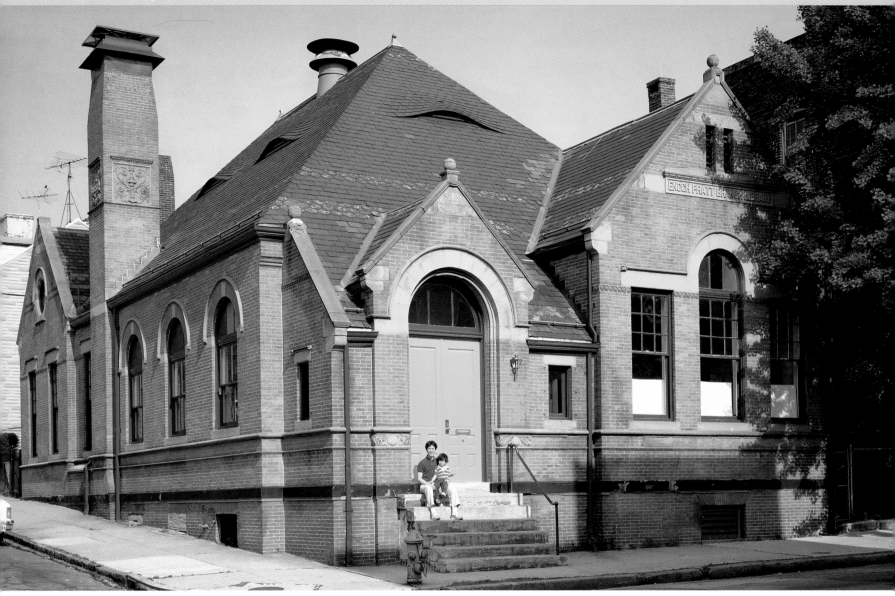

There are hundred-year-old buildings to be had in Baltimore, but most of them are fourteen feet wide. In a city where row houses dominate, people brag about residences that measure sixteen feet across. Architect Peter Doo is particularly happy, in such a city, to have a home forty feet wide with twenty-five-foot ceilings. It is an old library, built in 1883 the way that city structures were built then—with lots of volume and light.

The library is one of six built at the turn of the century from the same pattern; the others still stand in the city as libraries, or have been converted to churches or community centers. But this one became a home after Doo and his wife, Barbara, noticed it sitting vacant for months and finally convinced the city, with the community's support, to let them convert the building. It is so completely unresidential in its structure and demeanor, so municipal and public in character, that to have anyone use it as a residence at all is somewhat remarkable. As an architect friend of Doo's says, "Just the idea of putting a couch into the place is wonderful."

136

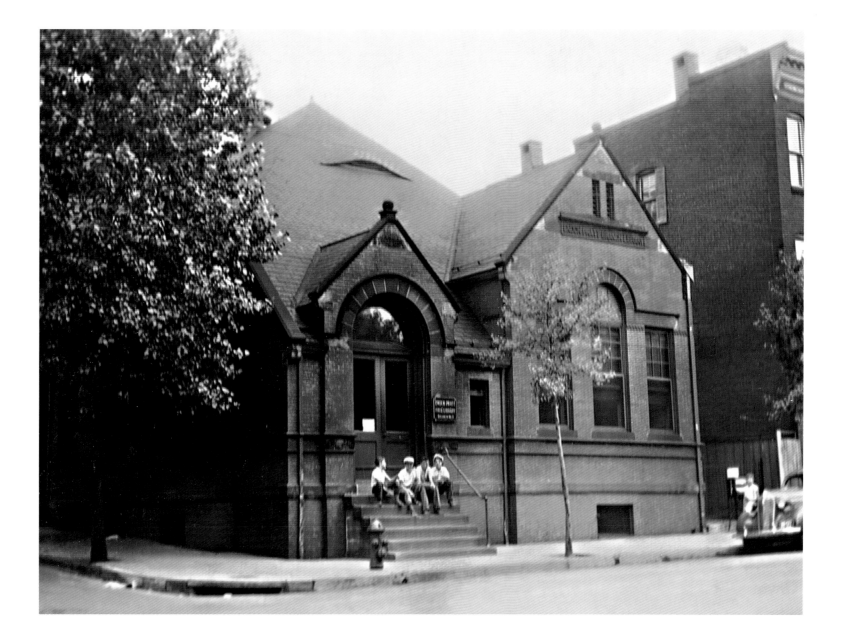

∧ Schoolchildren sit on the stoop of the
original Enoch Pratt Free Library branch,
which sits in a historic section of
Baltimore near Federal Hill.

◄ Architect Peter Doo and his son sit on the
same stoop now that the building is a
home. The neighborhood is filled with old
buildings that have been renovated.

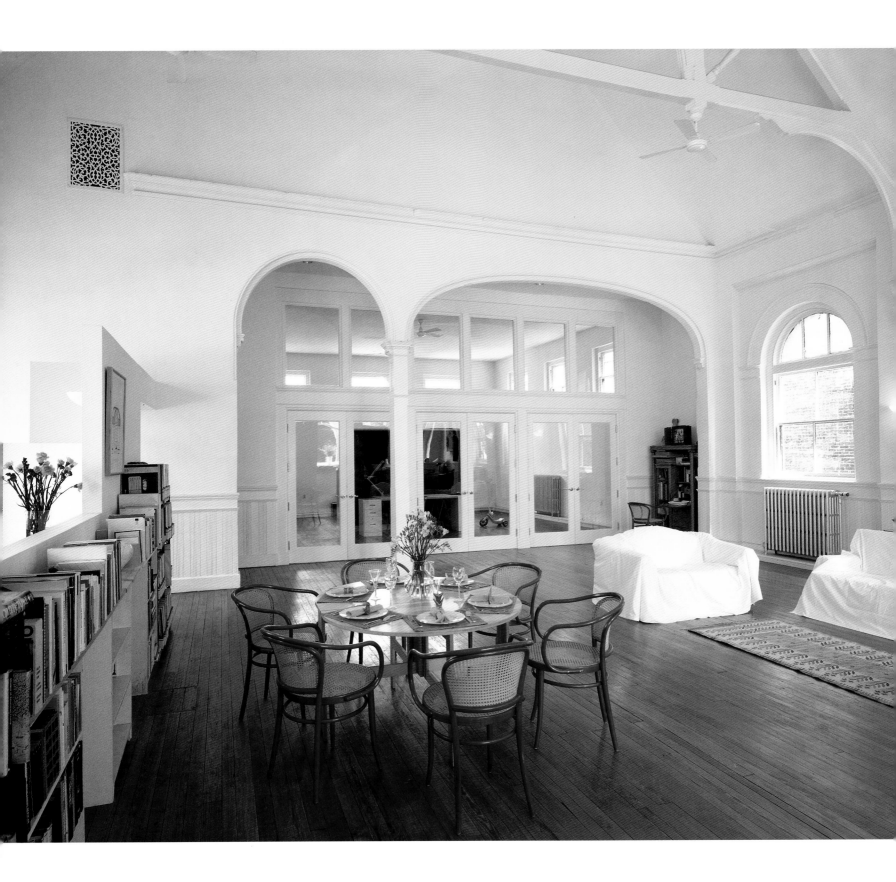

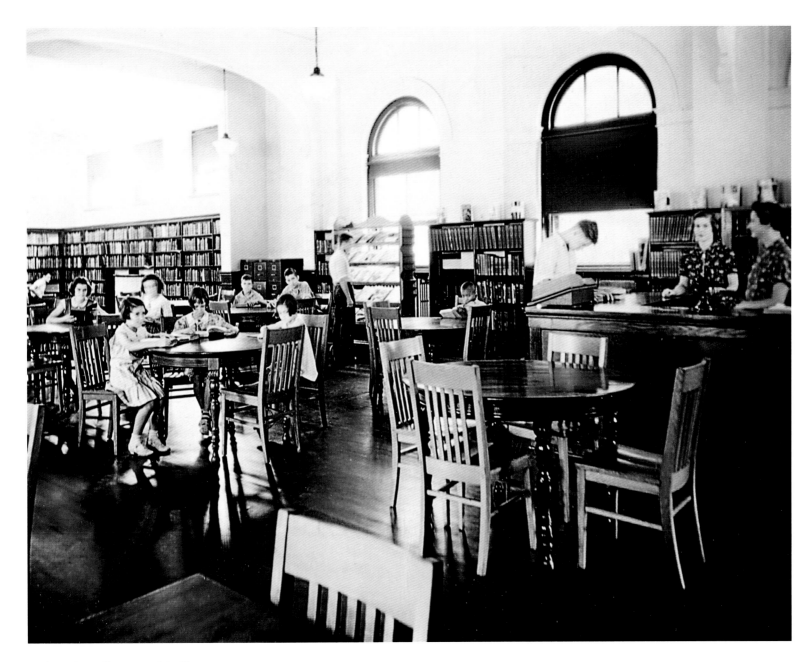

∧ The main reading room of the library was a popular place in its day. Electricity did not come to the library until the early 1920s, when librarians complained that it was difficult to read the titles of shelved books by gas lights.

‹ The reading room is now a living room, with a wall of windows and glass doors added to separate the bedroom space from the rest of the home.

In effect, the couple did do little more than place a couch where the librarian's desk used to be, and moved in. Their simple approach allows the graceful spirit of the structure to show. The conservative Victorian exterior was basically left the way it was—some paint and a few roof repairs were all that was needed structurally, and original detailing was maintained, including the stone lettering spelling out "Enoch Pratt Branch Library." (Baltimore lore has it that Mr. Pratt was responsible for giving Andrew Carnegie the idea of branch libraries, who then had them built throughout the country.) The only contemporary accent is the front door, rebuilt in the pattern of the old one that had been removed and painted bright yellow to contrast with the Victorian darkness of the rest of the exterior.

The couple found the inside of the building pretty much intact when they first entered with a flashlight. It looked dark, since the windows were boarded up, but it also looked, in Doo's words, "pretty wonderful." What attracted him was the sheer volume—2,500 square feet of it. The prospects only got better as workers uncovered the large arched windows and stripped away the plywood that protected the woodwork on the walls. (The building spent its most recent years in use as a boys' club after the library was closed, and it was boarded up to take the wear and tear.)

Underneath the boards was dirt, but also wonderful ornamental molding and detailing. The couple patched all the flat surfaces, repaired the woodworking, and painted, but they left the broken molding as it was, starting and stopping occasionally in breaks around the room. This is a charming revelation of the age of the building, and its effect is more successful than a renovation of the molding. It shows *how* the building has aged—what is has endured, what it has survived. The passage of time is made comprehensible.

The one-story space was left largely open, with only two partitions added. One is the half-wall that separates the kitchen from the main living and dining areas and holds bookshelves on one side; the other is the series of glass doors and, above them, windows that close off the bedroom space. The glass partition keeps the space visually open, retaining the building's airy spirit. Through the doors is the room where the stacks once stood, and evidence of them remains—in the windows that were placed high to protect the books from the sun, in the pale marks in regular rows on the floors where the shelves shadowed over the wood and the sun couldn't darken it, as it did everywhere else. Off this space is the only separate room in the original layout—the librarian's office that now serves as the baby's room. The small room has, as Doo jokes, "only fourteen-foot ceilings" and a fireplace.

The entire building is still floored with the original "hard pine" surface. Often used in public buildings, this is wood that comes from the center of the log and is the densest, hardest, and darkest. It was left unstained to let the beauty of its years show through.

Unhampered by its residents, the natural elegance of the building shows; as Doo points out, with a good building one shouldn't have to touch much. The joy of living there comes from the structure itself more than anything that was done to it. "We can sit back and look up at the trusses," he says, "and that's really our view. It's a pleasure."

> The arched form of the entryway to the library home is echoed in the windows, which span the sides of the building. On the other side of the partition is the kitchen, hidden from view.

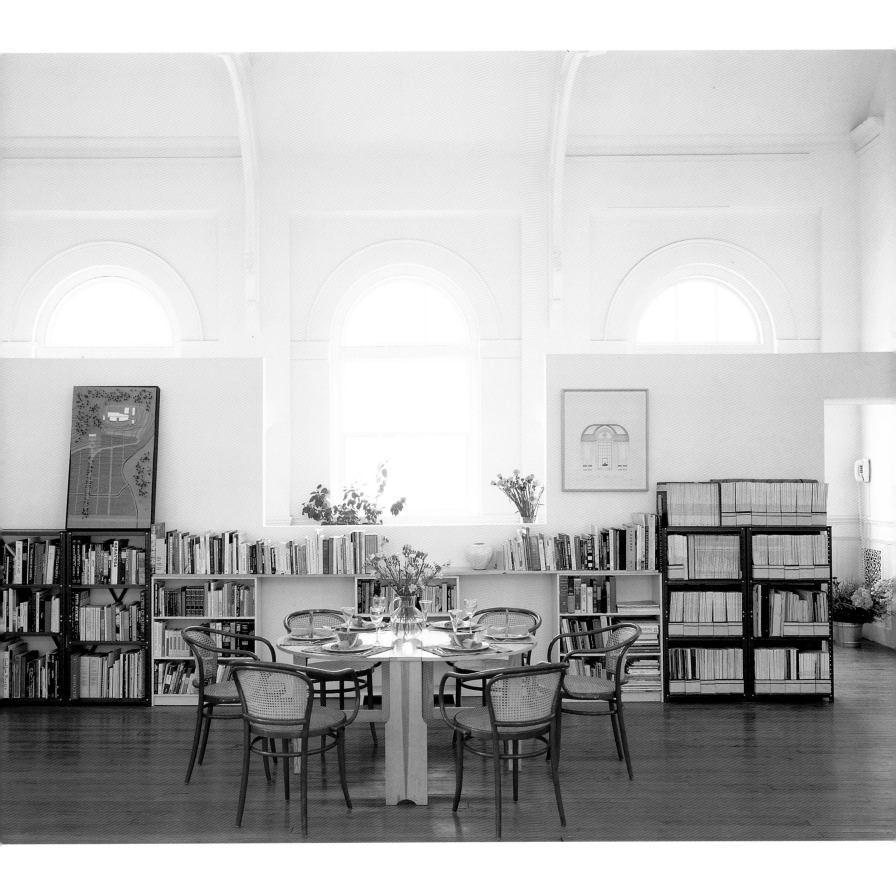

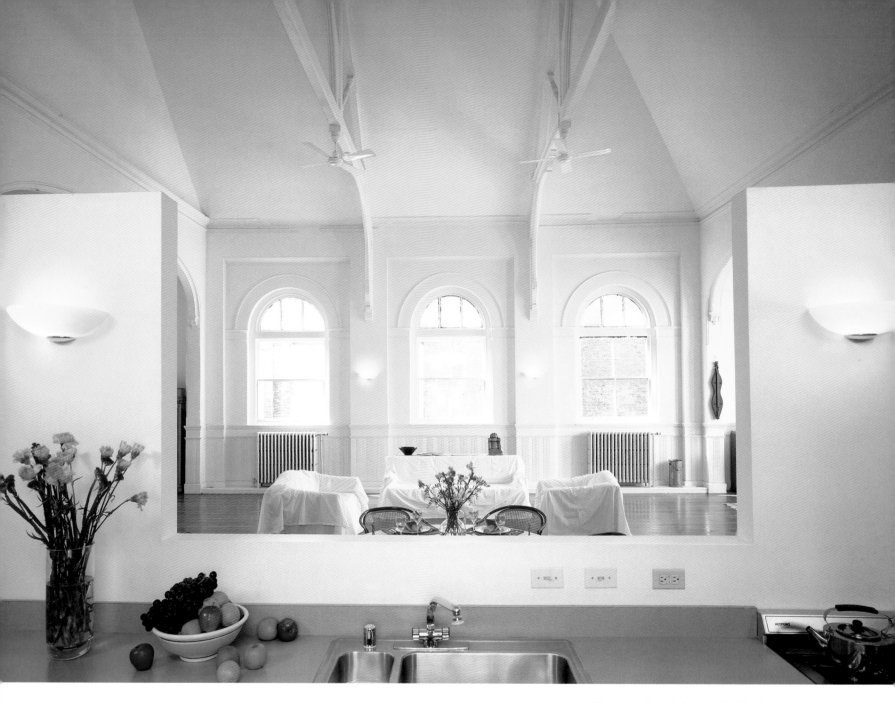

⌃ The expansive windows and original
trusses of the building can be seen from
the kitchen while making dinner.

➤ The bedroom area held the original stacks
of the library. The window wall and glass
doors installed by the architect provides
privacy but its transparency keeps the
space connected.

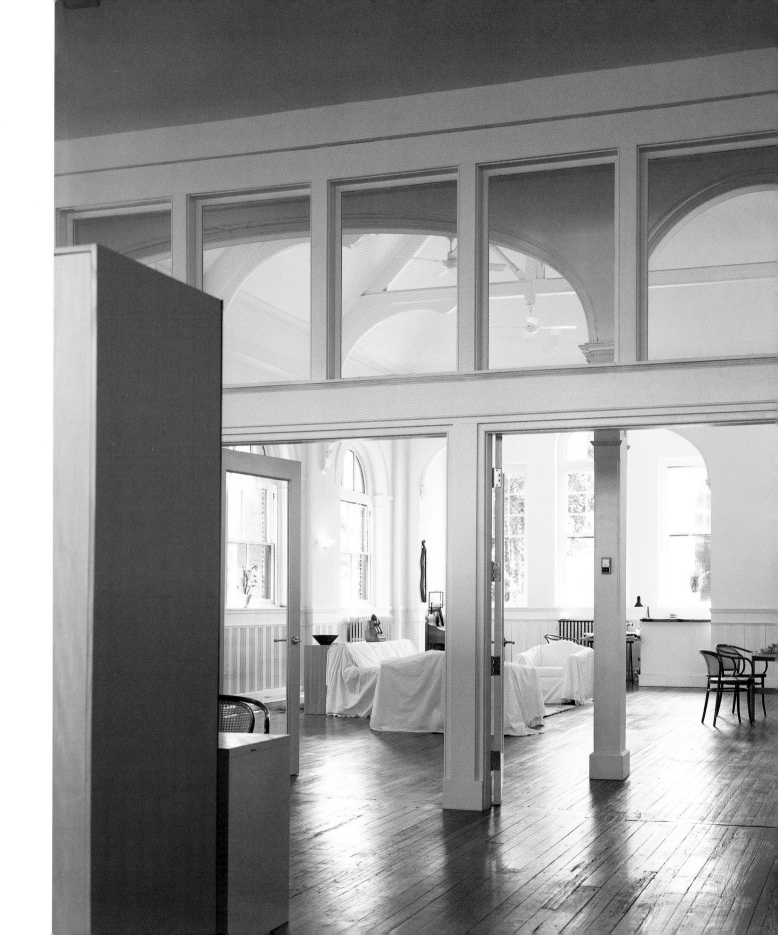

▲ The original 1845 post office is the marble building; the addition is to its right. Together, they make up one home and a little village of living.

➤ Stable-like doors on the new addition lead to the interior courtyard, which, like the doors, is a reminder of the rural beginnings of the post office.

➤➤ The dining and living areas are set in one open space to make as much as possible of the 1,900 square feet of the home.

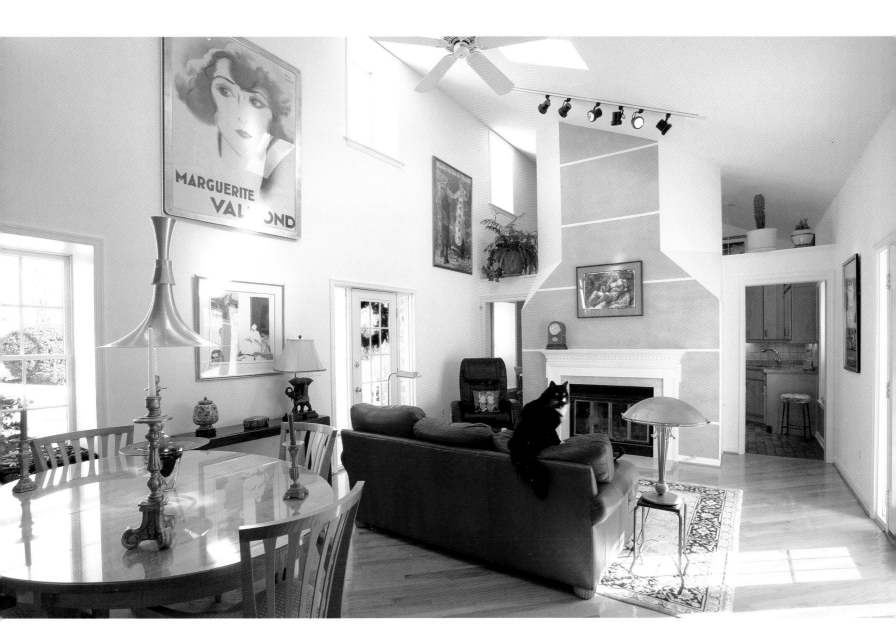

Bob Staniewicz has had the unique experience of people walking into his home without knocking on the door, and asking to buy stamps. This is understandable, because the house has a sign on the front, placed by the historical society, saying "Post Office, circa 1845," and the little building is inviting in a way that would make anyone want to have a reason to visit it.

The former post office, built for the old mill town of Ashland just outside of Baltimore, derives its character not only from its former use but from how it was made. Aside from the grand, many-columned main post office in New York

City, this is probably one of the only post offices in the country made of marble. Yet the architecture of the building is very basic; architect David Gleason, who converted the building, calls it "an elegant material in a rustic format." The opulent material was used because there is a marble quarry—limestone to be exact—just a few miles down the road, and it was the most convenient substance to use.

Next to the post office sat the general store. Equally essential to the town, the gable-roofed brick building is also still standing, now as a residence. Both buildings served the little

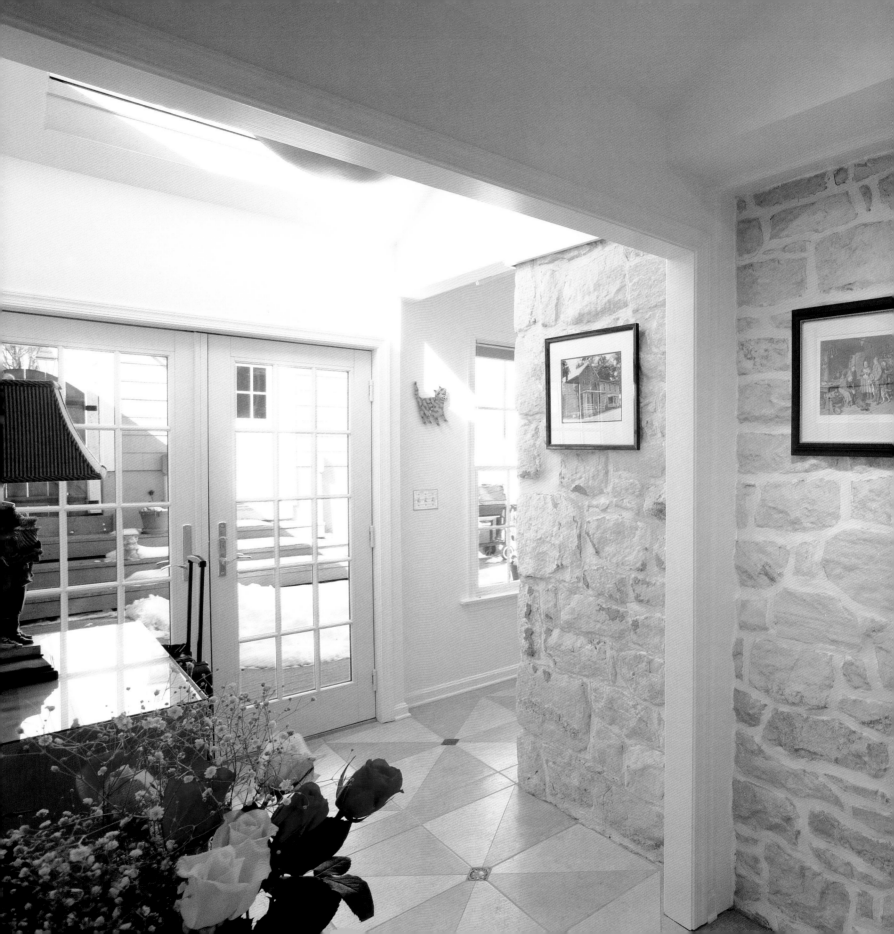

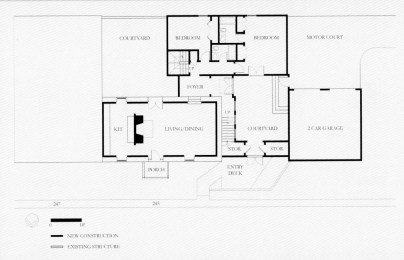

FIRST-FLOOR PLAN

COURTYARD · BEDROOM · BEDROOM · MOTOR COURT
FOYER
KIT · LIVING/DINING · COURTYARD · 2 CAR GARAGE
STOR. · STOR.
PORCH · ENTRY DECK

247 · 245

0 · 10'
— NEW CONSTRUCTION
═ EXISTING STRUCTURE

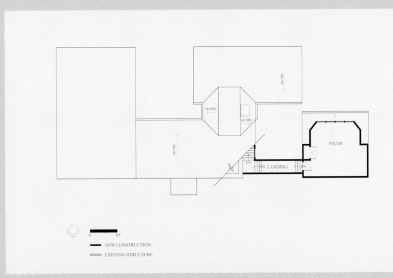

SECOND-FLOOR PLAN

SLOPE · SLOPE
SLOPE
STUDY
DN · ON LANDING · DN

0 · 10'
— NEW CONSTRUCTION
═ EXISTING STRUCTURE

◄ One is never very far from a reminder of the building's true character, since the interior limestone walls exist throughout the house.

▲ The original post office building, with the general store sitting next to it, was one of the most important structures in town.

► The original post office was only 594 square feet, so architect David Gleason added a new addition with a bridge that connects the structures from above and allows for an interior courtyard below.

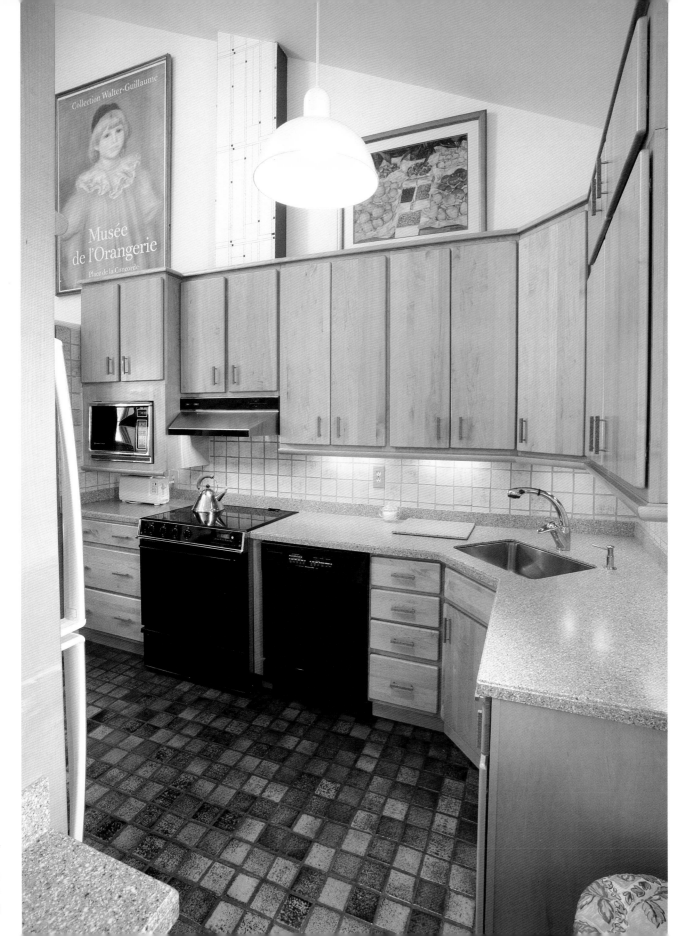

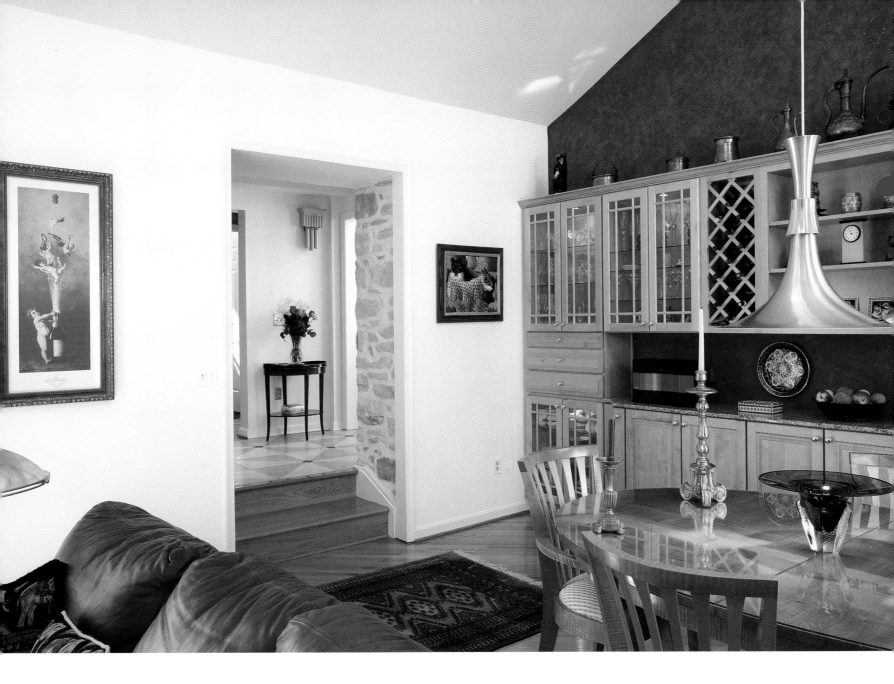

‹ The ceilings of the home are eighteen feet at
their highest places, making it feel much
more spacious than its square footage would
normally allow.

⌃ The owner kept the space open by painting
three walls of each room white and only one
wall in an accent color for interest.

town for years, with a break for the Civil War, when a group of Confederate soldiers used the post office for an outpost. Not until the 1920s did the post office stop delivering mail.

It is this "pocket of history" that Gleason wanted to respect and represent when he considered the approach to the conversion. The post office was only 594 square feet, so more space needed to be added while keeping the integrity of the original structure, and while not disrupting the old general store next door and keeping in line with the requirements of the historical association. So Gleason built additions to the other side and the back. The additions are contained in small buildings, which, when placed next to the original post office, form a street façade, like a little village. The spirit of the environment from the original structure is kept and celebrated.

To save what Gleason calls "the profile" of the old building, the new additions were built with steeply sloping roofs that mirrored the distinctive pitch of the post office roof. The original roof was designed this way for the practical reason of letting snow run off easily, but also created what Gleason calls a "strong form." He wanted to echo the format of what he refers to as the simple, utilitarian look of the original building, the specific vernacular of it. He also wanted to convey the sense of rural life that the building existed in when it was built. One of the ways that he did this is to create new doors for the additions that resemble stable doors, which speak both to a life lived heartily in the outdoors and to the buildings that held that life, the down-to-earth charm of serviceable structures like the post office. Another way that Gleason brought forth this kind of life was to create courtyards in between the additions to the post office, so there would be a sense of the countryside, a daily connection to nature built into the house.

Of course, living with two-foot-thick limestone walls inside the house, Staniewicz is among nature even when he is indoors. Aside from having what he calls "the beauty of stone," there is a tactile element. The stairway that leads to a second-floor study next to one particularly large exposed wall of stone has a banister, but Staniewicz says that he reaches out to touch the wall when coming down the stairs anyway. The stone glimmers with natural sparkling grains, most of them mica. At night, when the lights are shining on it, it glitters even more beautifully. "It's really luminous," remarks Staniewicz.

During the day, however, the light is natural. Gleason took advantage of the orientation and original clerestory windows of the building to bring in as much light as possible, and also added skylights to the additions. The highest pitch of the roof creates eighteen-foot ceilings in places, so even more light is available. Staniewicz never has to have a light on in the daytime, even on a cloudy day.

The high ceilings and open plan of the house also kept its relatively small square footage—about 1,900 total—from feeling crowded. Staniewicz says it feels nowhere near that small, and part of this is due to the "uncluttered" approach that he took with decorating it, with white on three walls of each room and a bold color on the fourth, which echoes the visual weight of the stone but doesn't take over the room.

Even the thresholds are a joy to cross. They are made of four-inch-thick cast iron that was set into the stone. The historic town used to have iron furnaces that produced pig iron, so iron was set into the building as matter-of-factly as the building was put up with marble. And the marble walls have developed into a very successful little village of living.

> Even this hallway connecting the old and new structures is blessed with a stone wall. Sloping ceilings in the new parts of the house keep it visually connected to the sloping ceilings of the original post office.

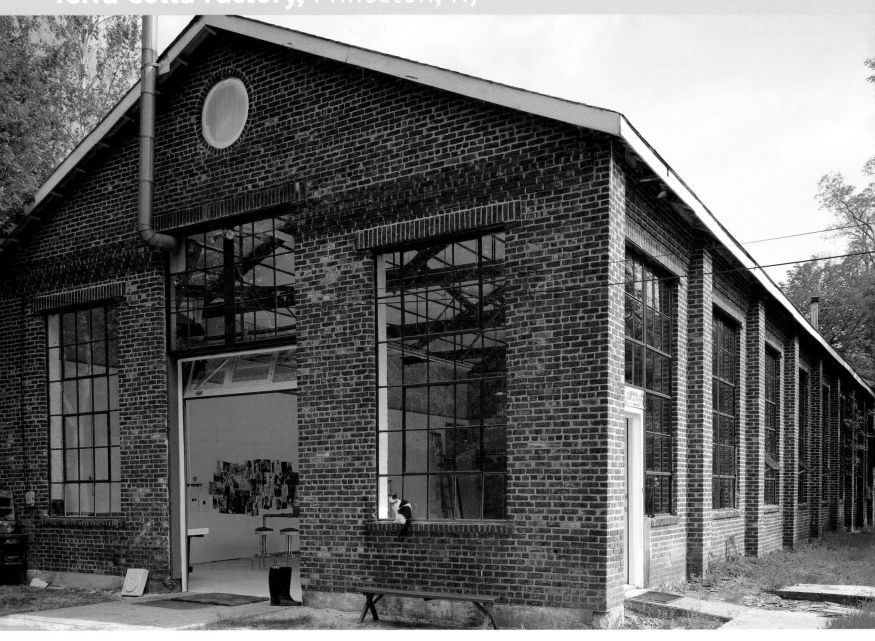

∧ The former terra cotta factory is a Victorian classic: a brick and glass, gable-roofed industrial structure that is a work of art in itself.

➤ Another kind of industrial look comes from the loft-like, contemporary structure that the architects created out of wood and Lexan panels to make two stories for the building.

Great Adaptations

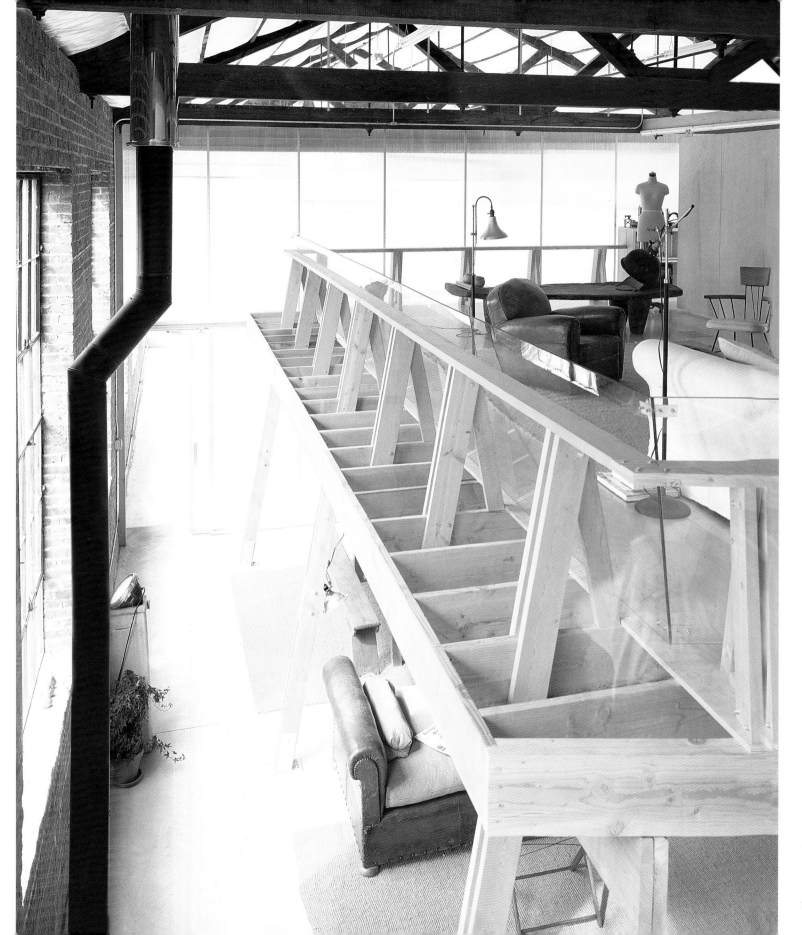

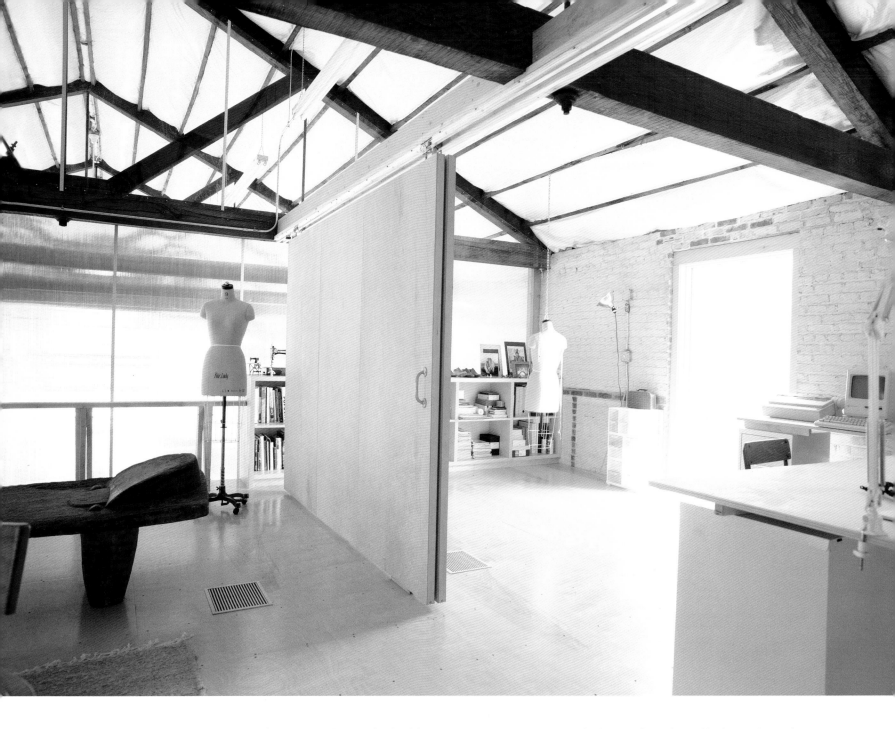

It is quite extraordinary that the former residents of a building should be flying angels, Greek gods and goddesses, roaring lions, expressive gargoyles, and hundreds of different types of flowers. All of these not only used to live, but were born, in a former terra cotta factory in Princeton, New Jersey, in the form of clay, then fired so that they could reside on some of the most important structures in the world, including the Woolworth and Flatiron buildings in New York City.

"Terra cotta," which translates literally from the Italian to "cooked earth," is the magic substance that turned buildings that were first scraping the sky into buildings that were, and still are, alive with figures and objects from nature, with designs and ornate patterns that made the record-tall structures accessible to people on street level. One of several factories of the Atlantic Terra Cotta Company, this ancient-looking but strongly profiled 1894 brick industrial Victorian building

has its own beauty in period detail, with additional bricks patterned on the outside above the windows.

This is a story of layers of art: The piece of art that the building is and the objects of art it produced; the home that it was made into and how it interacts with the original structure is another contribution to that art. In addition, one end of the building was reserved as a separate studio for ceramic artists who make original tile there, completing the circle of the life of the building.

The residence is loft like and surprisingly urban in spirit. This is a striking contrast to the surrounding landscape—a setting of woods with the Delaware and Raritan Canal directly across the road. Smith-Miller + Hawkinson Architects designed a structure that broke the vastness of the 3,200-square-foot place into livable spaces, a modern industrial-spirit platform that echoes the original industrial stance of the

building. The platform allows for two floors: the first holding the public spaces of kitchen, dining room, living room, and a library with so many books against the wall that they become their own design element, and the second containing the more private spaces—the bedrooms, baths, and an office and library. Fiberglass panels form the perimeter of the second floor and divide other spaces. The supports of the platform slope away so that the views and light from the huge garage doors on either end and the walls of windows on the sides will show. This slope also visually fits in with the expansiveness of the space. The temporary look of the structure was intentional—a contrast to the history that exists everywhere else in the building. But the old and the new complement each other because of their common rusticity, their honesty, and their simplicity.

The residents are also in the arts—Alastair Gordon is an architectural writer and Barbara de Vries designs clothes. In many ways, they were led to the structure even before the day that they drove by it and saw that it was for lease. Gordon grew up in Princeton and, as a kid playing in the rural areas of town, came to know the building and thought that when he grew up he'd like to live there. De Vries was raised in a family of architects and was always around "models and drawings." The approach they took to decorating the building has a lot to do with its overall effect. There is an elegant rusticity in the pieces around the home. Just as the building itself is a large found object, found objects are everywhere; many of the lights were made by Gordon from old automobile headlights. A bed came from the Ivory Coast, a leather couch was a second-hand find in Paris that cost more to ship than it did to buy, and a romantic old bathtub somehow fits in perfectly next to the yards of exposed brick walls.

◄◄ Space is elastic in this 3,200-square-foot home. In the studio created for designing clothing, sliding doors can be closed to make smaller work areas or opened for a larger room.

◄ Books are a design element of the home; with so many of them in the house, they appear on walls everywhere, as common as the centuries-old bricks that make up the walls.

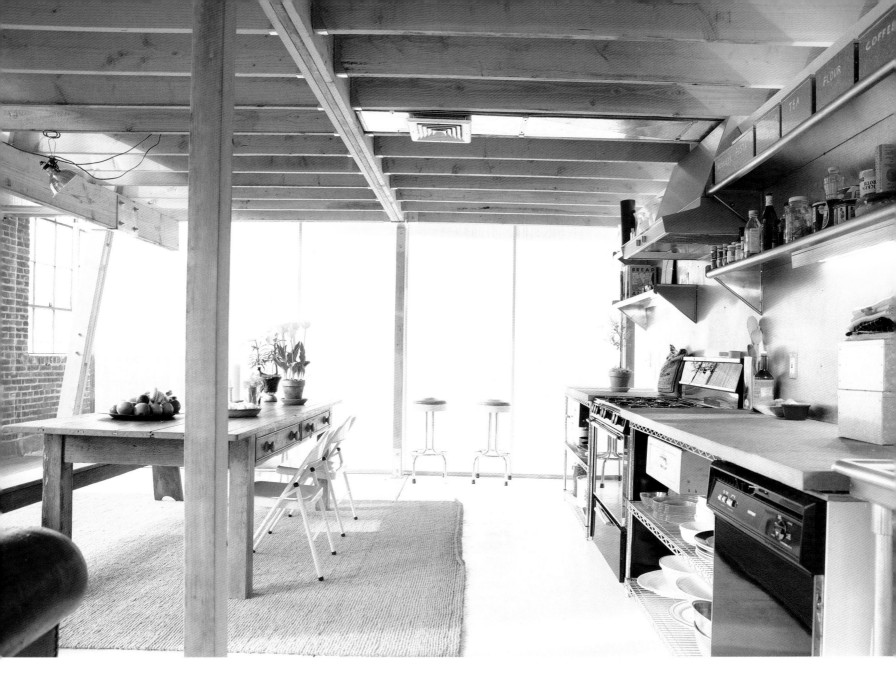

The views outside the building are as striking as those within. To the front of the building is the hand-dug canal that was used by barges, with mules to pull them, to transport goods between New York and Philadelphia. To the back are the kilns that fired the terra cotta after the pieces were formed from wet clay pressed onto molds and glazed. The round brick kilns, so big that one can stand inside them, have their own poetic beauty, standing quiet among the trees after having made thousands of pieces of tile, for the subway station walls and the Holland Tunnel of New York, for the Philadelphia

Museum of Art, for skyscrapers all over the country. The Atlantic Terra Cotta Company was the largest manufacturer of terra cotta in the early twentieth century, so much of the character of the nation's skylines and cities was created right here. Without too much digging, in fact, one can find pieces of the tile in the backyard, where they were thrown away when the glaze colors came out a shade off, or crackled in the firing, or when a piece didn't represent the ornate swirls and designs of the patterns—a sumptuous bunch of grapes, a cascading bouquet of flowers—as exactly as they were supposed to. It is

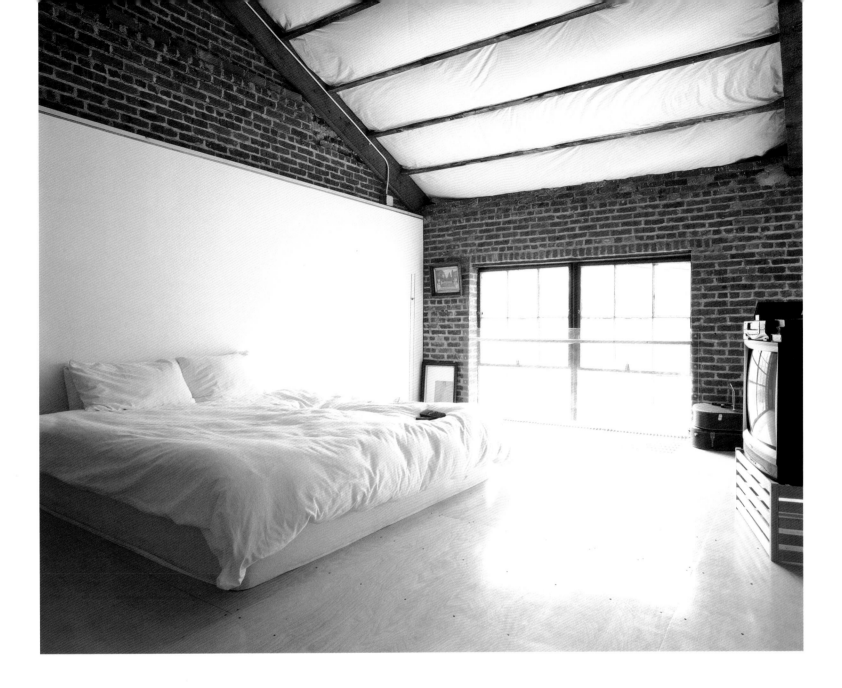

◄ The long galley kitchen gets much of its functional design and its beauty from galvanized metal. The industrial material fits perfectly in the industrial-era building.

▲ The master bedroom on the top floor is graced with the angled ceilings created by the gable-roofed structure; new birch plywood was installed for the flooring.

what tile maker Abby Hoffman, who has a studio in the building, calls a "terra cotta graveyard." These treasures, when found, show the detail and incredible demand for beauty that the time and the art required, and the love and care that was put into it.

Hoffman says she feels the ancestry of the building, that she and others have heard noises there from the past. Certainly there are reminders everywhere of what the building used to be, even on approaching it. At every door there is a

plaque of richly engraved terra cotta, some with goddesses in gowns, every drape in detail, some with mottos, such as the word "Humilitas," in rich lettering, some with strange beings, such as the cow with wings that sits above the main entrance. All have glaze colors in many gradations, drawn from the awareness in fine art that it takes many colors to make up one color. With this residence, there is no living alone—there is only living with history, living with art, and living with the background of how much beauty could come out of one place.

◄ A leather flea market couch found in Paris
is typical of the found-object-approach to
furnishing the home, appropriate since
the house itself was a large found object.

▲ The building has as much architectural
integrity inside as it does outside. The
windows are expansive multi-pane, steel
pivot models, which were saved.

▲ The barn is fifty feet by thirty feet, a big rectangle divided into three floors and four bays.

▶ Looking out from the "door to nowhere," which is fronted by Plexiglas, the full volume of the building becomes visible. The study and master bedroom are on the second floor; the living room, dining room, and smaller bedrooms are on the first floor; and the lower floor, where the animals lived, is used for a workspace.

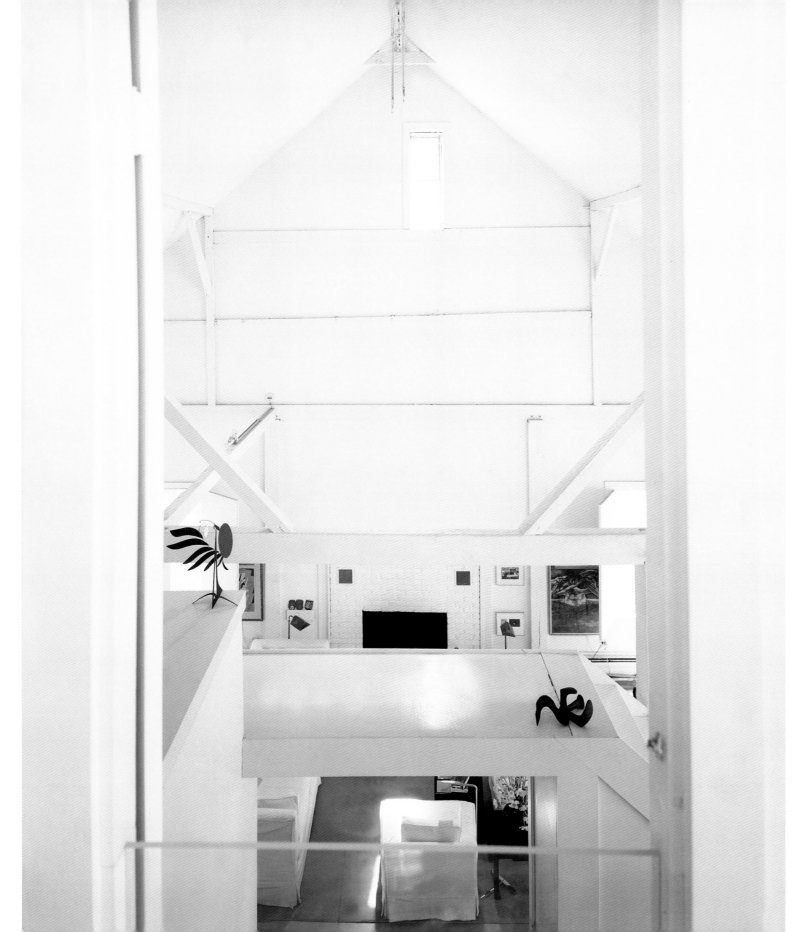

Architect Keith Kroeger took what he calls a "discarded" barn in New York and made it into a home, thinking that after he fixed it up for fun, he would live in it for a few years and then sell it. More than a decade later, he and his wife Susan are still there after raising four children in it. Having that many children is reason enough to live in a barn, but the Kroegers had other reasons. There was the opportunity to live with the history of a building that has been around since 1837 and had been filled with hay and animals rather than a family. The barn also presented a ground for architectural experimentation, a chance for change and evolution.

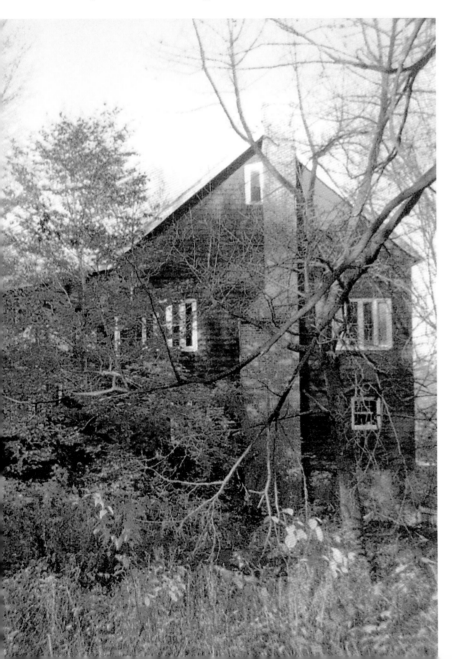

Kroeger views the barn as "a great big volume with a regular structural system," a space readily adaptable to different approaches and uses. The building itself doesn't say, as Kroeger puts it, "now you are in the living room," but leaves that up to its inhabitants. The Kroegers have the house arranged so freely that they have only to move a couch or a dining room table to transport a room from one place to another. This inherent flexibility has allowed the barn to be many different things over the years: The quality of its light and its high walls rendered it the perfect setting for the art shows the Kroegers have held there; its natural acoustics and hayloft balcony have made for some great concerts; and, in its early days, when a famous actress first converted it, it served as the rehearsal hall for the local theater group.

But even with change as a central factor in the life of the barn, its history and the spirit of its original use endures, and cannot really be escaped. This is another kind of joy for the Kroegers. They can't dig very deep in the garden without finding a horseshoe, nor renovate very far, as they did recently on the first level, without uncovering a trough strong with the wonderfully agrarian scent of manure. And there are the huge sliding barn doors on the first level where the cows came home, original wide-plank floors that are knotted and nailed and anything but refined and residential, massive rafters that emphasize the power of the structure. These elements say the building remembers its past, no matter what its present use.

Ten years ago Kroeger told real estate agents that he was looking for "a piece of junk that no one else wanted," and in this ramshackle structure, that's pretty much what he found. For him, the barn was like a big found object that he could transform into something new, while saving its essential properties. Though it had been lived in before, it had stood empty

◄ The barn was red in its former life. A bank barn, it contained a lower floor, made possible by the landscape, for the animals to enter.

► The hayloft master bedroom of the old barn continues the clean lines of the building that represents the simple life on a farm. The "door to nowhere" is visible here.

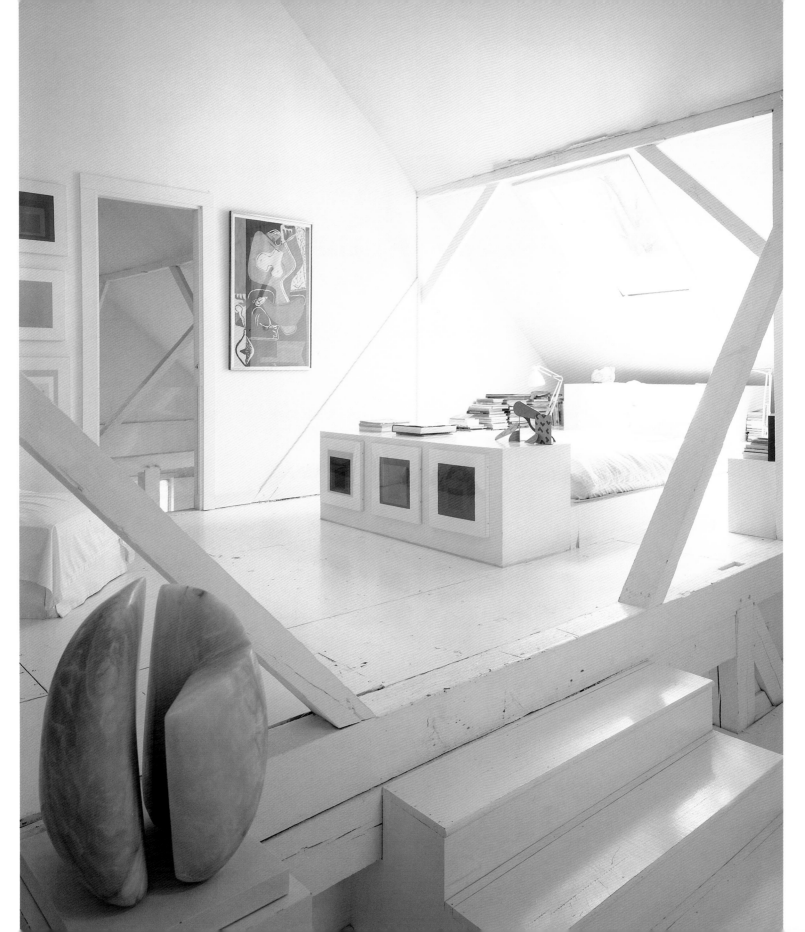

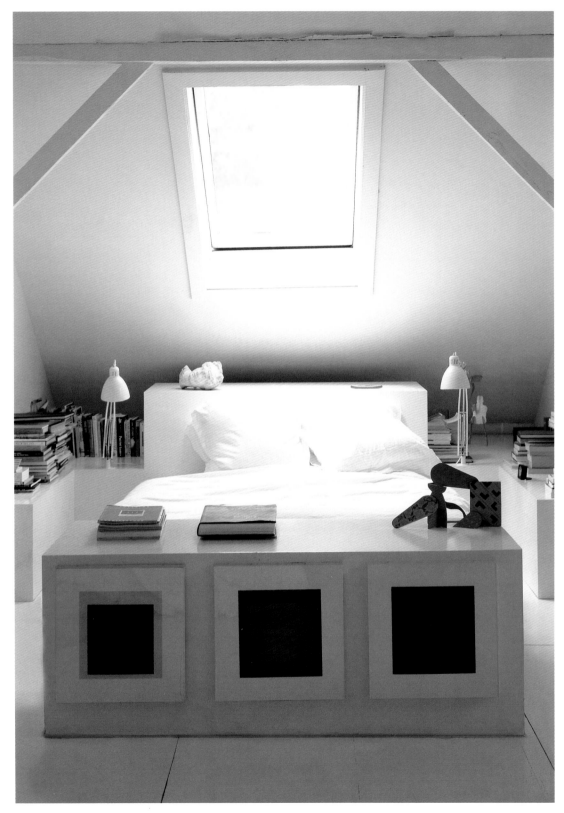

◄ The bed, which is itself painted white along with the rest of the barn, is framed by original corner beams and topped by a skylight.

► The intent in designing the interior was to make it flow with the structure and spirit of the building. Kroeger says, "We wanted very much to feel like we were living in a barn." Visible from here are the kitchen windows that Kroeger saved from buildings slated for demolition.

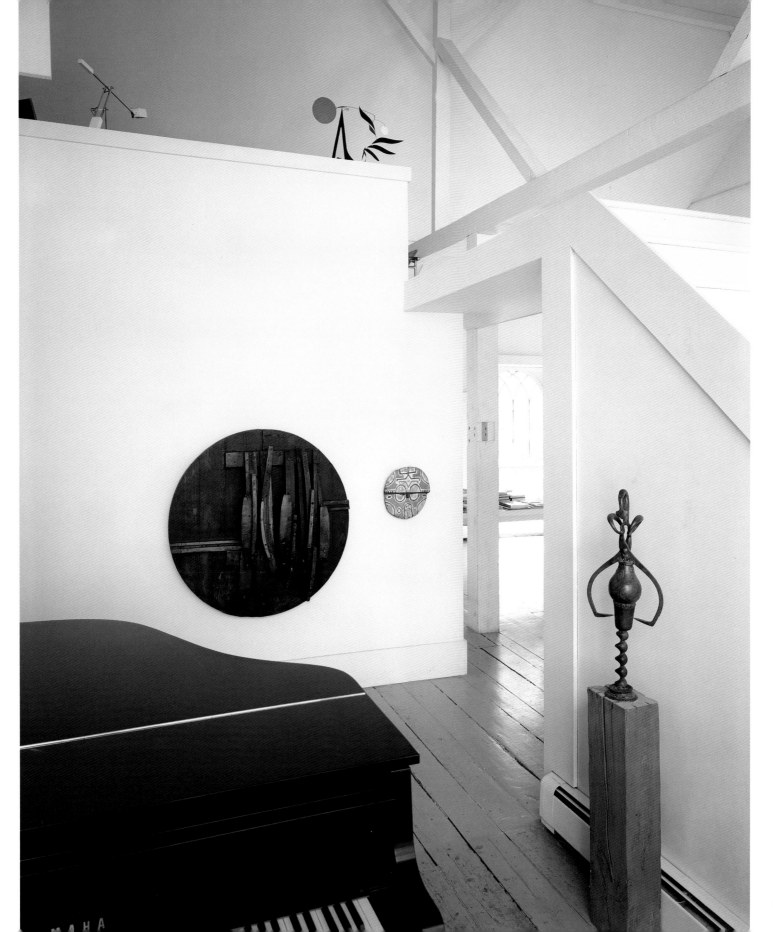

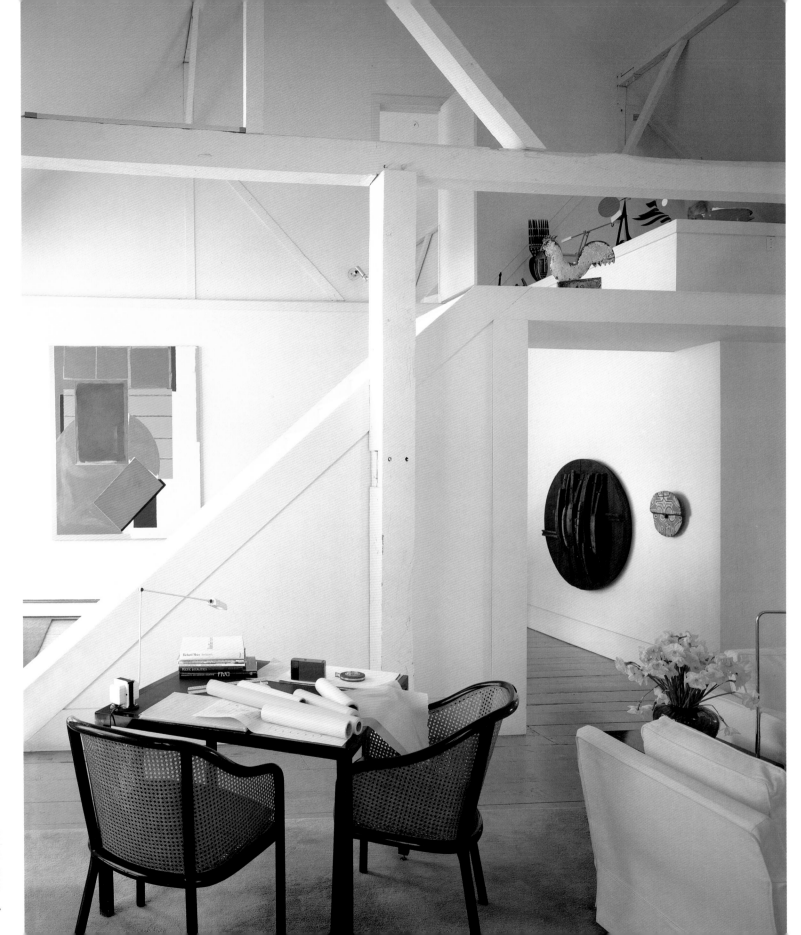

for years until a local bank took it over. While the fabric of the building was in terrible shape, the structure was sound, and the foundation was made of reinforced concrete rather than the loose stones found beneath most barns. (Horace Greeley, who lived in the area when the barn was being built, came back from Italy with news of great foundations for agrarian structures, influencing the construction of everything for miles around.) After being shown the barn, the Kroegers sat down in a restaurant and figured out on a napkin what it would cost to make the structure livable, then bought it at a bargain price from the bank, which was happy to get rid of it.

It took a lot of vision to see the beauty in a dilapidated building whose intrinsic qualities were hidden by low ceilings and a sagging—and inappropriate—front porch; they let in little light and even less of the spirit of the original structure. Kroeger stripped out the ceilings to open up the barn to its original soaring height, took off the front porch, and installed so many windows on one side of the building that it practically became a wall of glass.

Then he had the entire barn painted white—inside and out. "We really just whitewashed everything," he says. The children say it's like living in a snowstorm. Because of its simplicity and minimalism, the white lets everything in the structure show—the beams, the rafters, the interior angles of the building are in clear view because no color or texture distracts from them.

All these changes opened up the volume of the building, and in the upper part are evocative reminders of the barn: A hay trolley that once brought hay from the loft to the floor now hangs from the ceiling; the hayloft itself, now a bedroom, still sits nearby; and light slants in through the simple barn window near the ceiling.

Above all, the Kroegers appreciate the barn's lack of pretension and preciousness, its friendliness and fun. Family photographs of kids hanging off the rafters show the sheer playfulness of it. "Every time you come back to it," Kroeger says, "it somehow makes you smile." Any building that can make people smile when they walk into it was obviously well worth saving.

◄ With no balustrade for simplicity, a staircase connects the first and second floors.

▲ This photo before conversion shows that the barn was sited on a one-acre lot so that as much of the land as possible was available for farming. This siting is unusual for a home; most houses are placed in the middle of the lot.

Great Adaptations

167

▲ A New Haven, Connecticut meetinghouse
dating to 1948 that was described as an
"eyesore" by its neighbors was converted
to an award-winning apartment building
by architect Peter Woerner. The building
is now deemed "a gentle, discreet, simple
neighbor."

APPENDIX

There are a number of considerations and tools that are helpful in finding the way through adapting a building to a home, which are detailed here. The websites listed in this section give a tremendous amount of guidance.

UNDERSTANDING THE BUILDING

Before buying a building for conversion, a potential owner must first address two concerns—the structure's physical condition and its history. Full consideration of these issues will provide an overview of what to expect from an older building and can save the buyer much trouble and expense during the conversion process.

Anyone serious about purchasing an old building should hire at least one professional to help assess its condition. Architectural firms that convert structures gather a team of experts—sometimes as many as ten specialists in as many disciplines—to evaluate a project before undertaking it. For the individual buyer, an architect or a structural engineer can be invaluable (the buyer will, in all likelihood, be hiring an architect to help with the conversion, and the earlier that the architect is brought into the project the better). He or she can provide information on the soundness of the building and the extent of any structural damage, and estimate the expense of repairs (these will be in addition to the conversion costs). He

or she will also be versed in local zoning restrictions and building codes, and so can advise the buyer as to the feasibility of the project.

Having hired a consultant, the potential buyer and consultant should make a thorough inspection of the building. While examining all facets of the structure, one should keep in mind that problems immediately evident often indicate more serious ones that are not apparent. No matter how thorough an inspection one undertakes, it is improbable that everything will be spotted during the initial inspection; but, with the help of the consultant, one can attempt to get a good idea of what to expect.

THE STRUCTURE

The following is a list of the most serious potential problems a prospective owner can expect to face from older buildings:

The Roof
Often the first element to show wear, the roof is generally a good indicator of the condition of a structure. A sound roof usually reflects a building in good condition. A roof that has

holes in it or that is missing pieces of the roofing material, however, should be taken as a warning of other serious probable damage. A leaky roof allows water and snow to drip onto the beams, rotting them, then the floor, and so on, until it finally undermines the foundation. Is the roof complete? Is the roofing material in good shape? Are there loose, missing, or damaged shingles? Is the roof sagging? What is the condition of the drainage system?

Foundation Walls

The erosion of the foundation walls is usually indicated by the visible sagging and twisting of the building. Is this the case? Are the foundation walls cracked? Do they show other signs of erosion—particularly where the walls meet the ground?

Location

The site of a building can be a cause of structural damage. In inspecting the building, the potential buyer should consider if the location of the building is apt to contribute to structural harm. For instance, a bank barn, which is set on a hill, may suffer if the hill around it is eroding. In this case, the foundation will eventually crumble with the hill. Other examples of potentially risky sites include foundations built on or near fault lines, the sea, and rivers with a history of flooding.

Beams, Ties, and Rafters

All of these ceiling elements are vital to the structural soundness of the building. Beams, particularly those in barns, are especially important. Before the 1800s they were generally made of oak, making them stronger than the softer-wooded ones made later of fir or hemlock. However, oak beams are more susceptible to powder-post beatles that drill holes into the wood and leave evidence in the form of fine sawdust on the floor of the structure. As far as the strength of beams is concerned, if a screwdriver can be pushed into a beam, its soundness should be questioned and an expert consulted.

Plumbing, Electricty, Heating, and Cooling

Repairs to these aspects of a structure may appear daunting to the potential owner, but in reality they are rarely much of a problem to install or repair these days (when done by properly skilled and accredited workmen). These kinds of repairs should not deter one from buying an otherwise sound building.

Additional Elements

A detailed examination of the following may reveal a great deal about the condition of a building: floorboards, exposed joints, baseboards, paneling and trim, plaster work, framing members, nail holes, architectural woodwork, and wall sills.

PRESERVATION SOCIETIES

When looking into a building's background, one of the most important questions to research is the history of its occupancy. Some buildings have been abandoned for years, in which case potential owners can expect general deterioration to be as much, if not more, of a problem than structural soundness. There are thousands of local preservation societies in the United States. Potential homeowners should check with the society representing the area where they hope to convert. These societies can not only be of help in researching the building and the area, but oftentimes they can suggest buildings, help converters with the Internal Revenue Service, and supply valuable information not available elsewhere.

The National Trust for Historic Preservation is an invaluable resource for many aspects of conversion. They may be able to help provide information on the building you choose. Contact the Resource Center at The National Trust for Historic Preservation, 1785 Massachusetts Ave., NW, Washington, DC 20036, 202-588-6164, or visit their website at www.nationaltrust.org. See the Sources section for more information on historical societies.

LOCAL CONSTRUCTION LAWS

What you are and are not allowed to do with a building you are considering converting may have a big impact on your decision about whether you should take on the conversion. Here's how to determine what you can expect.

Zoning Laws

In the United States, restrictions on construction are set down by local zoning boards. Local zoning laws control how many stories a building may be, how many housing units may be constructed on a given area, and so forth. A potential homeowner needs to have his or her plans approved by the regional zoning board before beginning work.

Building Codes

Checking the building codes is an important preliminary step, as many are strict and very specific—and will affect how a building is transformed. Model codes serve as minimum standards for local jurisdictions that adopt them. They, like zoning laws, evolved regionally, and may be modified by and for the locality to meet its needs. There are three major codes, which, while they have many similarities, were drafted to reflect regional building differences. The model codes undergo periodic revision, and in recent years have been amended to provide greater flexibility and sensitivity for older buildings and districts. For help on understanding the codes, contact the National Conference of States on Building Codes and Standards, 505 Huntmar Park Dr., Suite 410, Herndon, VA 20170, 703-437-0100, or visit their website at www.ncsbs.org.

LOCATING FINANCIAL HELP

Though more should be available, there is some financial help offered on the government and local levels for converting buildings. Government, and especially local councils, realize that in converting a building one is often saving it, and therefore enhancing the culture of the place where it exists.

TAX INCENTIVES AND GRANTS

There are no incentives from the federal government for those who convert historic structures, unless the conversion includes a commercial use, such as a rental or shop within the building. There are, however, grants and tax benefits on the state and local levels. These vary widely by state and are ever-changing.

The National Trust for Historic Preservation provides an incredible source of information for local and state incentives on their website. Go to www.ncbs.org and click on "Help from the National Trust" and then "How to Preserve a Public Building." There you will be led to links for each state that tell about funding and tax credits.

If you don't find information for your state, contact the Resource Center at 202-588-6164 or feedback@nthp.org.

Here are other valuable resources for tax information:

American Society of Appraisers
P.O. Box 17265
Washington, DC 20041
703-478-2228
www.appraisers.org

International Association of Assessing Officers
130 E. Randolph St., Suite 820
Chicago, IL 60601
312-819-6100
www.iaao.org

National Conference of States on
Building Codes and Standards
505 Huntmar Park Dr., Suite 210
Herndon, VA 22101
703-437-0100
www.ncsbs.org

MORTGAGE PROGRAMS

The Department of Housing and Urban Development's Federal Housing Administration (FHA) has a flexible loan program that helps developers, investors, and families at all income levels to buy and restore properties in urban and rural historic districts. The program operates through FHA approved lending institutions, and the loans are insured by FHA. The 203(k) Mortgage Rehabilitation Insurance Program helps preservationists deal with problems such as appraisal barriers, the high cost of second mortgages, and prohibitive down payment and closing costs. Unlike most mortgage programs, the 203(k) is available to potential homeowners before restorations are completed. Learn more about the 203(k) program from HUD's Web site, at http://www.hud.gov/offices/hsg/sfh/203k/203kmenu.cfm.

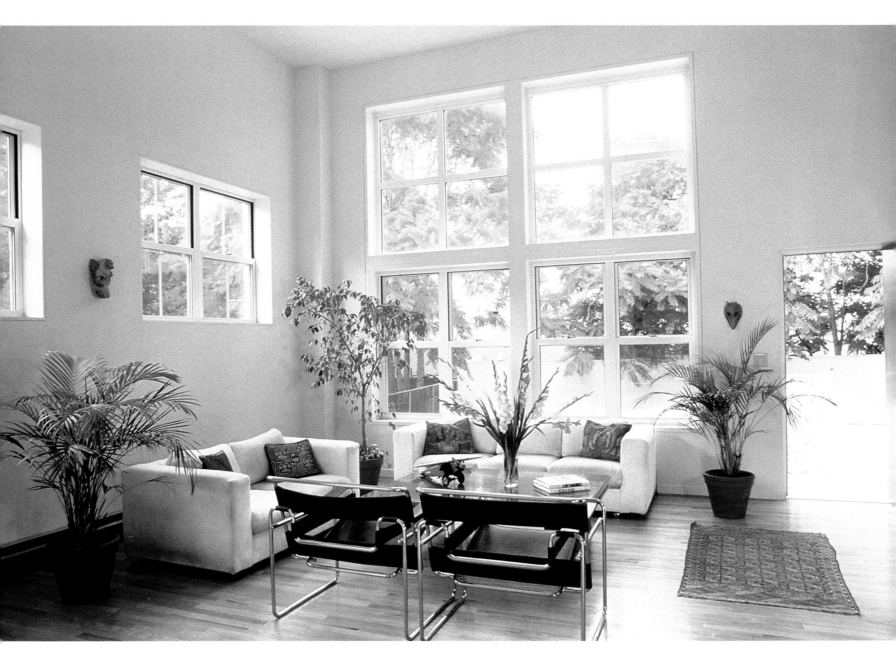

▲ The seventeen-foot ceilings of the former
meetinghouse were used to divide the
space into a big main room and lofts; floor-
to-ceiling windows were added to bring in
light and keep the apartments airy.

SOURCES

ARCHITECTS

David Bergman
241 Eldridge St., #3R
New York, NY 10002
info@cyberg.com
www.cyberg.com

Richard Bergmann Architects
63 Park St.
New Canaan, CT 06840
203-966-9505

Carlos Brillembourg Architects
87 Crosby St.
New York, NY 10012
212-431-4597
brillembourg.architects@verizon.net
www.carlosbrillembourgarchitects.com

Gilles Bouchez
66 Rue Rene Boulanger
Paris 75-010
France
011-33-01-42-39-44-39
gbouchez@club-internet.fr

Gary M. Cunningham
918 Dragon St.
Dallas, TX 75207
214-915-0900
www.cunninghamarchitects.com

Peter Doo
Hord, Coplan & Macht
111 Market Pl., Suite 710
Baltimore, MD 21202
410-837-7311

Tom Fennell
Fennell Purifoy Architects
111 Center St., Suite 1620
Little Rock, AR 72201
501-372-6734

Frederick Fisher & Partners
12248 Santa Monica Blvd.
Los Angeles, CA 90025
310-820-6118
www.fisherpartners.com

Grattan Gill
128 Route 6A
Sandwich, MA 02563
508-888-4884

Bryant Glasgow
3212 West End, Suite 300
Nashville, TN 37203
615-386-9600

**David H. Gleason Associates, Inc.
Architects**
520A N. Eutaw St.
Baltimore, MD 21021
410-728-1810
gleasonaia@aol.com

Graham Gund
47 Thorndike St.
Cambridge, MA 02141
617-577-9600
www.grahamgund.com

Philetus Holt III
Holt Morgan Russell Architects
350 Alexander St.
Princeton, NJ 08540
609-924-1358
www.hmr-architects.com

Keith Kroeger
Kroeger Woods Associates, Architects
255 King St.
Chappaqua, NY 10514
914-238-5391

Robert Orr & Associates
441 Chapel St.
New Haven, CT 06511
203-777-3387
www.robertorr.com

Dan Shipley
Shipley Architects
5538 Dyer St., #107
Dallas, TX 75206
214-823-2080
www.shipleyarchitects.com

Smith-Miller + Hawkinson Architects
306 Canal St.
New York, NY 10013
212-966-3875
www.smharch.com

Richard Tremalgio
5 Story St.
Cambridge, MA 02138
617-492-4469
www.rctarchitects.com

Peter Kurt Woerner & Associates
Architects and Builders
44 Kendall St., Studio 44
New Haven, CT 06512
203-466-1923
pwoerner@sbcglobal.net

BUILDERS AND CARPENTERS

These companies and individuals specialize in historic buildings.

Stephen Chase Contracting
P.O. Box 262
Athol, MA 01331
978-249-4860
www.traditional-building.com/brochure/members/chase.shtml

Historic Structures
3711 Cumberland St., NW
Washington, DC 20016
202-686-0135
www.historicstructuresdc.com

Walter Kenul
176 Norman Ave.
Brooklyn, NY 11222
718-383-3667
bfdfirehousestudios.us

Landmark Services, Inc.
7 Oakland St.
Medway, MA 02053
508-533-8393
www.landmarkservices.com

Pinneo Construction
33 Vandeventer Ave.
Princeton, NJ 08542
609-921-9446
www.pinneoconstruction.com

Showcase Contracting
3 Emerald La.
Suffern, NY 10901
845-357-6772
www.showcasecontracting.com

Traditional Builders, Inc.
7 Windwhisper La.
Annapolis, MD 21403
410-991-1834
www.tradbuild.com

Winans Construction
3947 Opal St.
Oakland, CA 94609
510-653-7288
www.winconinc.com

The Restoration Trades Catalog
http://www.restorationtrades.com/
An online service that has more than
244 categories of artisans that work
on pieces of architecture as diverse
as masonry and weathervanes.

ARCHITECTURAL SALVAGE

These outlets and stores, each unique,
carry everything from pieces of build-
ings, like columns and stained-glass win-
dows, to their details, like doorknobs
and tower bells.

Architectural Antiques Exchange
715 N. Second St.
Philadelphia, PA 19123
215-922-3669
www.architecturalantiques.com

Architectural Artifacts
4325 N. Ravenswood
Chicago, IL 60613
773-348-0622
www.architecturalartifacts.com

The Architectural Salvage Company
727 Anacapa St.
Santa Barbara, CA 93101
805-965-2446

Artefact Design & Salvage
697 W. San Carlos Blvd.
San Jose, CA 95126
408-279-8766
www.artefactdesignsalvage.com

The Back Doors Warehouse
2329 Champlain St., NW
Washington, DC 20009
202-266-0587

The Bank Antiques
182 Felicity St.
New Orleans, LA 70015
504-523-6055

Brass Knob
2311 18th St., NW
Washington, DC 20009
202-332-3370
www.thebrassknob.com

Demolition Depot
216 E. 125th St.
New York, NY 10035
212-860-1138
www.demolitiondepot.com

Garden Park Antiques
7121 Cockrill Bend Blvd.
Nashville, TN 37209
615-350-6655
www.gardenpark.com

Gargoyles Limited
512 Third St.
Philadelphia, PA 19147
215-629-1700

Liz's Antique Hardware
453 S. LaBrea
Los Angeles, CA 90036
323-939-4403
www.lahardware.com

Restoration Hardware
800-762-1005
www.restorationhardware.com
Stores across the country carry repro-
ductions only of historic items, like the
"Schoolhouse Sconce."

Restoration Resources
31 Thayer St.
Boston, MA 02118
617-542-3033
www.restorationresources.com

Salvage One
1840 W. Hubbard Rd.
Chicago, IL 60622
312-733-0098
www.salvageone.com

United House Wrecking Corporation
535 Hope St.
Stamford, CT 06920
203-348-5371
www.unitedhousewrecking.com

Urban Archeology
143 Franklin St.
New York, NY 10013
212-431-4646
www.urbanarcheology.com

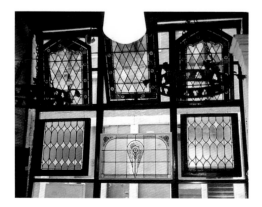

Vintage Beams & Timbers, Inc.
P.O. Box 548
Sylva, NC 28779
828-586-0755
www.vintagebeamsandtimbers.com

Some organizations have been set up
so that parts of buildings can be
donated for charitable purposes. The
motto of one of these, The Loading
Dock, is "You could build a house out
of what people throw away." Depending
on their inventory, you may also be
able to buy historic items there to fund
their programs.

Housing Works
143 W. 17th St.
New York, NY 10011
212-366-0820
www.housingworks.org

The Loading Dock
2523 Gwynns Falls Pkwy.
Baltimore, MD 21216
410-728-DOCK
www.loadingdock.org

SOCIETIES, ASSOCIATIONS, AND EXPERTS

American Society of Appraisers
P.O. Box 17265
Washington, DC 20041
703-478-2228
www.appraisers.org

BARN AGAIN!
Hotline: 303-623-1504
www.nationaltrust.org
This program through the National
Trust provides advice, information,
and referrals on historic barns and
works to preserve them, with awards
for best barns and exhibitions and
workshops to learn more.

**International Association of
Assessing Officers**
130 E. Randolph St., Suite 820
Chicago, IL 60601
312-819-6100
www.iaao.org

**National Conference of States on
Building Codes and Standards**
505 Huntmar Park Dr., Suite 210
Herndon, VA 22101
703-437-0100
www.ncsbs.org

**The National Trust for Historic
Preservation**
1785 Massachusetts Ave., NW
Washington, DC 20036
202-588-6000
www.nationaltrust.org

Real Estate Buyer's Agent Council
430 N. Michigan Ave.
Chicago, IL 60611
318-329-8559
www.rebac.net

William Shopsin,
Historical Consultant
280 W. 11th St.
New York, NY 10014
212-989-7009

Society for the Preservation of
New England Antiquities
141 Cambridge St.
Boston, MA 02114
617-227-3956
www.spnea.org

CONVERTED INNS

Hotels and bed-and-breakfasts
that have been converted from
non-residential buildings are not
only fun to visit, they can also give an
idea of what it is like to live for
a few days in a converted structure.

Emerson Inn by the Sea
1 Cathedral Ave.
Rockport, MA 01966
978-546-6321
800-964-5550
www.emersoninnbythesea.com
A tavern that became an inn in 1856
when a raid by the townspeople
destroyed all of the alcoholic spirits in
the town.

The Inn at Millrace Pond
P.O. Box 359
Hope, NJ 07844
908-459-4884
millrace@epix.net
An inn made from what was a
stone gristmill.

The Lighthouse Inn
P.O. Box 128
1 Lighthouse Inn Rd.
West Dennis, MA 02670
508-398-2244
www.lighthouseinn.com
Built in 1855, the former lighthouse
is still lit.

The Tremont House
2300 Ship's Mechanic Row
Galveston, TX 77550
409-763-0300
800-WYNDHAM
www.galveston.com/thetremonthouse
Once the South's largest dry goods
company, built in 1879.

The White Barn Inn
37 Beach Ave.
Kennebunkport, MA 04046
207-967-2321
whitebarninn.com
Formerly a classic New England barn.

A few organizations present entire
programs for staying in historic build-
ings, most of which are conversions.
Represented here are buildings in the
United States, the United Kingdom,
and France:

The Landmark Trust
Landmark Trust USA
707 Kipling Rd.
Dummerston, VT 05301
802-254-6868
www.landmarktrust.co.uk
A building preservation charity that
rescues and restores architecturally

interesting and historic buildings at
risk in Europe, giving them a future
by renting them out for vacations.
For the handbook with full details
of all 178 buildings, send $25 or
e-mail or call the number listed
above. The money is refundable
against the price of the first stay.

Historic Hotels of America
National Trust/HHA
1785 Massachusetts Ave., N.W.
Washington, DC 20036
202-588-6295
202-588-6292
Toll-Free Reservations: 800-678-8946
hha@nthp.org
A division of The National Trust for
Historic Preservation, which provides
hundreds of listings for buildings
more than fifty years old in both rural
and urban locations that maintain a
very high standard of historical accu-
racy. Most are on the National
Register of Historic Places. Call or
e-mail for a directory.

Châteaux & Hôtels de France
info@chateauxhotels.com
E-mail for a hotel guide of 526
charming locations overseas.

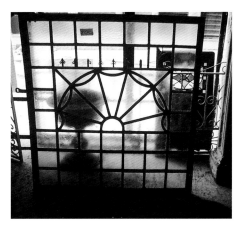

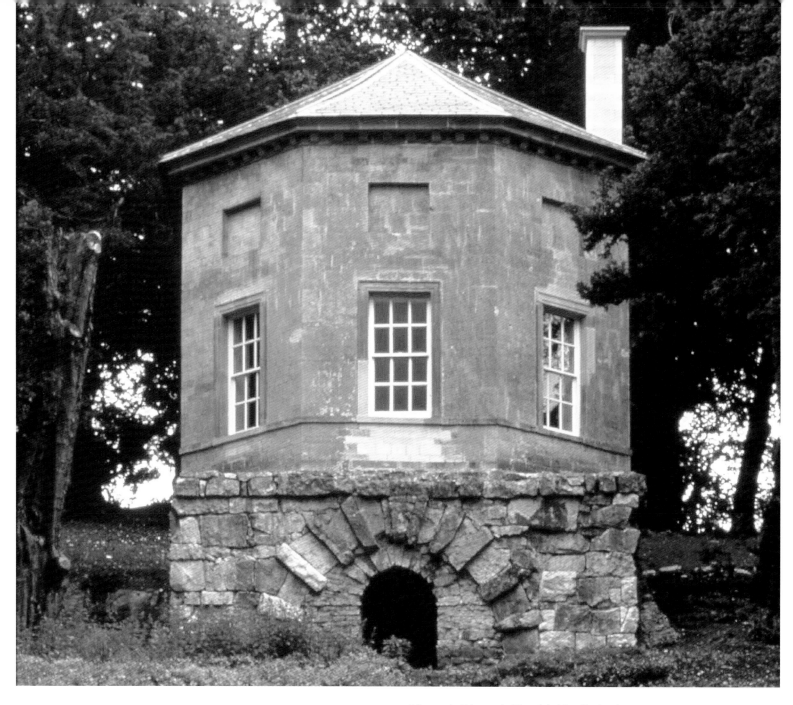

▲ A former bathhouse in Warwickshire, England that was created in 1748 to further the positive effects of cold-water bathing is now a place to vacation, thanks to The Landmark Trust, an organization that rescues and revives old buildings by making them into destinations for tourists to stay.

INDEX

CREDITS